PORTRAIT
PHOTOGRAPHER'S
HANDBOOK

Third Edition

Bill Hurter

AMHERST MEDIA, INC. ■ BUFFALO, NY

Copyright © 2007 by Bill Hurter.
All rights reserved.

Front cover photograph by Tim Kelly.
Back cover photograph by Chris Nelson.

Published by:
Amherst Media, Inc.
P.O. Box 586
Buffalo, N.Y. 14226
Fax: 716-874-4508
www.AmherstMedia.com

Publisher: Craig Alesse
Senior Editor/Production Manager: Michelle Perkins
Assistant Editor: Barbara A. Lynch-Johnt
Editorial Assistance from: Carey A. Maines and Artie Vanderpool

ISBN-13: 978-1-58428-207-5
Library of Congress Control Number: 2006937290
Printed in Korea.
10 9 8 7 6 5 4 3 2 1

Notice of Disclaimer: The information contained in this book is based on the author's experience and opinions. The author and publisher will not be held liable for the use or misuse of the information in this book.

TABLE OF CONTENTS

INTRODUCTION .7

1. EQUIPMENT AND BASIC TECHNIQUES10
Camera Format/Size .10
 Large Format .10
 Digital 35mm .10
Lenses .11
 Image Stabilization11
 Focal Length .11
 Digital Cameras and Focal Length13
 Focusing .14
 Depth of Field .15
 Shooting Apertures15
Shutter Speeds .17
Film .18
 Film Families .18
 Black & White .18
Digital Capture .19
 ISO Settings .19
 Contrast .20
 Black & White Mode20
 File Format .20
 White Balance .20
 Noise Reduction .21
 Sharpness .21
Exposure .21
Metering .21
 Reflected-Light Meters21
 Incident-Light Meters22
 Incident Flashmeters22
Lights and Light Modifiers22
 Continuous Light *vs.* Strobe22
 Light Modifiers .23

2. GOOD DIGITAL WORKING TECHNIQUES24
Exposure .24
Determining Your Camera's E.I.24
Metadata .25
File Formats .25

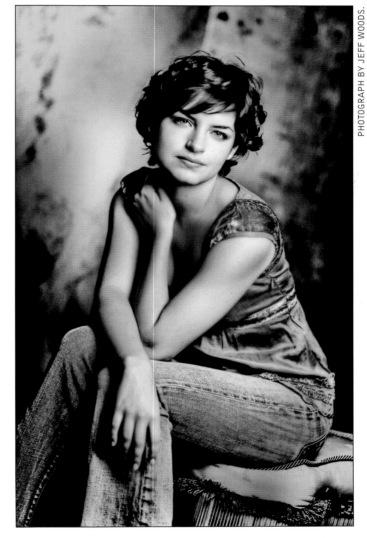

PHOTOGRAPH BY JEFF WOODS.

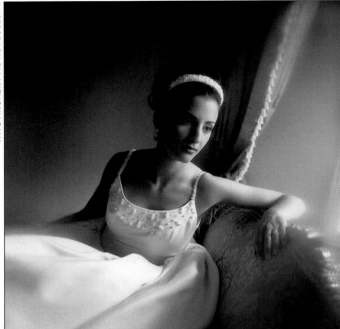

JPEG .25
RAW .26
RAW Converters27
Color Space30
Back Up Your Files31
Reformat Your Cards32
Printing Options32

3. POSING33
Subject Comfort34
The Shoulders34
Head Positions34
 The Seven-Eighths View34
 The Three-Quarters View35
 The Profile View35
Tilting the Head35
The Eyes .36
The Mouth36
 Natural Smiles36
 Moistening the Lips36
 Avoiding Tension36
 Gap Between the Lips36
 Laugh Lines37
Chin Height37
Arms .37
Hands .38
Three-Quarter- and Full-Length Poses40

Three-Quarter-Length Portraits40
Full-Length Portraits40
Feet and Legs40
Hands .41

4. COMPOSITION42
The Rule of Thirds42
The Golden Mean43
Direction .44
Compositional Forms45
Subject Tone45
Focus .46
Lines .46

5. BASIC PORTRAIT LIGHTING48
The Lights48
 Key and Fill Lights49
 Hair Light50
 Background Light50
 Kicker Lights50
Lighting Types50
 Broad Lighting50
 Short Lighting50
Basic Lighting Setups51
 Paramount Lighting51
 Loop Lighting51
 Rembrandt Lighting52
 Split Lighting53
 Profile Lighting54
The Finer Points54
 Feathering54
 Fill Light Placement55
Lighting Ratios56
 Calculating56
 Unique Personalities56
Setting the Lights58
Metering for Exposure61
Flags or Gobos62
Reflectors .62

6. LIGHTING VARIATIONS63
Window Light63
 Subject Positioning64
 Metering64
 While Balance65

Fill-in Illuminations66
Diffusing Window Light67
One-Light Portraits68
Portable Flash .68
TTL Flash Exposure70
On-Camera Flash70

7. OUTDOOR LIGHTING71
Shade .71
Fill-in Light .72
Reflected Fill Light73
Flash Fill Light .73
Subtractive Lighting74
Eliminating Overhead Light75
Scrims .76
Background Control76
Direct Sunlight .77
Skimming the Light77
Cross Lighting .77
Backlighting .77
Using Flash Outdoors78
Flash Fill .78
Flash Key .78
Additional Tips for Outdoor Lighting79
Create Separation79
Use Care in Subject Positioning79
Employ a Tripod79
Watch the Color in the Shadows80

8. SPONTANEOUS PORTRAITS81
Observing the Subject81
Shooting Techniques84
Composition .84
Shutter Speed .84
Don't Skimp .84
Master Your Camera Controls84

9. CORRECTIVE TECHNIQUES86
Facial Analysis .86
Soft Focus and Diffusion87
Camera Height and Perspective88
Correcting Specific Problems89
Overweight Subjects89
Thin or Underweight Subjects90
Elderly Subjects .90

Eyeglasses .90
One Eye Smaller than the Other91
Baldness .91
Double Chins .91
Wide Faces .91
Thin Faces .91
Broad Foreheads .92
Deep-Set and Protruding Eyes92
Large Ears .92
Very Dark Skin Tones92
Uneven Mouths .92
Long Loses and Pug Noses92
Long Necks and Short Necks92
Wide Mouths and Narrow Mouths93
Long Chins and Stubby Chins93

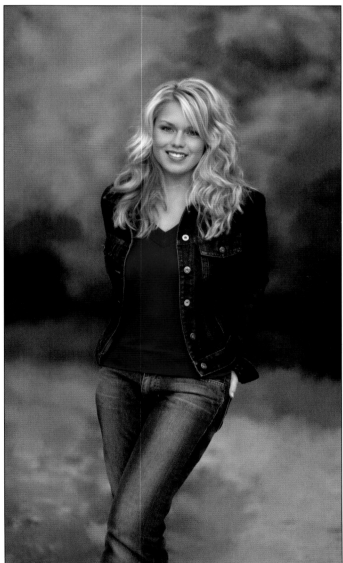

PHOTOGRAPH BY FUZZY DUENKEL.

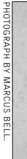

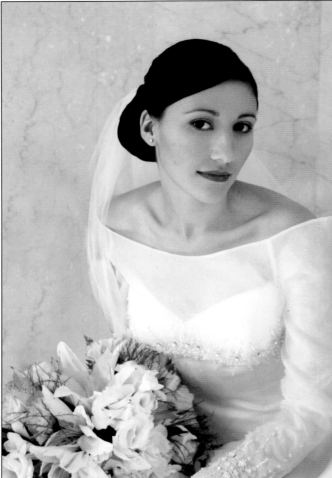

Layer Sets .97
Background Copy Layer97
Retouching .98
Soft Focus .98
Selective Focus .100
Removing Blemishes100
Shininess and Wrinkles101
Teeth and Eyes .101
Glare on Glasses .102
Contouring with the Liquify Filter102
Actions .102

11. FINE PRINTS .103
What is a Fine Print? .103
Good Color Management103
Camera Profiles .104
Monitor Profiles .105
Printer Profiles .105
Archival Permanence106
Enlarging Images .106
Stair Interpolation .106
Alien Skin's Blow Up106
Print Finishing .106
Dodging and Burning-In106
Contrast Control .107
Color Correction .108
Toning .109
Handcoloring Effects110
Vignettes .110
Sharpening .111

CONCLUSION .113
THE PHOTOGRAPHERS114
GLOSSARY .118
INDEX .122

Oily Skin .93
Dry Skin .93
Skin Defects .93
Be Discriminating .94

10. PHOTOSHOP RETOUCHING TECHNIQUES . . .95
Retouching Then .95
Retouching Now .96
Working with Layers .97
Linking Layers .97

ontemporary portrait styles have become more relaxed and less formal in the past decade. What is gained is a level of spontaneity and naturalness that people seem to like. What is lost is the idyllic, structured way of rendering the human form.

There are numerous reasons for the move to a more casual framework. The influence of fashion photography, with its heavily diffused lighting and untraditional posing, is one big reason. Another is the move by professional photographers to the smaller-format digital camera, with it's instantaneous nature and its bag of creative tricks. The modern DSLR gives photographers a level of flexibility that lends itself to shooting lots of images and many variations, including more spontaneous poses. Also, the advent of TTL-metered electronic

The advent of digital makes altering the reality of the image simple. In this award-winning image by Marcus Bell, the time of day and lighting angle have been altered in Photoshop. Even the location itself has been made to look more theatrical by the manipulations. Marcus darkened the image, which originally was rather flat, using traditional dodging and burning in Photoshop. He then combined a duplicate sepia layer and duplicate Gaussian blur layer until the final effect was achieved. He says of this image, "It's important for photographers to understand that capturing the image is only the first stage of many to produce a final image. I wanted to emphasize their fairytale-like dresses, so I printed the image to reflect this."

TOP—The fine portrait is a lasting work of art. Elegant posing and lighting and an acute sense of the environment make an outstanding image. The camera used was a Bronica SQ-Ai with a PS 80mm lens using Kodak Portra 400VC film. It was exposed for $^1/_{15}$ second at f/4. Available light from windows and lamps at the location was used, with the addition of a Lumedyne 50 Watt-second barebulb flash as a fill light. Photograph by Robert Lino. BOTTOM—The modern portrait photographer creates an image that imparts lifestyle and character in a casual, relaxed framework of posing and lighting. Photograph by Cherie Steinberg-Coté.

flash has made the modern-day portrait something that can be made anywhere, not just in a studio.

Digital technology offers the portrait photographer flexibility and speed and, perhaps most importantly, the ultimate in creative control. The photographer can change from color to black & white on the fly, change white balance similarly, and there is no delay for processing, proofing, and printing. Both the photographer and the client can examine the captured images instantly, capitalizing on the excitement of the just-finished portrait session. Additionally, the daunting task of traditional retouching has all but been eliminated by Adobe® Photoshop® and its many tools and techniques. The special effects tricks that were once the province of the accomplished darkroom technician are now routinely created quickly and expertly by the photographer in Photoshop.

Despite these technological advances, though, many of the techniques of the old-time portraitist have survived and are useful to today's photographers. The rudiments of posing and composition are timeless and date back to the beginnings of Greek civilization. This book attempts to combine some of the time-tested disciplines with more contemporary methods in such a way that they will be useful to the modern-day photographer. The emphasis will be on techniques rather than on sophisticated studio equipment. After all, if a specific type of portrait can be made with two

lights just as simply as with five lights, why not use the simpler setup?

It is not the intent of this book to impart a series of rules that must be followed without exception. Instead, this book was created to give photographers an understanding of the traditional rules and how they're frequently broken so they may incorporate what they will into their individual repertoire of techniques. It is my hope that after reading this book and studying the award-winning images, you will have a battery of knowledge that will enable you to produce pleasing, memorable portraits.

AUTHOR'S NOTE

This is the third edition of *Portrait Photographer's Handbook*. While the focus of this new edition remains essentially on lighting, posing, and creativity for professional portraiture, one cannot ignore the impact of digital technology in portraiture in the past few years. When the first edition was published, digital capture and output were in use by only a select handful of photographers. In those early years of digital, professional cameras could cost as much as $30,000, making them a luxury for only the well-off photographer. While the goal of the portraitist is still, above all other aims, to idealize the subject, the tools of today are not only more convenient, but they are vital to that primary task. As a result, many of the changes in both the imagery and text of this new edition of *Portrait Photographer's Handbook* reflect the expanding role of digital technology in professional portraiture.

Portraiture has changed, but the goal still remains the same, to reveal the character of the subject. This underwater portrait by Larry Peters is unique. The black tricot background and the soft side lighting of an underwater strobe, combined with a floating light tent that is illuminated from a 2500 Watt-second strobe on the pool deck makes this a striking image. The reflection of the subject on the surface almost looks like angel wings. The photographer made the image with a Canon EOS 5D and 24mm lens. This portrait is an example of how the changing technology has opened up new means to create images that were almost impossible to conceive of a few years ago.

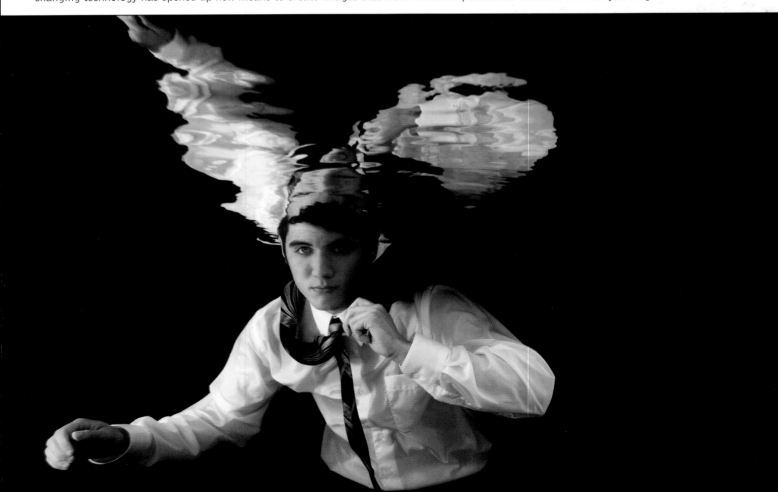

1. EQUIPMENT AND BASIC TECHNIQUES

A good portrait conveys information about the person's "self." Through controlled lighting, posing, and composition, the photographer strives to capture the essence of the subject, all at once recording the personality and the likeness of the subject. With a solid knowledge of professional equipment, portrait techniques, and a good rapport with your subject, you can create an image that is pleasing and salable—one that the subject will cherish.

CAMERA/FORMAT SIZE

Large Format. Large-format cameras and films—4x5-inches and larger—were traditionally used in portrait studios to provide greater technical accuracy and the ability to retouch the film. However, there are a great many limitations to using large format, especially now that so many of the popular emulsions available in sheet film size have been discontinued. Although there are still a fair number of fine-art portrait photographers who prefer the precision and enlargeability of sheet film, these are rare.

Digital 35mm. One of the greatest assets of digital capture is the ability to instantly preview images on the camera's LCD screen. If you miss the shot for whatever reason, you can delete the file and redo it right then and there. That kind of insurance is priceless. For example, imagine you are working outdoors using flash-fill. You examine the first couple of frames and find that the color balance is too cyan because of the color of the shade you are working in. Having noticed the problem immediately, you can just make a quick adjustment to the white balance and be ready to continue shooting. When you review the next frame, though, you find the flash output is a half stop too weak. You can then review

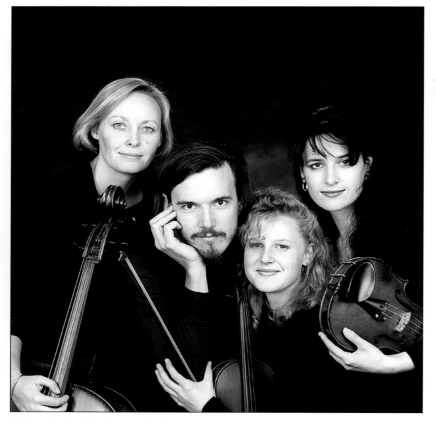

When shooting digitally with 35mm-format cameras, the size of the imaging chip (in most instances smaller than the conventional 1x1.5-inch 35mm frame) creates an effective increase in lens focal length by a factor of 1.2 to about 1.8. Thus, a 50mm f/1.2 "normal" lens becomes an f/1.2 portrait lens in the 75–80mm range. This marvelous portrait of a string quartet was made by David Williams with a FujiFilm FinePix S2 digital camera and Sigma DG 24–70mm f/2.8 zoom.

TOP—The days of needing medium format to create a large enough negative to accommodate retouching are pretty much over. Digital files can be made to virtually any size and the retouching and artistry that are possible in Photoshop and Corel Painter are more comprehensive than could have ever been accomplished traditionally. This beautiful portrait was made by Fuzzy Duenkel. BOTTOM—This wonderful portrait of actor, songwriter, politician Rubén Blades was made by Mauricio Donelli with a Sinar P2 4x5-inch camera, 210mm Rodenstock lens, and Polaroid Type 55 film. Lighting was with a Bowens 1000 Watt-second head in a large softbox.

the image histogram (a graphic representation of the tones captured in the digital file) to confirm that there's a problem, then simply adjust your flash output to correct it. With digital, instead of waiting a week or two to see that you blew it, you can adjust things and move on with the knowledge that your exposures and lighting will be flawless.

LENSES

Image Stabilization. One of the greatest enhancements in lens design has been the advent of the image-stabilization lens, which counteracts camera movement, allowing the photographer to handhold the camera and shoot at impossibly slow shutter speeds of $\frac{1}{15}$, $\frac{1}{8}$, or even $\frac{1}{4}$ second without encountering any image-degrading camera movement. Such lenses provide the ability to shoot in low light at maximum apertures and still obtain

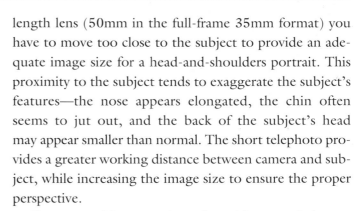

sharp images. Currently, Nikon and Canon offer such lenses for their systems. Other DSLR makers such as Sony, Olympus, and Pentax have begun incorporating image stabilizing features in the camera body, thus reducing the cost of individual lenses in which this feature is present.

Focal Length. Portraiture requires that you use a longer-than-normal lens, particularly for head-and-shoulders portraits. The rule of thumb with film cameras and lenses is to choose a lens that is twice the diagonal of the film format you are using. For instance, with the full-frame 35mm format, a 70–85mm lens is a good choice for portraits.

A short telephoto provides normal perspective without subject distortion. If you are using a "normal" focal-length lens (50mm in the full-frame 35mm format) you have to move too close to the subject to provide an adequate image size for a head-and-shoulders portrait. This proximity to the subject tends to exaggerate the subject's features—the nose appears elongated, the chin often seems to jut out, and the back of the subject's head may appear smaller than normal. The short telephoto provides a greater working distance between camera and subject, while increasing the image size to ensure the proper perspective.

You can achieve good results with a much longer lens—if you have the working room. A 200mm lens, for example, is a beautiful portrait lens for 35mm because it provides very shallow depth of field and allows the back-

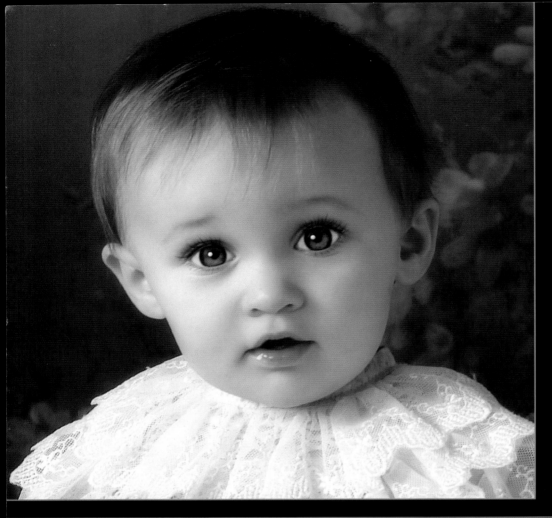

LEFT—Working with true telephotos in the 135–200mm range provide a much larger image size and a good working distance. Telephotos used at wide apertures, also produce beautiful, blended background effects. Photograph by Deborah Lynn Ferro. **BELOW**—For three-quarter- or full-length portraits, a normal focal-length lens is suggested. Not only is the perspective better for rendering the human form, but the wider field of view and greater depth of field let you incorporate scenic elements into the portrait. This portrait, called *October*, actually uses a 90mm lens, the equivalent of a 135mm lens on a full-frame 35mm camera. The working distance is greater than normal, creating a similar effect to a normal lens used at a 10- to 12-foot working distance. Photograph by Deborah Lynn Ferro.

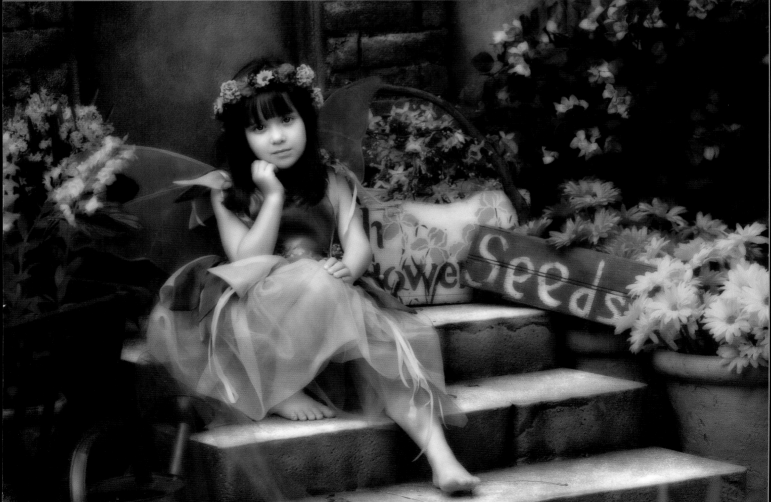

ground to fall completely out of focus, providing a backdrop that won't distract from the subject. When used at wide-open apertures, this focal length provides a very shallow band of focus that can be used to accentuate just the eyes, for instance, or just the frontal planes of the subject's face. Alternately, it can be used to selectively throw certain regions of the face out of focus.

You should avoid using extreme telephotos (longer than 300mm for the 35mm format), however, for several reasons. First, the perspective becomes distorted. Depending on the working distance, the subject's features may appear compressed, with the nose often appearing pasted to the subject's face, and the ears of the subject appearing parallel to the eyes. Second, when you use such a lens, you have to work a long distance away from the subject, making communication next to impossible. You want to be close enough to the subject so that you can converse normally without shouting out posing instructions.

When making three-quarter- or full-length portraits, it is advisable to use the normal focal-length lens for your camera. This lens will provide normal perspective because you are farther away from your subject than when making a head-and-shoulders shot. The only problem you may encounter with the normal lens is that the subject may not separate visually from the background. It is desirable to have the background slightly out of focus so that the viewer's attention is drawn to the subject, rather than to the background. With the normal lens, the depth of field is slightly greater, so that even when working at relatively wide lens apertures like f/4, it may be difficult to separate subject from background. This is particularly true when working outdoors, where patches of sunlight or other distracting background elements can easily detract from the subject.

When making group shots, you are often forced to use a wide-angle lens. The background problems discussed above can be even more pronounced with such a lens, but a wide-angle is often the only way you can fit the entire group into the shot and still maintain a decent working distance for good composition.

Digital Cameras and Focal Length. Digital cameras use image sensors and not film. This is an obvious point, but it has important consequences for lens selection. Although full-size image sensors exist (the same size as a 35mm frame), most imaging sensors are smaller. While

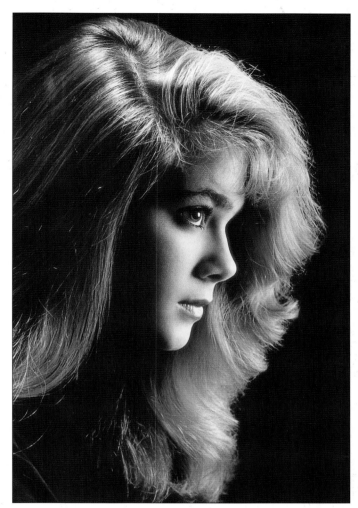

Here is an example of an incredible job of focusing and use of available depth of field. The eyes and highlighted regions of the face are the primary points of focus, but sharp focus extends throughout the image. Careful adjustment of the point of focus will make optimum use of the depth of field of the shooting aperture, in this case, f/8. The image was shot using a Pentax 645 camera with a 150mm lens. Kodak VPS at ISO 100 was exposed for $1/60$ second at f/8. The main light was a double-scrimmed, 28-inch softbox set at f/8. A "snooted" hair light set at f/8 was used slightly behind subject (a snoot is a conical reflector that is placed on the lamp housing to narrow the beam of light). Photograph by Norman Phillips.

this does not necessarily affect image quality or file size, it does affect the effective focal length of the lens. With sensors that are smaller than a 35mm frame, all lenses get effectively longer in focal length. This is not usually a problem where telephotos and telephoto zooms are concerned, but when your expensive wide-angles or wide-angle zooms become significantly less wide on the digital camera body, it can be somewhat frustrating. With a 1.4x focal-length factor, for example, a 17mm lens becomes a 24mm lens.

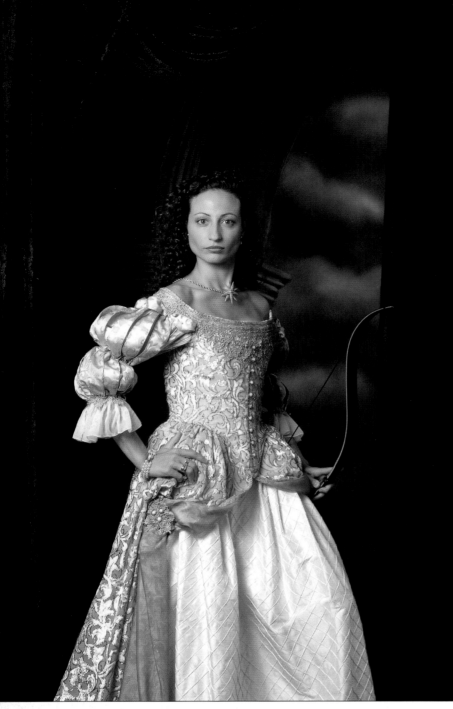

This image by David Williams, titled *Winter*, was inspired by Vivaldi's *The Four Seasons*. The subject is portrayed as Diana the Huntress, after the painting by Sir Peter Lely (1618–1680). The image was made with a FujiFilm Finepix S1 Pro and Sigma DG 24–70mm zoom lens. Studio lighting was used. The image required very sharp focus to hold the distance from the right hand to the left, which holds "Dianna's" bow. Beyond that, Williams wanted the background to fall out of focus, offering only shapes and color, but no vivid details. An f/8 aperture provided the necessary depth of field. Knowing what areas must be sharp and what areas should not be sharp are essential to creating a memorable portrait.

Focusing. Generally speaking, the most difficult type of portrait to focus precisely is a head-and-shoulders portrait. It is important that the eyes and frontal features of the face be tack sharp. It is usually desirable for the ears to be sharp as well (but not always).

When working at wide lens apertures where depth of field is reduced, you must focus carefully to hold the eyes, ears, and tip of the nose in focus. This is where a good knowledge of your lenses comes in handy. Some lenses will have the majority of their depth of field behind the point

of focus; others will have the majority of their depth of field in front of the point of focus. In most cases, the depth of field is split 50/50; half in front of and half behind the point of focus. It is important that you know how your different lenses operate. And it is important to check the depth of field with the lens stopped down to your taking aperture, using your camera's depth-of-field preview control.

Assuming that your depth of field lies half in front of and half behind the point of focus, it is best to focus on the subject's eyes in a head-and-shoulders portrait. This will generally keep the full face and the main center of interest, the eyes, in focus. The eyes are a good point to focus on because they are the region of greatest contrast in the face, and thus make focusing simple. This is particularly true for autofocus cameras that often seek areas of contrast on which to focus.

Focusing a three-quarter- or full-length portrait is a little easier because you are farther from the subject, where depth of field is greater. Again, you should split your focus, halfway between the closest and farthest points that you want sharp on the subject or in the scene.

Autofocus (AF), once unreliable and unpredictable, is now thoroughly reliable and extremely advanced. Some cameras feature multiple-area autofocus so that you can, with a touch of a thumbwheel, change the active AF sensor area to different areas of the viewfinder (the center or outer quadrants). This allows you to "de-center" your im-

ages for more dynamic compositions. Once accustomed to quickly changing the AF area, this feature becomes an extension of the photographer's technique.

Autofocus and moving subjects used to be an almost insurmountable problem. While *you* could predict the rate of movement and focus accordingly, the earliest AF systems could not. Now, however, almost all AF systems use a form of predictive autofocus, meaning that the system senses the speed and direction of the movement of the main subject and reacts by tracking the focus of the moving subject. This is an ideal feature for activity-based portraits, where the subject's movements can be highly unpredictable.

A new addition to autofocus technology is dense multiple sensor-area AF, in which an array of AF sensor zones (up to 45 at this writing) are densely packed within the frame, making precision focusing much faster and more accurate. These AF zones are user selectable or can all be activated at the same time for the fastest AF operation.

Depth of Field. This is a good place to discuss some basic points about lenses and depth of field.

First, shorter lenses have much greater apparent depth of field than telephotos. This is why so much attention is paid to focusing telephoto lenses accurately in portraiture.

Second, the closer you are to your subject, the less depth of field you will have. When you are shooting a tight face shot, be sure that you have enough depth of field at your working lens aperture to hold the focus fully on the subject's face.

Since most of today's lenses no longer have a depth-of-field scale it is important to review depth of field in the camera's LCD in a magnify mode, or using the camera's

This lovely portrait made by Vicki Taufer was taken with a Canon EOS 1DS and 70–210mm f/2.8 lens. Vicki knew the amount of depth of field she needed—enough to cover the face and hands—so she decided on an aperture of f/4 at the lens's 150mm setting. She also posed the little girl so both key areas would be in the same plane of focus, making her f/4 aperture adequate for the job. The wide aperture also blurs the background, making it a wash of color.

depth-of-field preview. The problem with the latter method is that when the lens is stopped down with the depth of field preview, the viewfinder screen is often too dim to gauge depth of field accurately.

Shooting Apertures. Choosing the working lens aperture is often a function of exposure level. In other words, you often don't always have much of a choice in the aperture you select, especially when using electronic flash or when shooting outdoors.

When you do have a choice, though, experts say to choose an aperture that is 1½ to 2 stops smaller than the lens's maximum aperture. For instance, the optimum lens aperture of an f/2 lens would be around f/4. A lens used wide open (at its maximum aperture) theoretically suffers from spherical aberration; a lens at its smallest apertures—f/16 or f/22—suffers from diffraction. Both of these conditions reduce the overall sharpness of the recorded image.

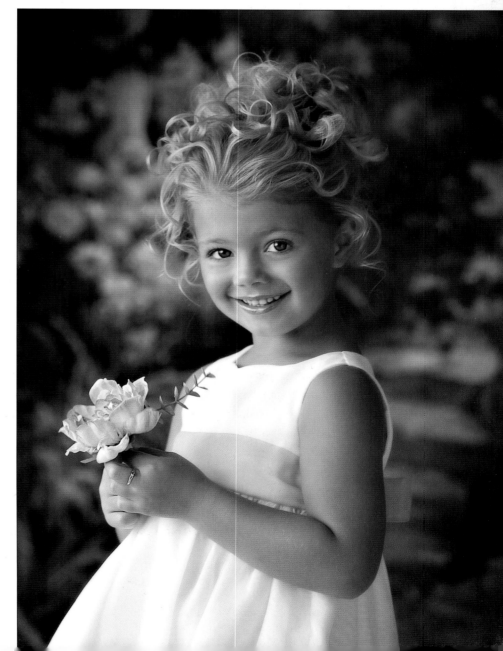

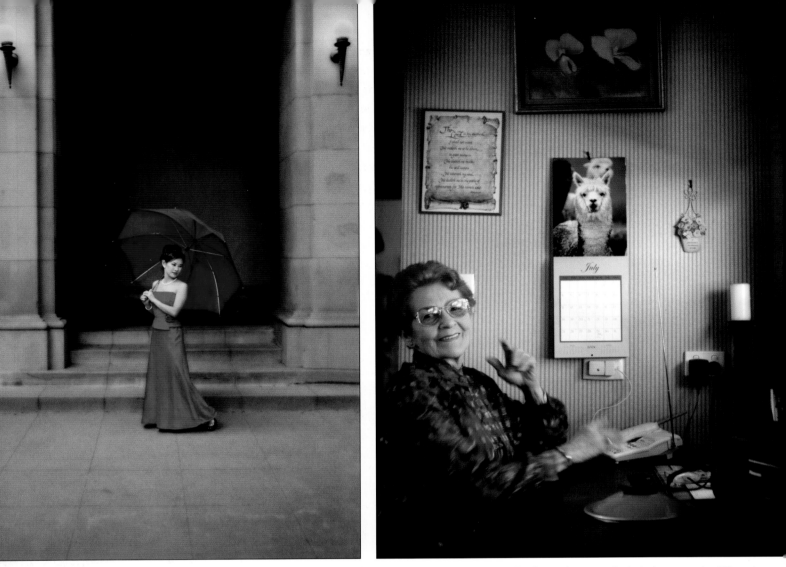

LEFT—Jerry D, a well known photographer from Southern California, likes to work late in the day—almost at dusk, to incorporate different light sources in his images, like the globe lights in this image. His shutter speeds are long, from ¹/₃₀ to ¹/₈ second, and his apertures are minimal, usually around f/4. This image was made in open shade at a government building in Riverside, CA. In Photoshop, he darkened and softened the stonework and added texture with grain. He also enhanced the contrast and saturation of the subject and umbrella. He helped the lights out by adding a touch of yellow to the globes. RIGHT—Not wanting to use flash, which would spoil the delicate window lighting and balance of light sources in the scene, Marcus Bell opted for available light, shooting with an ISO of 400 and exposure settings of ¹/₄₀ second at f/2.8. Knowing how slow a shutter speed you can work with is part of the professional's repertoire of experience. Notice the hands moving, but not the woman's face.

It should be noted that most of today's lenses are optimized for wide-open shooting so there is no reason not to use them at their widest aperture.

Expert portrait photographer Fuzzy Duenkel always shoots at f/4, even though his lenses are all f/2.8 or faster. The reason, he says, is to cover any autofocusing errors that may occur. The slight increase in depth of field afforded by the smaller lens aperture can compensate for minor focusing errors.

The optimum aperture, however, may not always be small enough to provide adequate depth of field for a head-and-shoulders portrait, so it is often necessary to stop down. These apertures are small enough to hold the face in focus, but not small enough to pull the background into focus. They usually also allow for the use of a fast enough shutter speed to stop subtle camera or subject movement. Note that the use of optimum lens apertures is dependent on the overall light level and the ISO you are using.

The trend in contemporary portraiture is to use wide apertures with minimal depth of field. The effect is to produce a thin band of focus, usually at the plane of the eyes.

One of the by-products of shooting wide open is a blurred background, which can be quite appealing when working outdoors.

SHUTTER SPEEDS

You must choose a shutter speed that stills camera and subject movement. If you are using a tripod, $\frac{1}{30}$–$\frac{1}{60}$ second should be adequate to stop average subject movement. If you are using electronic flash, you are locked into the flash-sync speed your camera calls for unless you are "dragging" the shutter, meaning, working at a slower-than-flash-sync speed to bring up the level of ambient light. This effectively creates a flash exposure blended with an ambient-light exposure.

When working outdoors you should generally choose a shutter speed faster than $\frac{1}{60}$ second, because slight breezes will cause the subject's hair to flutter, producing motion during the moment of exposure.

If you are not using a tripod, the general rule is to use a shutter speed that is the reciprocal of the focal length of the lens you are using for a shutter speed. For instance, if using a 100mm lens, use $\frac{1}{100}$ second (or the next highest equivalent shutter speed, like $\frac{1}{125}$ second) under average conditions. If you are very close to the subject, as you might be when making a tight face shot, you will need to use a faster shutter speed. When farther away from the subject, you can revert to the shutter speed that is the reciprocal of your focal length.

When shooting candids, or action-type portraits, use a faster shutter speed and a wider lens aperture. It's more important to freeze the subject's movement than it is to have great depth of field in such situations. If you have

Tim Schooler shoots digitally, but employs film profiles in his RAW file processing, done using Phase One Capture One, to emulate the qualities of Portra film, his film of choice when he shot with film only. One of his goals in doing this is to enhance the contrast of the image and increase color saturation without blowing out detailed highlights.

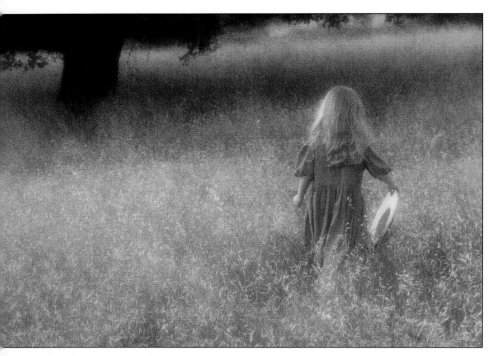

Today's color films provide a wide range of tools for the contemporary portrait photographer. Here, the low inherent contrast of Kodak Ektapress 1600 film and its pleasing "pointillist" grain structure make an ideal romanticized portrait. The image was shot on a Canon EOS camera with a Tamron 28–200mm lens at the 100mm setting. Diffused sun setting to the left of the camera illuminated the little girl's hair. Soft-focus filtration was also used to lower the scene contrast and maximize the grain effect. Photograph by Robert and Suzanne Love.

any question as to which speed to use, always use the next fastest speed to ensure sharp images.

FILM

Although film use has diminished significantly, many people still make portraits with film, which is why this section is still included in this edition. Good quality portraits can be made on any type of film stock. However, extremely slow and extremely fast films should be avoided. Black & white and color films in the ISO 25 range tend to be slightly too contrasty for portraits, and exposure latitude tends to be very narrow with these films. With the slower, more contrasty films, you tend to lose delicate shadow and highlight detail if the exposure is even slightly off.

Faster films, particularly in black & white, provide a greater margin for error in the area of exposure and development, but they are often too grainy to be used successfully in portraiture. The contrast of such films is often lower than what is desirable for portraiture, but, at least in the case of fast black & white films, the contrast can be suitably altered in development or by printing the nega-

tives onto variable- or high-contrast enlarging papers.

Today's color negative films in the ISO 100–400 range have an almost nonexistent grain structure. Also, their exposure latitude often ranges from –2 to +3 stops from normal. Of course, optimum exposure is still and will always be recommended, but to say that these films are forgiving is an understatement.

Film Families. Kodak and FujiFilm, offer "families" of color negative films. Within these families are different speeds, from ISO 160 to 800, for example, and variations in contrast or color saturation, but with the same color palette. Kodak's Portra films include speeds from ISO 160 to 800 and are available in NC (natural color) or VC (vivid color) versions. Kodak even offers an ISO 100 tungsten-balanced Portra film. Fujicolor Portrait films, available in a similar range of speeds, offer similar skin-tone rendition among the different films as well as good performance under mixed lighting conditions because of a fourth color layer added to the emulsion. These films are ideal for portrait photographers, because different speeds and format sizes can be used in the same session with only minimal differences observed in the final prints. Another advantage of these films is that they have similar printing characteristics and identical scanner settings, meaning that different speed films can be scanned at the same settings.

Black & White. Contrast is a more important ingredient in black & white portraits than in color ones. In color, you are locked in to the degree of contrast you can produce in the image. The color paper can only hold so much contrast, and it cannot be significantly altered.

With black & white negatives, on the other hand, contrast can be increased or decreased in development (increasing the negative development increases contrast; decreasing the development reduces contrast). This is important to know, because the contrast in your portraits will vary a great deal. Those shot in bright sunlight with a minimum of fill-in illumination, or those shot in other types of high-contrast lighting, should be altered in development by decreasing development a minimum of 10 per-

cent. Portraits made under soft, shadowless light, such as umbrella illumination, will have low contrast, so the development should be increased at least 10 percent—sometimes even 20 percent. The resulting negatives will be much easier to print than if developed normally and will hold much greater detail in the important tonal areas of the portrait.

DIGITAL CAPTURE

ISO Settings. Digital ISO settings correlate closely to film speeds. However, they can be increased or decreased between frames, making digital capture inherently more flexible than shooting with film, where you are locked into a film speed for the duration of the roll.

As with film, the lower the ISO setting, the less noise (the digital equivalent of grain) and the more contrast. Shooting at the higher ISOs, like ISO 1600, produces a lot of digital noise in the exposure, although it's worse with some cameras than others. Many digital image-processing programs contain noise-reduction filters that address this issue. Products like Nik Software's Dfine, a plug-in filter for Adobe Photoshop, effectively reduce

NOISE

Noise occurs when stray electronic information affects the sensor sites. It is made worse by heat and long exposures. Noise shows up more in dark areas making evening and night photography problematic with digital capture. It is worth noting because it is one of the areas where digital capture is quite different from film capture.

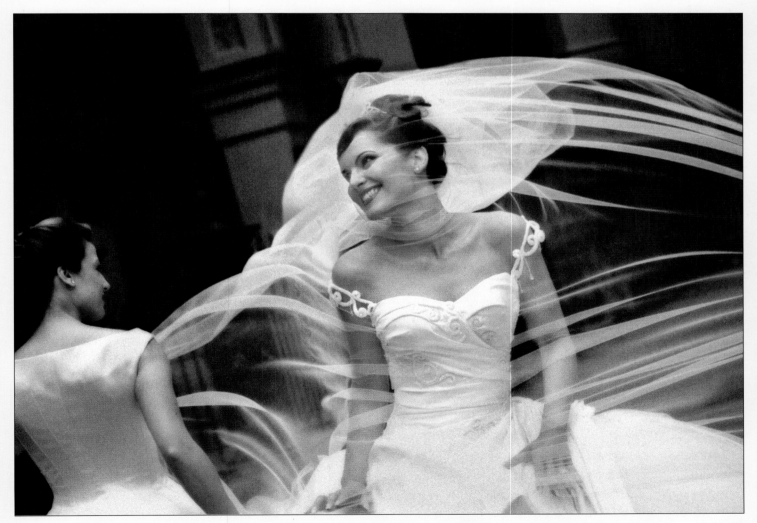

This image, by Yervant, was shot with available light on a windy and overcast day in Melbourne, Australia. The bride's veil was a very light silk and kept flying in the wind while she had fun under it with her bridesmaids. Yervant chooses a few images that he works on in Photoshop, even before showing any proofs to the couple. These are his "signature" images. Yervant copied sections of the image to make a new layer—the veil. Once he had the new layer, he then added Motion Blur in Photoshop in the direction of the veil's natural flow to boost the extra life in the moment. He then selected a section of the background and applied the purple hue to make the background less demanding, tonally. After he flattened the image, he added a bit of Photoshop grain [Filter>Texture>Grain] to make the image grainy to suit his own personal taste.

Knowing the effect of backgrounds on exposure meters is crucial for a scene like this. Anthony Cava, a photographer well known for his fine portraits, shot this image as a commercial portrait for a clothing-design catalog. He metered the available light, decided to underexpose his background by almost a full f-stop, and fired an umbrella-mounted studio flash to provide brilliance and facial modeling. The light was positioned above and to the right of the model, creating a "loop" like pattern. No fill was used. The image was made with a Nikon D1X, 80–200mm zoom (at 80mm setting) at an exposure of $^1/_{30}$ second at f/3.5.

should be set to the lowest possible contrast setting. It's always easy to add contrast later, but more difficult to take away."

Black & White Mode. Some digital cameras offer a black & white shooting mode. Most photographers find this mode convenient, since it allows them to switch from color to black & white in an instant. Of course, the conversion can also easily be done later in Photoshop.

File Format. When you shoot with a digital camera, your digital file is your "negative." Digital SLRs offer the means to shoot files in many formats, but the two most popular ones are RAW and JPEG. For more on this, see chapter 3.

White Balance. On digital cameras, white-balance settings allow the photographer to correctly balance the color of the image capture when shooting under a variety of different lighting conditions. Accurate white balance is particularly important if you are shooting highest-quality JPEG files. It is not as important if shooting in RAW file mode, since these files are easily remedied in processing.

image noise. RAW file processors, such as Adobe Camera RAW and Adobe Lightroom, also feature powerful noise-reducing filters that can minimize or eliminate the problem altogether.

Contrast. When shooting digitally, contrast is a variable you can control at the time of capture. Professional-grade digital SLRs have a setting for contrast, which most photographers keep on the low side. According to award-winning wedding photographer Chris Becker, "Contrast

White balance can be set by selecting from a menu of preset options corresponding to common light sources, such as daylight, strobe, tungsten, and fluorescent. Some digital cameras also allow the photographer to select color-temperature settings in Kelvin degrees. These are often related to a time of day. For example, pre-sunrise lighting might call for a white-balance setting of 2000K and heavy, overcast light might call for a white-balance setting of 8000K.

Most DSLRs also have a provision for creating custom white-balance settings, which is essential in mixed light conditions, most indoor available-light situations, and with studio strobes. To use this, you simply point your camera at a white area and sample it with the camera's built-in software. The camera then calculates and records what color-balance adjustments are needed to neutralize this area and applies these changes to other images shot in the same lighting. If you do this, you can be assured of a fairly accurate rendition in your image captures.

Noise Reduction. When you know you are going to be shooting at ISOs higher than 800, turn on the camera's noise reduction filters, which are accessible through the main menu. This will save you time later in RAW file processing.

Sharpness. Most photographers set their cameras to a medium sharpness to avoid letting the camera software make critical decisions as to the sharpness of the image. It is much better to apply sharpness in post-processing, where the fine controls are better and the image can be viewed on a large monitor at greater magnifications.

EXPOSURE

Digital exposures are not nearly as forgiving as color negative film. The latitude is simply not there. Most digital photographers compare shooting digital to shooting transparency film, in which exposure latitude is usually ±½ stop. With transparency film, erring on either side of correct exposure is bad; with digital, underexposures are still salvageable, but overexposed images (where there is no highlight detail) are all but lost forever. You will never be able to restore highlights that don't exist in the original exposure. For this reason, most digital images are exposed to ensure good detail in the full range of highlights and midtones. The shadows are either left to fall into the realm of underexposure or they are filled in with auxiliary light or reflectors to boost their intensity.

To evaluate the exposure of a digitally captured image you can evaluate the histogram and/or the image itself on the camera's LCD screen. By far, the more reliable is the histogram, but the LCD monitor provides a quick reference (and is particularly useful for checking to ensure that the image is sharp).

The histogram is a graphic representation of the tones in an image file, indicating the number of pixels that exist for each brightness level. The scale of brightness levels range from 0 to 255, with 0 indicating solid black and 255 indicating pure white.

In an image with a good range of tones, the histogram will fill the complete length of the scale (*i.e.*, it will have detailed shadows and highlights and everything in between). When an exposure has detailed highlights, these will fall in the 235–245 range; when an image has detailed blacks, these will fall in the 15–30 range. The histogram may show detail throughout (from 0 to 255) but it will trail off on either end of the scale (as the tones approach solid black and pure white).

> ## With digital, underexposures are still salvageable, but overexposed images are all but lost forever.

Histograms are scene-dependent. In other words, the amount of data in the shadows and highlights will directly relate to the subject and how it is illuminated and captured. The histogram also gives an overall view of the tonal range of the image, and the "key" of the image. A low-key image will have a high amount of data in the shadows, since this is where its tones are concentrated; a high-key image, on the other hand, will have its tones concentrated in the highlights. An average-key image has its tones primarily in the midtones. An image with full tonal range has a significant amount of data in all areas of the histogram.

METERING

Reflected-Light Meters. Because exposure is so critical to producing fine portraits, it is essential to meter the scene properly. Using the in-camera light meter may not always give you consistent and accurate results. Even with sophisticated multi-pattern in-camera reflected meters, brightness patterns can influence the all-important flesh tones. Usually these meters are center-weighted because that's where most people place their subjects within the frame.

The problem with these meters arises from the fact that they are designed to average all of the brightness values in a scene to produce a generally acceptable exposure. To be precise, the in-camera meter is designed to suggest a reading that will render the metered tone as 18-percent gray.

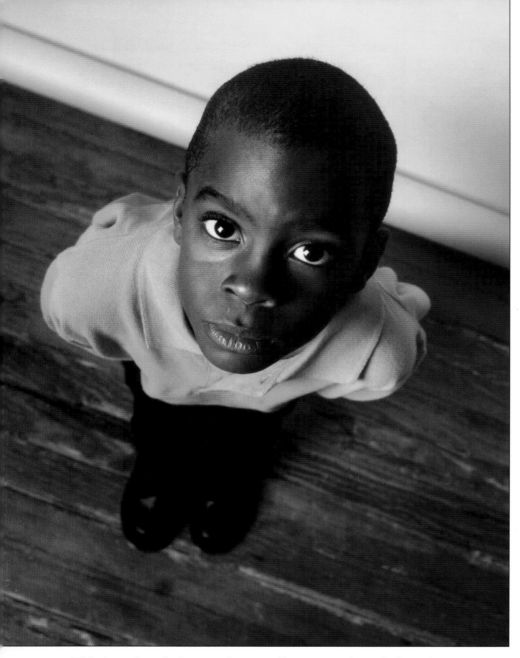

In this quirky little portrait by children's portrait specialist, Stacy Bratton, you can see the square catchlight of the large softbox mirrored in the young boy's eyes. Stacy used an unusual point of view here, deciding to shoot straight down, showing the studio floor and matching seamless background paper as a part of the portrait.

the same light that your subject will be in. This type of meter yields extremely consistent results, because it measures the light falling on the subject rather than the light reflected from the subject. This means it is less likely to be influenced by highly reflective or light-absorbing surfaces.

Incident Flashmeters. A handheld incident flashmeter is essential for working indoors and out, but particularly when mixing flash and daylight. It is also useful for determining lighting ratios. Flashmeters are invaluable when using multiple strobes and when trying to determine the overall evenness of lighting in a large-size room. Flashmeters are also ambient incident-light meters; they measure the light falling on them and not light reflected from a source or object as the in-camera meter does.

LIGHTS AND LIGHT MODIFIERS
Continuous Light *vs.* Strobe. There are many choices when it comes to lighting equipment, and the subject of light sources can be a topic of endless debate. The three basic types of lighting equipment, however, are portable flash, continuous-light units, and studio strobes.

In professional portraiture, portable flash units are usually appropriate only as a source of fill light. On-camera flash should especially be avoided, as the light produced is too harsh and flat to create roundness or contouring on the subject's face. Additionally, these units have no modeling lights to show you the lighting effect, making predictable results difficult, if not impossible. Using continuous light sources or studio strobe with built-in modeling lights, on the other hand, allows you to see the ef-

This is rather dark even for a well-suntanned or dark-skinned individual. Therefore, if you are using the in-camera meter, be sure to meter from an 18-percent gray card held in front of the subject, using a card that is large enough to fill most of the frame. If using a handheld reflected-light meter, do the same thing.

Incident-Light Meters. Another type of meter that is ideal for portraiture is the handheld incident-light meter. This does not measure the reflectance of the subject, but rather measures the amount of light falling on the scene. Simply stand where you want your subject to be, point the hemisphere dome of the meter directly at the camera lens, and take a reading. Be sure that the meter is held in exactly

fect of the lighting while you are shooting. With either of these systems, there is also much more light available for focusing than when using portable flash.

When it comes down to a decision between continuous light sources and studio strobes, the choice is yours. You can achieve excellent results with either type of lighting.

Continuous light sources do have one major advantage over instantaneous ones: you can see exactly the lighting you will get, since the light source is both the modeling light and the actual shooting light. Achieving the correct color balance is a simple matter of changing the white balance to the proper color temperature setting or, for more precise results, creating a custom white-balance setting. All continuous lights are not hot. A new breed of short fluorescent tube lights in fixture banks has become very popular for both location and studio. These fluorescent tubes can be mixed with tungsten globes to alter the color quality of the light.

With studio strobe lighting there is little or no heat from the lights, which can be a major factor in subject comfort when several units are used. With strobe lighting, the modeling light (a continuous light source) is only a guide to the lighting and it is not the actual light source that exposes the image. In most cases, however, the modeling light is very accurate.

Light Modifiers. Umbrellas and softboxes are by far the most popular light modifiers for portraiture, used to soften the light and create a more flattering look. Lights with these modifiers may be used over the camera for a fashion-type effect, or to either side for a more traditional portrait lighting. While these light sources are very soft, it is still usually necessary to fill in the shadow side of faces to prevent the shadow areas from going "dead."

Umbrellas. You can use umbrella lighting with either flash or continuous light sources. If using tungsten or quartz lighting with umbrellas, be very careful not to get the light in too close to the material, as it may catch fire.

Photographic umbrellas normally have either a white or silver lining. A silver-lined umbrella produces a more specular, direct light than does a matte white umbrella. When using lights of equal intensity, a silver-lined umbrella can be used as a main light because of its increased intensity and directness. It will also produce wonderful specular highlights in the overall highlight areas of the face. A matte-white umbrella can then be used as a fill or

secondary light. (Some umbrellas, called "zebras," have a lining of alternating white and silver for an effect that is soft like a white-lined umbrella, but still offers a bit of the sparkle of a silver-lined model.)

You can also experiment with the placement of the light within the umbrella to obtain different degrees of softness. Most photographers prefer to place the light far enough up the shaft of the umbrella that the full beam of light is within the curve of the umbrella's surface. The light is aimed at the center of the umbrella for the most even lighting. This is called "focusing" the umbrella and results in the most efficient use of the light.

Some photographers use the umbrella in the reverse position, turning the light and umbrella around so that the light shines through the umbrella and onto the subject (rather than being reflected out of the umbrella onto the subject). This gives a more directional light than when the light is turned away from the subject and aimed into the umbrella. Of course, with a silver-lined umbrella, you can't shine the light through it, because the silvered material is almost fully opaque.

Softboxes. Softboxes are black fabric boxes with a layer of white diffusion material on the front. Some softboxes are double-diffused, with a second scrim used over the lighting surface. When using a softbox, the light unit is placed inside the box and its output is directed through the diffusion material on the front of the box. Because the light unit is placed within the modifier, most softboxes can be used only with strobes (which, as noted above, produce much less heat than continuous sources). Some softbox units accept multiple strobe heads for additional lighting power and intensity.

LIGHTING THE BACKGROUND

Because umbrellas and softboxes produce a broad beam of light, the light scatters, often eliminating the need for a background light. But this is also subject to how far the background is from the light source and the tone of the background. The farther it is from the light, the darker it will record.

2. GOOD DIGITAL WORKING TECHNIQUES

EXPOSURE

Working with digital files is very much different than working with film. For one thing, the exposure latitude, particularly toward overexposure, is almost non-existent. The up side of this seeming flaw in the process is that greater care taken in creating a proper exposure only makes you a better photographer. But for those used to ±2 stops of exposure latitude with color-negative films, this is a different ball game altogether.

Proper exposure is essential in that it determines the dynamic range of tones, the overall quality of the image, and is one of the key factors determining the quality of the final output from your digital file. Underexposed digital files tend to have an excessive amount of noise and overexposed files lack detail and tone in the highlights.

Greater care taken in creating a proper exposure only makes you a better photographer.

According to Claude Jodoin, a portrait photographer and digital expert, "Your days of overexposing are over! Kiss them goodbye. You must either be right on with your exposures or, if you make an error, let it be only slightly underexposed, which is survivable. Otherwise you will be giving refunds to your clients. Overexposure of any kind is death with digital." Strong words to be sure, but with digital capture you must guarantee that the dynamic range of the processed image fits that of the materials you will use to exhibit the image (*i.e.,* the printing paper and ink or photographic paper).

DETERMINING YOUR CAMERA'S E.I.

Not all-digital cameras are created equal. Just as in all things man-made, there are manufacturing and production tolerances that make complex electronic devices dissimilar. It is important to know whether your camera's metering system, on which you will rely heavily, is faster or slower than its rated film speed index.

Here's an adaptation of a simple test that technical wiz Don Emmerich came up with using an 18-percent gray card. To begin, fill the frame with the gray card and meter the scene with the in-camera meter. Expose exactly as the meter indicates and view the histogram. If the exposure is correct, there will be a single spike dead center in the histogram and you will know that the camera is giving you a true, rated film speed. If the spike is to the right or left of center, adjust the camera's film speed by $\frac{1}{3}$ or $\frac{1}{2}$ of a stop and try again. If, for example, your initial test was made with an ISO of 400 and the spike on the histogram is slightly to the left of center, it means the exposure is slightly underexposed, so adjust the film speed setting to E.I. 320 or E.I. 250 and make another frame and review that histogram.

If the spike is to the right of center, the frame is overexposed and you will have to reduce exposure by setting the ISO to $\frac{1}{3}$ or $\frac{1}{2}$ stop higher (*i.e.,* E.I. 500 or E.I. 620). Once the spike is properly in the middle of the histogram, you have a perfect exposure for this particular lighting.

So how do you apply what you've learned? If you repeat this test at different film-speed indices and under different lighting conditions, you should come up with a reliable factor. Or you may find your meter is perfectly accurate. If, however, you find that the meter is consistently underexposing frames by $\frac{1}{3}$ stop, you can set the camera's

exposure compensation for +⅓ stop exposure compensation. If, on the other hand, the meter is consistently overexposing by ⅓ stop, you can dial in −⅓ stop of exposure compensation or adjust your ISO accordingly.

Perform this same series of tests with your handheld incident meter to make sure all the meters in your arsenal are precisely accurate.

METADATA

DSLRs give you the option of tagging your digital image files with data, which often includes date, time, caption, as well as camera settings. To find this information, open the image in Photoshop and go to File>File Info. Here, you will see a range of data, including caption and ID information. If you then go to EXIF data in the pull-down menu, you will see all of the data that the camera automatically tags with the file. This can be useful for either the client or lab.

To this data, you can also add your copyright notice—either from within Photoshop or from your camera's metadata setup files. Adobe Photoshop supports the information standard developed by the Newspaper Association of America (NAA) and the International Press Telecommunications Council (IPTC) to identify transmitted text and images. This standard includes entries for captions, keywords, categories, credits, and origins from Photoshop.

FILE FORMATS

JPEG. When you shoot JPEG, a built-in converter turns the captured data into a color image, then compresses it using JPEG compression. Some camera systems allow you to set parameters for this JPEG conversion—usually, a choice of the sRGB or Adobe RGB 1998 color space, a sharpness setting, and a curve or contrast setting.

JPEG files are smaller than RAW files, so you can save more images per card and they do not take as long to write to memory. Both factors allow you to work more quickly, which can be a significant advantage in some situations. If you shoot JPEGs, selecting the JPEG Fine or JPEG Highest Quality mode will provide the best possible files, while maintaining the convenience and speed of the format.

After the shoot, JPEGs offer fairly limited editing abilities. This is because the mode applies heavy compression to the color data. This process essentially throws away a large amount of the captured data. In the typical conversion process, JPEG mode will discard roughly a stop of usable dynamic range, and you have very little control over what information gets discarded. As a result, you need to get everything right in the camera, because there's very little you can do to change it later.

The other drawback to JPEG files is that they are compressed using a "lossy" format, meaning that the images

SHADOW/HIGHLIGHT IN PHOTOSHOP

Choose Image > Adjustments > Shadow/Highlight in any 8- or 16-bit RGB, LAB, or CMYK image. For an underexposed image where the highlights are okay, make a layer copy, and work on it. Go to Shadow/Highlight. The default setting is almost too much, so reduce the Shadows setting down to a realistic level. Make another copy of the corrected layer so you can go in and selectively adjust the shadow values. Create a layer mask on this layer and fill it with black (Edit > Fill > Black). With white as the foreground color and a brush opacity of about 25 percent, selectively paint over each of the faces to conceal the underlying data. This will help adjust the shadows to a more normal level.

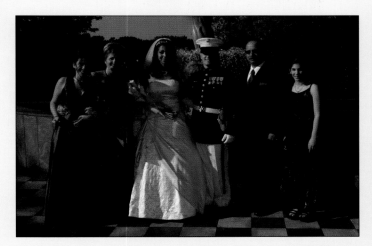

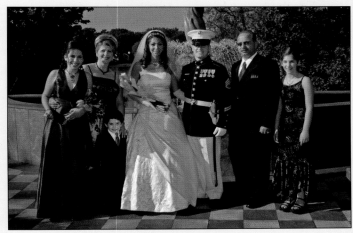

Claude Jodoin shows how effective Photoshop's Shadow/Highlight control can be useful in reviving an underexposed JPEG.

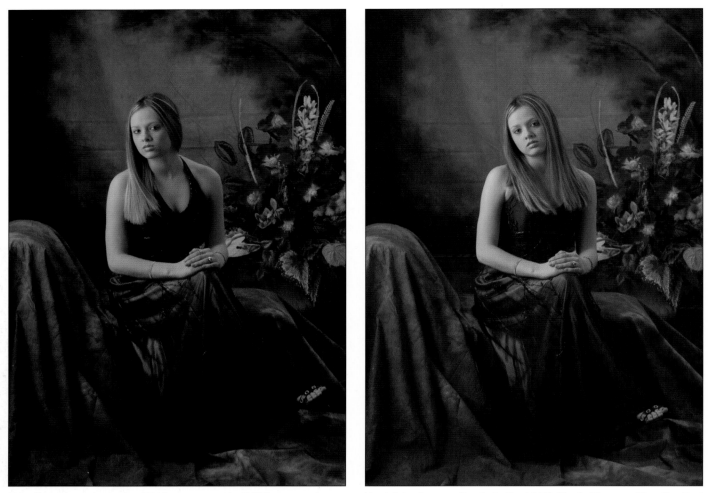

Here is a comparison of a JPEG capture and a RAW capture (processed in Adobe Camera Raw). In the JPEG file (left), you will notice that there is less detail in the shadows and that the hue of the dress is slightly altered. The color rendition in the RAW file version (right) is much closer to reality. Photographs by Claude Jodoin.

are subject to degradation by repeated saving and resaving of the same file. Most photographers who shoot in JPEG mode either save a new copy of the file each time they work on it, or save it to the TIFF format, which uses "lossless" compression so it can be saved again and again without degradation.

RAW. RAW is a general term for a variety of proprietary file formats, such as Nikon's .NEF, Canon's .CRW and .CR2, and Olympus' .ORF. While there are many different ways of encoding these files, in each case the file records the unprocessed image-sensor data. This includes two different types of information: the image pixels themselves, and the image metadata (a variety of information about how the image was recorded and how the RAW converter should process the capture into an RGB image).

When you shoot in RAW mode you get unparalleled control over the interpretation of the image. The only on-

camera settings that have an effect on the captured pixels are ISO setting, shutter speed, and aperture. Everything else is under your control when you convert the RAW file. This means that, after the shoot, you can reinterpret the white balance, the colorimetric rendering, the tonal response, and the detail rendition (sharpening and noise reduction) with complete flexibility. Within limits (which vary from one RAW converter to another), you can even reinterpret the exposure compensation.

While RAW files offer the benefit of retaining the highest amount of image data from the original capture, they take longer to write to the storage media and, because of their increased file size, drastically reduce the number of files you can capture on a single memory card. With the appearance of lower-priced storage media (at this writing, 1GB cards are retailing for around under $30 apiece; in the second edition of this book the same card was retail-

ing for $80), the cost of media is continually coming down. Likewise, buffer size and write speed on the latest DSLRs is increasing without much fanfare from the manufacturers. All of this is making RAW file capture more appealing—especially for the portrait photographer, where high burst rates are not necessarily a prerequisite.

Adobe DNG Format. To resolve the disparity between proprietary RAW file formats, Adobe Systems introduced an open RAW file format called the Digital Negative (DNG) format. Adobe is pushing digital camera manufacturers and imaging software developers to adopt the new DNG RAW format. Unlike the numerous proprietary RAW formats out there, the DNG format was designed with enough flexibility built in to incorporate all the image data and metadata that any digital camera might generate. Proprietary RAW file format images that are pulled into Photoshop CS2 can be saved to the new DNG file format with all the RAW file format characteristics being retained. DNG Save options include the ability to embed the original RAW file in the DNG file, to convert the image data to an interpolated format, and to vary the compression ratio of the accompanying JPEG preview image.

RAW Converters. All RAW image files must be processed by a RAW converter before they can be utilized. All RAW converters process white balance, colorimetric data (the assigning of red, green and blue to each pixel), Gamma correction, noise reduction, antialiasing (to avoid color artifacts), and sharpening. But they

may use very different algorithms, which is why the same image may look very different when processed through different RAW converters. Some converters will process the tones with less contrast in order to provide editing maneuverability, while others will increase the contrast of the file to achieve a more film-like rendition. It is up to the individual photographer to choose a processing engine that best suits their taste and workflow.

Although in-camera RAW file processing can optimize image data for sharpness, contrast, brightness and color balance, among other settings, the current thinking is to minimize these parameters in your in-camera RAW file set-

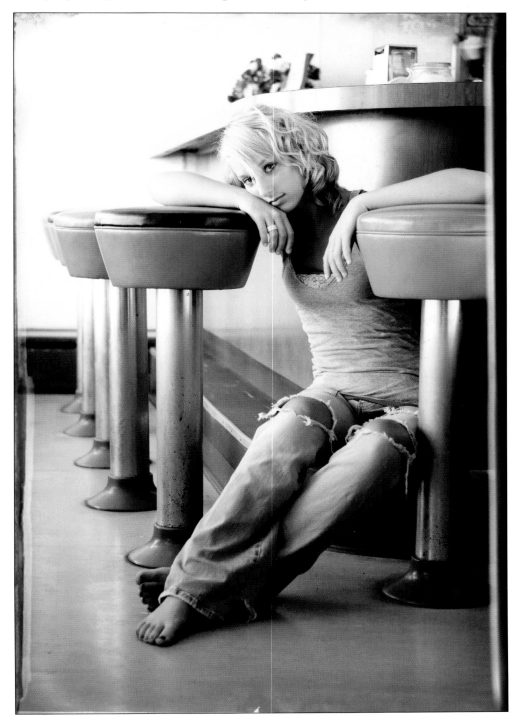

RAW file capture yields plenty of data that can be manipulated in the RAW file processing stage. In this case, Jeffrey Woods exposed the image to preserve good highlight detail. In Adobe Camera RAW, he then adjusted the tone curve, contrast, tint, color temperature, and white balance to create the exact image he envisioned when he found this relic diner.

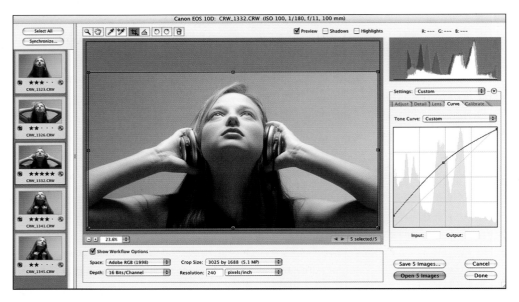

Processing images in Adobe Camera RAW allows great flexibility and speed, because you can process multiple images simultaneously. Just open as many RAW files as you choose, select the images you want to share settings, adjust the settings, and click save. That's it, you're done! While the RAW files are being processed, you can continue to work. Photoshop CS2 also includes the options for adjusting RAW-file settings before file conversion or pulling the RAW file into the main Photoshop editor, where it can be further optimized and then saved in a wide variety of different file formats.

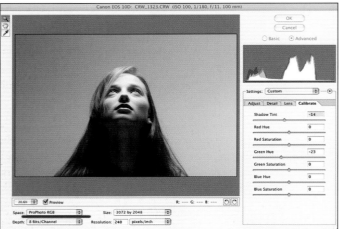

In the image shown here, the file was processed in Adobe Camera RAW. The color space was changed from Adobe RGB 1998 to ProPhoto RGB to increase the amount of color data to be processed.

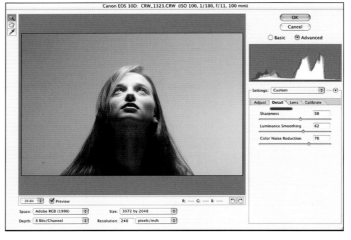

Sharpness, luminance smoothing, and color noise reduction were then adjusted.

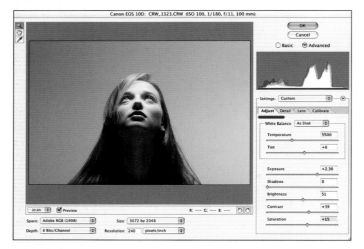

White balance, overall exposure, shadow exposure, brightness, contrast, and saturation were then adjusted.

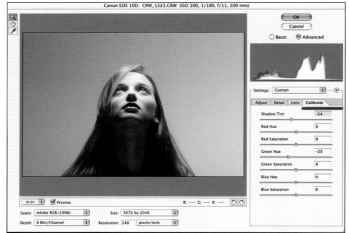

Shadow tint, hue and saturation were adjusted. Also vignetting was adjusted in the Lens menu (not shown).

tings. A better option is to process this data using a RAW converter and the power of a state-of-the-art computer, where subtle changes to the file can be easily applied.

Adobe Camera RAW. Adobe Camera RAW lets you far exceed the capabilities of what you can do to a JPEG file in the camera. For instance, in the example shown on the facing page and below, the native file size is roughly 2000x3000 pixels. By converting the file from Adobe

RGB 1998 to a wider-gamut color space (ProPhoto RGB), the file can be easily enlarged to 4000x6000 pixels with almost no loss in photographic quality.

Using the Advanced Settings in Adobe Camera RAW, you can adjust many of the image parameters with much more power and discrimination than in the camera. For instance, under the Detail menu, you can adjust image sharpness, luminance smoothing (reduces grayscale noise), and color noise reduction (reduces chroma noise). In the Adjust menu, you can control white balance, exposure, shadow density, brightness, contrast, and color saturation. The Lens menu lets you adjust lens parameters that affect digital cameras, such as chromatic aberration and vignetting. These controls exist to allow you to make up for certain optical deficiencies in lenses, but can also be used for creative effects, as well, especially the vignetting control, which either adds or subtracts feathered image den-

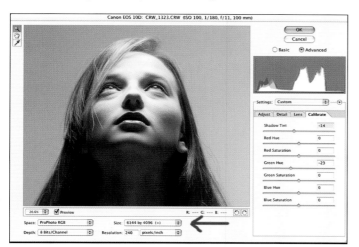

LEFT—The total number of pixels was quadrupled—from the chip's native resolution of 2000x3000 pixels (a total of six million pixels) up to 4000x6000 pixels (twenty-four million pixels). BELOW—The final, processed 72MB file. RAW file image courtesy of Adobe.

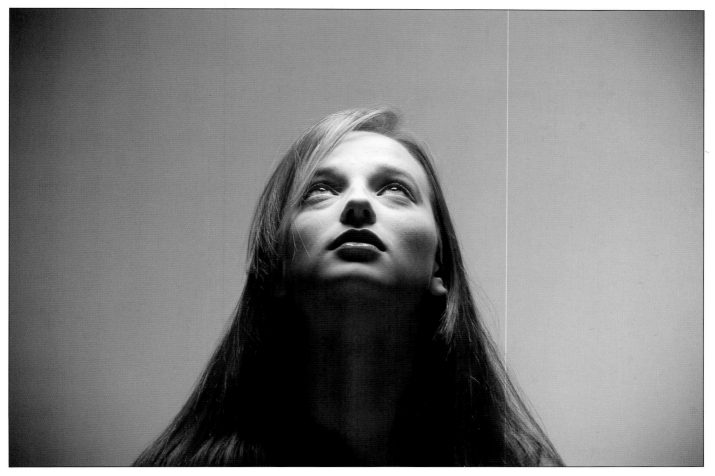

sity in the corners of the image. In the Calibrate menu, you can adjust the hue and saturation of each channel, as well as shadow tint. Shadow tint is particularly useful, as it provides the basis for color correction of images with people in them. In traditional color printing, color correction is done to neutralize the tint in the shadows of the face and body, so they are gray, or neutral. With shadow tint control, you isolate the shadows from the rest of the image so that you can neutralize the shadows, while leaving a warm tone, for example, in the facial highlights—an extremely useful tool.

In Photoshop CS2, Adobe Camera RAW combines with the modified file browser, called Bridge, to allow you to group a number of like files and correct them all the same way at the same time. This capability is a modified or selective batch processing that is much more useful than former means of batch processing. Plus you can continue working while the files process.

Adobe Lightroom. Adobe Lightroom is described as a next-generation photographer's software. Lightroom supports over a hundred cameras and incorporates RAW file conversion into a seamless workflow experience, providing new parameters for making adjustments and more freedom to address precise areas of the image. For example, the application offers split-toning controls, for richer, specialized black & white images. Lightroom is also designed for image processing, sorting, cataloging, presenting, and printing. This offers photographers the majority of the tools they'll need when working on their images—all under one roof.

COLOR SPACE

Many DSLRs allow you to shoot in Adobe RGB 1998 or sRGB color space. There is considerable confusion over which is the "right" choice, as Adobe RGB 1998 is a wider gamut color space than sRGB. Photographers reason, "Why shouldn't I include the maximum range of color in the image at capture?"

Professional digital imaging labs use the standardized sRGB color space for their digital printers. Therefore, photographers who work in Adobe 1998 RGB will be somewhat disheartened when their files are reconfigured and output in the narrower color sRGB space. Still, many photographers who work in JPEG format use the Adobe

Adobe Lightroom supports over a hundred cameras and incorporates RAW file conversion into a seamless workflow experience, providing new parameters for making adjustments and more freedom to address precise areas of the image. Images by Parker Pfister.

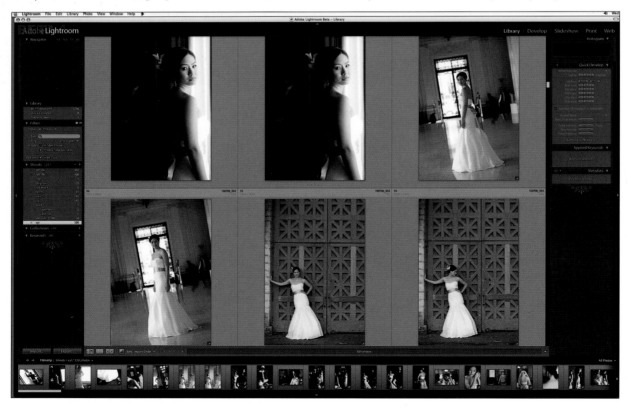

TIM SCHOOLER: FAMOUS FOR FACES

Tim Schooler is an award-winning photographer specializing in high-school senior photography with a cutting edge. His work is noted for the "pop" in the eyes and for the generally incredible way that he treats the faces he works with. He says, "I am not a fan of over-softening skin, I think it is done too much these days. But with digital, and the high-resolution sensors we're using now, you have to do a subtle amount of diffusion to take the edge off. But I still want to see detail in the skin, so I'll apply a slight level of diffusion on a layer, then back if off until I can see skin pores."

Schooler always shoots in RAW mode, then converts the files in Phase One's Capture One. Capture One has four options to emulate the look of film. According to Tim, "I use a custom profile from Magne Nielsen for skin tones. In Capture One, you can set the default film type to Linear response, Film Standard, Film Extra shadows, or Film High Contrast. I used to use Film Standard but found I was tweaking the curves a little for a bit more punch in Photoshop. Now I use Film High Contrast and I find it's a lot closer to Portra VC, which was my preferred film before we went digital." The net result is a little higher contrast and about a 7-percent increase in color saturation that gives Tim's finished work the look his seniors are after.

Another interesting aspect of Tim's work is that he shoots everything as a finished image. He says, "In fact, that's how I proof. Nothing is edited or retouched before the client sees it. Then we retouch only what they ask for. I have always felt that Photoshop should be icing, just a finishing touch after first baking a good cake. It's a corny analogy, but I really think it fits. More and more photographers seem to just shoot and fix it later in Photoshop. With

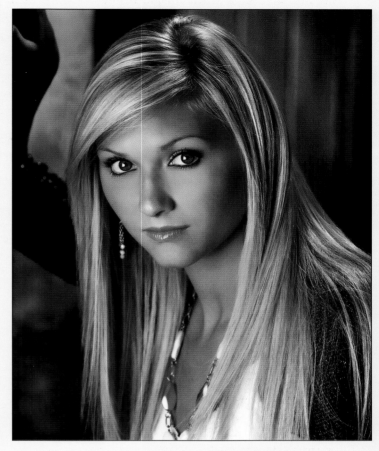

Tim Schooler's senior portraits have marginally higher contrast and about a 7-percent increase in color saturation due to custom settings he applies in his RAW file processing with Phase One Capture One.

the volume we had this year, there is no way I could spend that much time in Photoshop on every image—even if I wanted to."

1998 RGB color space right up to the point that files are sent to a printer or out to the lab for printing. Photographer Claude Jodoin, for example, works in Adobe 1998 RGB because he prefers to get the maximum amount of color information in the original capture and edit the file using the same color space for maximum control of the image subtleties.

Is there ever a need for other color spaces? Yes. For example, all the images you see in this book have been converted from their native sRGB or Adobe 1998 RGB color space to the CMYK color space for photomechanical printing. As a general preference, I prefer images from photographers be in the Adobe 1998 RGB color space as they seem to convert more naturally to CMYK.

BACK UP YOUR FILES

Some photographers shoot an entire job on a series of cards and take them back to the studio prior to performing any backup. Others refuse to fill an entire card at any time. Instead, they opt to download, back up, and reformat cards directly during a shoot. This is a question of preference and security. Many wedding photographers who shoot with a team of shooters train their assistants to perform these operations to guarantee the images are safe and in hand before anyone leaves the event.

After verifying that all of your image files exist on the memory card, save all of your original source files prior to making any modifications or adjustments to them. Most people use CD-ROMs or DVD-ROMs for this purpose,

because they are inexpensive and write quickly from most computers.

You can also save your source files to an auxiliary hard drive. This is a common practice among wedding photographers, many of whom download their images to a laptop in the field. Southern Californian wedding photographer Becker, for example, uses a G4 Powerbook and a Lexar FireWire card reader. Once the cards are downloaded, he transfers the downloads folder to an iPod (or any other portable external hard drive) for safekeeping.

You should also get into the habit of creating multiple versions of your work in case you ever need to work back through your workflow process to retrieve an earlier version of a file.

REFORMAT YOUR CARDS

It's a good practice not to format a memory card prior to backing up your files to at least two sources. After you back up these files, you can then erase all of the images and reformat the card. It isn't enough to simply delete the images, because extraneous data may remain on the card and cause data interference. After reformatting, you're ready to use the memory card again.

PRINTING OPTIONS

Many photographers have the equipment and staff to print their own images in house. It gives them a level of control that even the best lab cannot provide.

Other photographers have devised interesting ways to save money by employing the lab's wide-format digital printers. David Williams, for example, uses a lab called The Edge (Melbourne, Australia). The Edge uses a Durst Lamda Digital Laser Imager, which produces full continuous-tone images straight from Macintosh or PC files on photographic media. Williams prepares Photoshop files of finished album pages, panoramas, small prints and proofs on a 32-inch wide file (the width of the lab's Lamda), utilizing every square inch of space. The 32x32-, 32x50-, or 32x70-inch files are all output at one time—and very inexpensively. The lab even trims all of the images for Williams, thus increasing his productivity and lowering his costs.

David follows the guidelines of the lab and works in Adobe RGB (1998) at the gamma recommended for either PCs or Macs. The files may be TIFFS or JPEGs at

200 or 400dpi. The Edge will even provide a calibration kit to better coordinate your color space to that of the lab's.

David Williams assembles his images in single files to take advantage of the Durst Lamda's 32-inch wide printing capacity. This file is 32x50 inches. The lab even trims all his images.

3. POSING

The guidelines for subject posing are formalized and steeped in tradition. These rules have been refined over the centuries and have come to be accepted as standard means to render the three-dimensional human form in a two-dimensional medium. These rules need not be followed to the letter, but should be understood because they offer ways to show subjects at their best. Like all rules—especially artistic rules—they are made to be broken; after all, without innovation, portraiture would be a static, scientific discipline, devoid of emotion and beauty.

Even when photographing uncooperative subjects like kids, good head-and-shoulder positioning is important. Here, the photographer posed the boy with the shoulders at an angle to the camera and the boy's head at a slightly different angle and tipped toward the far shoulder in a typical masculine pose. Photograph by David Bentley.

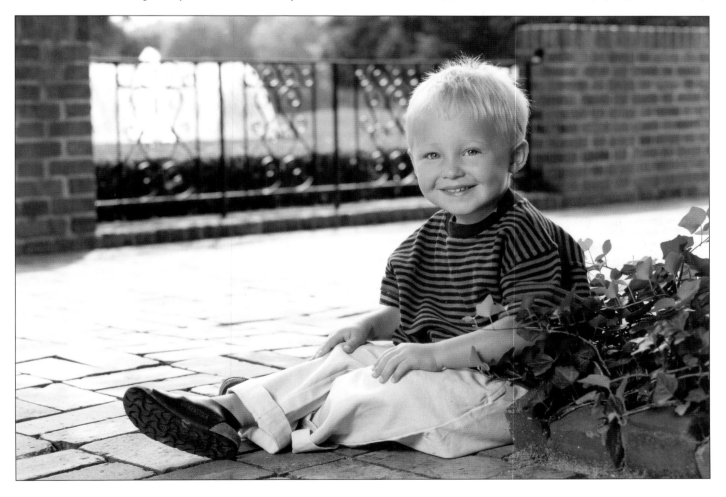

SUBJECT COMFORT

The first thing the photographer must do for a subject is to make the person comfortable. Posing stools and benches are commercially available that make the subject feel comfortable while also ensuring a good, upright posture. These are fine for studio work, but what about outdoors where no such tools exist? You must find a spot—a patch of grass under a tree or a fence, for example—that will be comfortable for the duration of the shooting session. Position your subject naturally, using a pose that feels good to the subject. If your subjects are to appear natural and relaxed, then the poses they strike must feel natural to them.

THE SHOULDERS

One of the fundamentals of portraiture is that the subject's shoulders should be turned at an angle to the camera. To have the shoulders facing the camera straight on makes the person look wider than he or she really is and can yield a static composition. The only exception is when you want to emphasize the mass of the subject, such as an athlete, or when the person is very thin or small. This is why one of the basic requirements of a good working model is that she be thin; if need be, she can be photographed head-on without looking heavy.

HEAD POSITIONS

There are three basic head positions in portraiture: the seven-eighths, three-quarters, and profile views. With all three of these head poses, the shoulders should be at an angle to the camera.

The Seven-Eighths View. The seven-eighths view occurs when the subject is looking just slightly away from the camera. In other words, you will see just a little more of one side of the face than the other when looking through the camera. You will still see both of the subject's ears in a seven-eighths view.

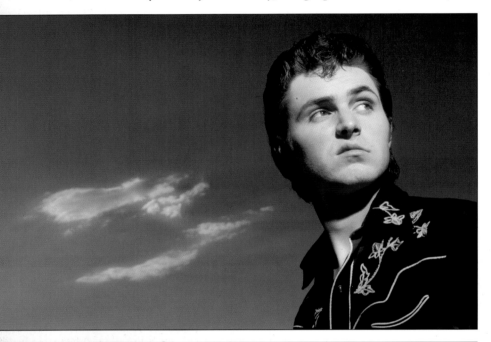

TOP—In this seven-eighths view, you can see both of the subject's ears. The photographer has lit only the "mask" of the subject's face (cheekbone to cheekbone) with an undiffused flash matched to the daylight exposure. The effect is a revealing look at this young man. Most of the time, one wouldn't want to photograph a subject from so low a vantage point, but in this case the photographer has opted for a more cinematic point of view and has hidden the area under his chin in shadow for a dramatic effect. Photograph by Bruce Dorn. BOTTOM—The basic head positions are the seven-eighths view, the three-quarters view (shown here), and the profile. The three-quarters view is a dynamic pose because it creates strong lines within the composition. Notice the attractive line of her eyes and the way the photographer had her make contact with the lens for an intimate portrait. Photograph by Fuzzy Duenkel.

This pose combines a three-quarters facial view and a profile. Notice how in the profile pose, the boy's face is turned just far enough away from the camera so the eyebrows and eyelashes on the right side of his face disappear. Notice, too, how the photographer lit only the frontal planes of both faces, creating a dramatic lighting ratio in keeping with the nature of the portrait. Photograph by David Bentley.

The Three-Quarters View. With a three-quarters view, the far ear is hidden from the camera and more of one side of the face is visible. With this type of pose, the far eye will appear smaller because it is naturally farther away from the camera than the near eye. People usually have one eye that is, physically, slightly smaller than the other. Therefore, it is important when posing the sitter in a three-quarters view to position him or her so that the smaller eye is closest to the camera. This way, the perspective is used to make both eyes appear to be the same size in the photograph.

The Profile View. In the profile, the head is turned almost 90 degrees to the camera. Only one eye is visible. In posing your subject in a profile position, have him or her turn their head gradually away from the camera position just until the far eye and eyelashes disappear from view. If you cannot see the eyelashes of the far eye, then you have a good profile pose.

TILTING THE HEAD

Your subject's head should be tilted at a slight angle in every portrait. By doing this, you slant the natural line of the person's eyes. When the face is not tilted, the implied line of the eyes is straight and parallel to the bottom edge of the photograph, leading to a static composition. By tilting the face right or left, the line becomes diagonal, making the pose dynamic. For a natural look, the tilt of the person's head should be slight and not overly exaggerated.

Whether to tilt the subject's head toward the near shoulder or the far shoulder is a sometimes-controversial issue among portrait photographers. In men's portraits, the traditional rule is to tilt the head toward the far shoulder (the one farthest from the camera). In women's portraits, the head is traditionally tilted toward the near shoulder for a supposedly feminine look.

These rules are frequently broken, because individuals and lighting usually determine the most flattering direction for the head to be tilted. The rule is simply mentioned here so that you can decide for yourself.

THE EYES

The area of primary visual interest in the human face is the eyes. The portrait photographer must live by the notion that the eyes are the most expressive part of the face. If the subject is bored or uncomfortable, you will see it in his or her eyes.

The best way to keep the subject's eyes active and alive is to engage them in conversation.

The best way to keep the subject's eyes active and alive is to engage them in conversation. Look at the person while you are setting up and try to find a common frame of interest. People almost always enjoy the opportunity to talk about themselves! If the person does not look at you when you are talking, they are either uncomfortable or shy. In either case, you have to work to relax them and encourage them to trust you. Try a variety of conversational topics until you find one that clicks and then pursue it. As you gain their interest, you will take their mind off the portrait session. Another great way to enliven the subject's eyes is to tell an amusing story. If they enjoy it, their eyes will smile. This is one of the most endearing expressions a human being can make.

The direction of the person's gaze is critical. Start the portrait session by having the person look at you. Using a cable release with a tripod-mounted camera forces you to become a host and allows you to physically hold the subject's attention. It is a good idea to shoot a few shots of the person looking directly into the camera, but most people will appreciate some variety. Looking into the lens for too long a time will bore your subject, as there is no personal contact when looking into a machine.

The colored part of the eye, the iris, should border the eyelids. In other words, there should not be a white space between the top or bottom of the iris and the eyelid. If there is a space, have the subject lower his or her gaze.

Pupil size is also important. If working under intense lights, the pupil will be very small and the subject will look beady-eyed. A way to correct this is to have them shut their eyes for a moment prior to exposure. This allows the pupil to return to a normal size for the exposure. Just the opposite can happen if you are working in subdued light. The pupil will appear too large, giving the subject a vacant look. In that case, have the subject stare momentarily at the brightest nearby light source to close the pupil.

THE MOUTH

Generally, it is a good idea to shoot a variety of portraits, some smiling and some serious (or at least not smiling). People are often self-conscious about their teeth and mouths, but if you see that the subject has an attractive smile, get plenty of shots of it.

Natural Smiles. One of the best ways to produce a natural smile is to praise your subject. Tell him or her how good they look and how much you like a certain feature of theirs. Simply saying "Smile!" will only produce that lifeless, "say cheese" type of portrait. By sincere confidence-building and flattery, on the other hand, you will get the person to smile naturally and sincerely.

Moistening the Lips. It will be necessary to remind the subject to moisten his or her lips periodically. This makes the lips sparkle in the finished portrait, as the moisture produces tiny specular (pure white) highlights.

Avoiding Tension. People's mouths are nearly as expressive as their eyes. Pay close attention to your subject's mouth to be sure there is no tension in the muscles around it, since this will give the portrait an unnatural, posed look. Again, an air of relaxation best relieves tension, so talk to the person to take his or her mind off the session.

Gap Between the Lips. Some people have a slight gap between their lips when they are relaxed. Their mouth is neither open nor closed but somewhere in between. If you observe this, let them know about it in a friendly way. When observing the person in repose, this trait is not dis-

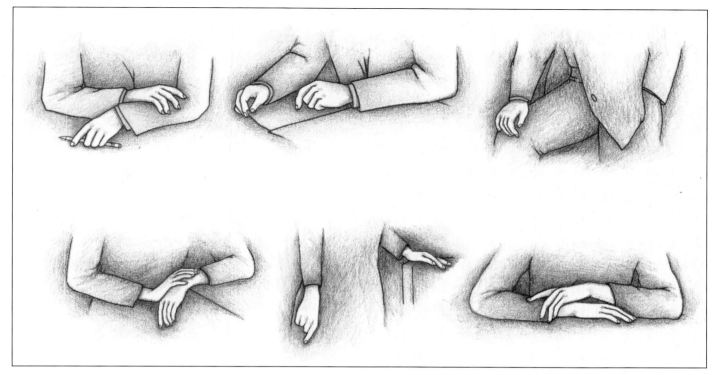

Here are six examples of good hand posing. In each case, the hand is at an angle to the lens. A woman's hands should look graceful and elegant. A man's hands should appear strong and dignified. The pose should always appear natural and never contrived. While these are only examples of formal hand posing, and need not always be followed, they offer good illustrations of how the hands can be used to enhance a portrait. They are also a means to photograph hands without distortion.

concerting, but when it is frozen in a portrait this gap between the lips will look unnatural, because the teeth show through it.

Laugh Lines. An area of the face where problems occasionally arise is the front-most part of the cheek—the areas on either side of the mouth that wrinkle when a person smiles. These are called furrows or laugh lines. Some people have furrows that look unnaturally deep when they are photographed smiling. Take note of this area of the face; if necessary, you may have to increase the fill-light intensity to illuminate these deep shadows or adjust your main light to be more frontal in nature. If the lines are severe, avoid a "big smile" type of pose altogether.

CHIN HEIGHT
Be aware of the psychological value put on even subtle facial positions, such as the height of the subject's chin. If the person's chin is too high, he may look haughty—like he has his nose up in the air. If the person's chin is too low, he may look afraid or lacking in confidence.

Beyond the psychological implications, a person's neck will look stretched and elongated if the chin is too high.

The opposite is true if the chin is held too low; the person may appear to have a double chin or no neck at all.

The solution is, as you might expect, a medium chin height. Be aware of the effects of too high or too low a chin height and you will have achieved a good middle ground. When in doubt, ask if the pose *feels* natural. This is usually a good indicator of what will *look* natural.

ARMS
The subject's arms should not be allowed to fall to the their sides. Instead, they should project outward slightly to provide gently sloping lines and a "base" to the composition. This is often achieved by asking the subject to put their hands together and position them close to waist height. In the case of a standing man, for instance, you can have him put his hands in his pockets to separate his arms from his torso. This will create a slight space between his upper arms and torso, slimming the appearance of the torso and avoiding a flattening effect on the outer surface of the arm. In a head-and-shoulders portrait, this also creates a triangular base for the composition, attracting the viewer's eyes up to the subject's face.

HANDS

Posing the hands properly can be very difficult, because, in most portraits, they are closer to the camera than the subject's head. Thus, they appear larger.

One thing that will give hands a more natural perspective is to use a longer lens than normal. Although holding the focus on both the hands and the face is more difficult with a longer lens, the size relationship between them will appear more natural. Additionally, if the hands are slightly out of focus, it is not as crucial as when the eyes or face are soft.

Throughout this book you'll see great examples of hand posing, pleasing images that render the hands with good dimension and form, but also in a way that seems to reveal the personality of the subject. It is impossible here to cover every possible hand pose, so it is necessary to make a few generalizations (and keep in mind that these are just that: generalizations, not hard and fast rules).

Jennifer George's *Embrace* is a masterpiece, and within the portrait is a wonderful treatment of the woman's right hand; it is integral to the embrace, yet there is no clutching or desperation. Instead, the hand conveys a sense of unity, safety, and satisfaction. The delicate lighting on the separated fingers makes the hand a beautiful and fundamental part of the portrait.

- Avoid photographing a subject's hands pointing straight into the camera lens. This distorts the size and shape of the hands. Instead, keep the hands at an angle to the lens.
- Photograph the outer edge of the hand whenever possible. This gives a natural, flowing line to the hands and eliminates the distortion that occurs when hands are photographed from the top or head-on.
- Try to "break" the wrist, meaning that you should bend the wrist slightly so there is a gently curving line where the wrist and hand join.
- Try to photograph the fingers with a slight separation in between. This gives the fingers form and definition. When the fingers are closed together, they can appear as a two-dimensional blob.
- When posing women's hands, you should generally strive to create a sense of grace. When photographing men, you will normally look to create an appearance of strength. (Obviously, the type of portrait and the subject must also be considered. For example, the hands of a female soldier in uniform would more logically be posed to convey strength than delicate grace.)

ABOVE, LEFT—Terry Deglau is a posing master. Notice how the right hand is elevated upward, the fingers separated and graceful. The eye is drawn upward toward the model's face, the primary center of interest. The line of the wrist and hand produces a gentle break, and while the hand does not dominate the portrait, it is as character-defining as any other part of the pose. ABOVE, RIGHT—In this senior portrait the photographer posed the hands expertly. The left hand is out of view of the camera, but helps build the composition. The right hand is curved gently, fingers separated, a slight break at the wrist—a very elegant pose for a young lady. Photograph by Fuzzy Duenkel. RIGHT—The late Don Blair created this lovely image of award-winning Canadian photographers Joseph and Louise Simone. Notice the hand of the artist as it is gracefully poised over the canvas. In the same portrait, notice the rugged pose of Joseph's right hand. It is strong and yet comfortably posed.

THREE-QUARTER- AND FULL-LENGTH POSES

As you probably understand by now, the more of the human anatomy you include in a portrait, the more problems you encounter. When you photograph a person in a three-quarter- or full-length pose, you have arms, legs, feet, and the total image of the body to deal with.

Three-Quarter-Length Portraits. A three-quarter-length portrait is one that shows the subject from the head down to a region below the waist. Usually, this type of portrait is best composed by having the bottom of the picture be mid-thigh or below the knee and above the ankles. Never break the portrait at a joint (an elbow, wrist, knee or ankle) as this has a negative psychological impact.

Full-Length Portraits. A full-length portrait shows the subject from head to toe. Whether the person is standing or sitting, it is important to remember to slant their shoulders and hips to the lens, usually at a 30- to 45-degree angle. Never photograph the person head-on; this adds mass to the body. The old adage about the camera adding ten pounds is true—and if certain posing guidelines are not followed, you will add a lot more than ten pounds.

Feet and Legs. Just as it is undesirable to have the hands facing the lens head-on, so it is with the feet, but even more so. Feet look stumpy when they are photographed head-on.

For standing poses, have the subject put his or her weight on the back foot rather than distributing it evenly on both feet (or, worse yet, on the front foot). There should be a slight bend

TOP—This is a decidedly masculine pose, done by photographer Tim Schooler. The shoulders are turned at an angle, the head is tilted back toward the far shoulder, and the thumbs are hitched over the pockets of his jeans. Tim used a harsh late afternoon sunlight to light the mask of his face. It's a dramatic, edgy portrait. BOTTOM—With a pregnant mother to be, one must be even more cognizant of all the body parts shown in the image. Photographer Jennifer George is a whiz at this. Even though she may have cropped the ankles and feet, you don't know it because she chose to vignette the area. Jennifer mated the perfect lighting and posing to the subject matter for this sensitive portrait, entitled *Anticipating*.

in the front knee if the person is standing. This helps break up the static line of a straight front leg. The back leg can remain straightened; since it is less noticeable than the front leg, it does not produce a negative visual effect.

When the subject is sitting, a cross-legged pose is often desirable. Have the top leg angled and not facing into the lens. With a seated woman, it is a good idea to have her tuck the calf of her front leg in behind her back leg. This reduces the size of the calves, since the back leg, which is farther from the camera, becomes the most important visually. Where possible, have a slight space between the leg and the chair. This will slim the thighs and calves.

Hands. When the subject is standing, the hands become a real problem. If you are photographing a man, folding his arms across his chest produces a strong pose. Remember to have the man turn his hands slightly so the edge of the hand is more prominent than the top of the hand. In such a pose, have him lightly grasp his biceps— but not too hard or it will look like he is cold and trying to keep warm. Also, remember to instruct the man to bring his folded arms out from his body a little bit. This slims the arms, which would otherwise be flattened against his body and appear larger. Separate the fingers slightly.

With a standing woman, one hand on a hip and the other at her side is a good standard pose. Don't let the free hand dangle, but rather have her turn the hand so that the edge shows to the camera. Always create a bend in the wrist for a more dynamic line.

This is a decidedly feminine portrait by Tim Schooler. Note the pronounced turn of the shoulders to a 45-degree angle, the tip of the head toward the near shoulder, and the delicate position of the hands.

4. COMPOSITION

Composition in portraiture is no more than proper subject placement within the frame. There are several schools of thought on proper subject placement, and no one school is the only answer. Several formulas are given here to help you best determine where to place the subject in the picture area.

THE RULE OF THIRDS

Many photographers don't know where to place the subject within the frame. As a result, they usually opt for putting the person in the center of the picture. Unfortunately, this is actually the most static type of portrait composition you can produce.

The rule of thirds (left) and the golden mean (right) are two ways of achieving dynamic compositions in portrait photography. In each case, the center of interest, the face or eyes, should be placed on or near an intersection of two lines within the picture rectangle.

ABOVE—In this portrait by Vicki Taufer, you can see the use of the rule of thirds by noting the placement of the subject's head and eyes. Note also the use of a strong diagonal (the tilt of the head to produce a strong diagonal line in the composition) and the sense of direction (the head is decidedly off to one side of center, creating more space in front of the image than behind it). RIGHT—You can see the grid of thirds overlaid over the Vicki Taufer portrait to see how effectively the concept is made to work.

The easiest way to improve your compositions is to use the rule of thirds. Examine the diagram shown below (left). The rectangular viewing area is cut into nine separate squares by four lines. Where any two lines intersect is an area of dynamic visual interest. The intersecting points are ideal spots to position your main point of interest. The main point of interest in your portrait can also be effectively placed anywhere along one of the dividing lines.

In head-and-shoulders portraits, the eyes are the center of interest. Therefore, it is a good idea if they rest on a dividing line or at an intersection of two lines. In a three-quarter- or full-length portrait, the face is the center of interest. Thus, the face should be positioned to fall on an intersection or on a dividing line.

In most vertical portraits, the head or eyes are two-thirds from the bottom of the print. This is also true in most horizontal compositions, unless the subject is seated or reclining. In that case, they may be at the bottom one-third line.

THE GOLDEN MEAN

A compositional principle similar to the rule of thirds is the golden mean, a concept first expressed by the ancient Greeks. Simply, the golden mean represents the point

where the main center of interest should lie and it is an ideal compositional type for portraits. The golden mean is found by drawing a diagonal from one corner of the frame to the other. Then, draw a line from one or both of the remaining corners so that it intersects the first line perpendicularly (see the drawing on page 42). By doing this you can determine the proportions of the golden mean for both horizontal and vertical photographs.

DIRECTION

Sometimes you will find that if you place the main point of interest on a dividing line or at an intersecting point,

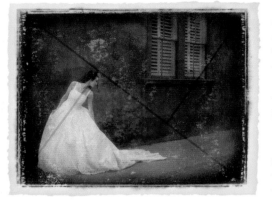

BELOW—This is a collaborative effort between master photographer Ken Sklute and master printer Jonathan Penney. The overall look, suggested by Jonathan, was to replicate a Polaroid-transfer print. The original film image was made using a Canon A1 with a 35–105mm lens at $^1/_{60}$ second and f/16 with yellow filter. Jonathan scanned the negative in grayscale on an Imacon Photo Flex-Tite scanner, brought it into Adobe Photoshop, adjusted for contrast and density using Levels, then converted to RGB. He then adjusted the red and blue channels in Curves to produce the split-tone effect. The border effect is from the Auto F/X Photographic Edges collection, a Photoshop plug-in. What is fascinating about this image, apart from its technology, is the pure simplicity of its design. The placement of the bride in the frame, her direction, and the C shape her body creates combine to create a pleasing dynamic composition. LEFT—With the overlay, you can see how effectively the golden mean is incorporated into this portrait by Ken Skute.

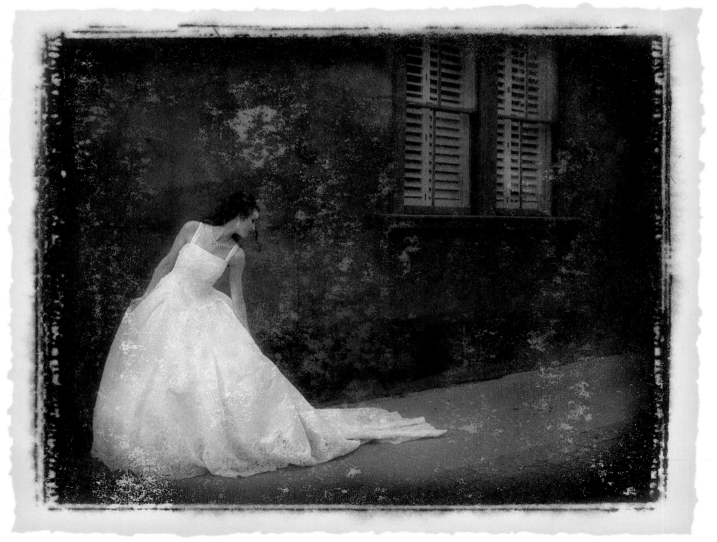

there is too much space on one side of the subject and not enough on the other. Obviously, you would then frame the subject so that he or she is closer to the center of the frame. It is important, however, that the person not be placed dead center, but to one side of the center line.

Whatever direction the subject is facing in the photograph, there should be slightly more room in front of the person (on the side of the frame toward which he is facing). For instance, if the person is looking to the right as you look at the scene through the viewfinder, then there should be more space to the right side of the subject than to the left of the subject in the frame. This gives the image a sense of visual direction.

Even if the composition is such that you want to position the person close to the center of the frame, there should still be slightly more space on the side toward which the subject is turned. This also applies when the subject is looking directly at the camera. He should not be centered in the frame; there should be slightly more room on one side to enhance the composition.

COMPOSITIONAL FORMS

The S-shaped composition is perhaps the most pleasing of all compositions. The gently sloping S shape is used to lead the viewer's eye to the point of main interest, which should still be placed according to the rule of thirds or the golden mean.

Another pleasing type of composition is the L shape or inverted L shape. This type of composition is ideal for reclining or seated subjects. Again, the center of interest should still be placed according to the rule of thirds or the golden mean.

SUBJECT TONE

The rule of thumb is that light tones advance visually, while dark tones retreat. It is a natural visual phenomenon. Therefore, elements in the picture that are lighter in

Even in close-up views when the subject is looking directly at the camera, the dynamic rules of composition should apply. In this portrait of a little angel, photographer Chris Becker introduced the diagonal line of the eyes and a higher placement of them in the frame to strike these chords of good composition. He made the image with a FujiFilm FinePix S2 Pro and 80–200mm Nikkor zoom. The exposure was made at $1/60$ second at f/3.2 at the 105mm zoom setting.

tone than the subject will be distracting. To reduce this effect, bright areas, particularly at the edges of the photograph, should be darkened in printing, in the computer, or in the camera (by masking) so that the viewer's eye is not brought away from the subject.

Of course, there are portraits where the subject is the darkest part of the scene, such as in a high-key portrait with a white background. This is the same principle; the eye will go to the region of greatest contrast in a field of white or on a light-colored background.

The guiding principle is that, regardless of whether the subject is light or dark, it should visually dominate the rest of the photograph either by brightness or by contrast.

FOCUS

Whether or not an area is in focus has a lot to do with the amount of visual emphasis it will receive. For instance, imagine a portrait in which a subject is framed in green foliage, yet part of the sky is visible in the scene. In such a case, the eye would ordinarily go to the sky first. However, if the sky is soft and out of focus, the eye will revert back to the area of greatest contrast—hopefully the face.

The same is true of foreground areas. Although it is a good idea to make them darker than your subject, sometimes you can't. If the foreground is out of focus, however, it will detract less from a sharp subject.

LINES

To effectively master the fundamentals of composition, the photographer must be able to recognize real and implied lines within the photograph. A real line is one that is obvious—a horizon, for example. An implied line is one that is not as obvious; the curve of the wrist or the bend of an arm is an implied line.

Real lines should not intersect the photograph in halves. This actually splits the composition into two halves. It is better to locate real lines at a point one-third into the photograph. This weights the photo in a way that is more appealing to the eye.

In this surreal infrared portrait made in Central Park in New York City, the subject tones draw your eye to the couple, despite the other bright image tones within the scene. This defines the couple and the boat as the most important things to look at in this wide-angle portrait. Image was made with a Contax 35mm camera with 25mm Zeiss lens on Kodak black & white infrared film. Photograph by Ferdinand Neubauer.

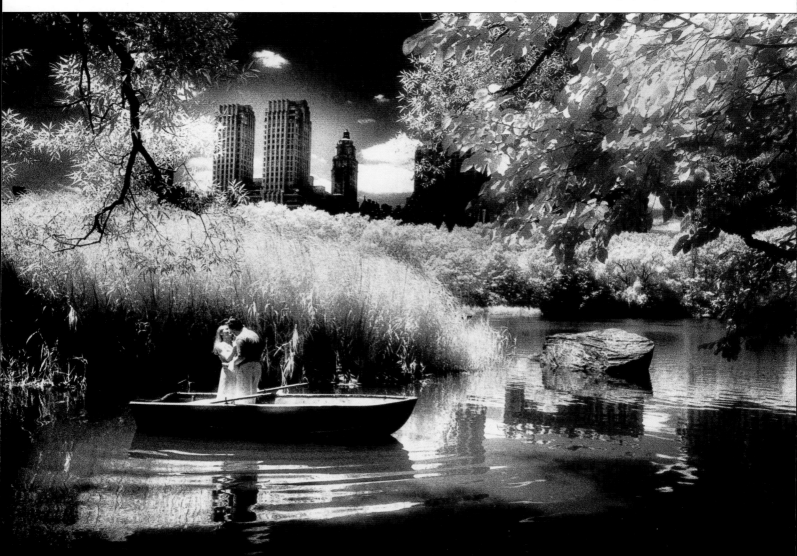

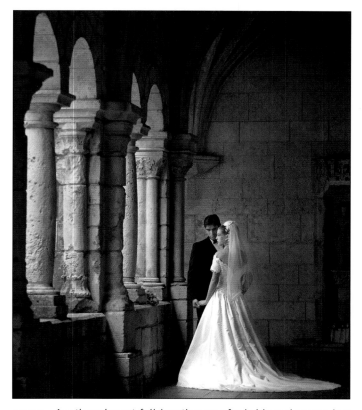

ABOVE—Another elegant full-length pose of a bride and groom is a study in static and flowing lines. The straight arm and somewhat abrupt "break" of the bride's wrist serve to complement the wonderful flowing lines of her dress and the arches. Another fine point: the line of the bride's arm and dress form a powerful diagonal line that rivets your attention on the center of interest. Photograph by Rick Ferro. RIGHT—It's often been said that part of being a great photographer is being a great observer. Wisconsin photographer Fuzzy Duenkel creates masterpieces of his senior subjects, photographing them in their own homes by available light. Here, he found the afternoon sun highlighting the arches in her home, creating the perfect compositional echo for this portrait. Fuzzy coordinated the tones of her hair and skin with the wall colors, creating a masterful composition.

Lines, real or implied, that meet the edge of the photograph should lead the eye into the scene and not out of it—and they should lead toward the subject. A good example of this is the country road that is widest in the foreground and narrows to a point where the subject is walking. These lines lead the eye straight to the subject.

Implied lines, such as those of the arms and legs of the subject, should not contradict the direction or emphasis of the composition, but should modify it. These lines should present gentle, not dramatic, changes in direction. Again, they should also lead to the main point of interest—either the eyes or the face.

5. BASIC PORTRAIT LIGHTING

This chapter will cover the basic forms of conventional portrait lighting. They are "conventional" in that they are used day in and day out by professional portrait photographers to produce salable portraits. They are "basic" in that they represent a starting point for any photographer. Once you have mastered these forms of lighting, you can refine them and vary them to meet the needs of your subject and to meet the artistic demands of your photography.

A photograph is only a two-dimensional representation of three-dimensional reality, thus the aim of the photographer is to produce a portrait that shows the roundness and form of the human face. This is done primarily with highlights (areas that are illuminated by the light source) and shadows (areas that are not). Just as a sculptor models clay to create the illusion of depth, so light models the shape of the face to give it depth and form.

In the studio, the portrait photographer has more control of highlights and shadows than in any other portrait situation—plus the ability to manipulate the placement and intensity of these features. Still, although numerous lights may be used, one light must dominate, establishing a pattern of shadows and highlights on the face. All other lights should be secondary to this main light and modify it. The placement of this key light (also called the main light) is what determines the lighting pattern in studio portraiture.

The shape of the subject's face usually determines the best lighting pattern to use. You can widen a narrow face, narrow a wide face, hide poor skin, and disguise unflattering facial features (such as a large nose) all by thoughtful placement of your key light.

THE LIGHTS

Portrait lighting can be done with very basic equipment. A full set of four lights with stands and parabolic reflectors can be purchased quite reasonably. If you shop for used

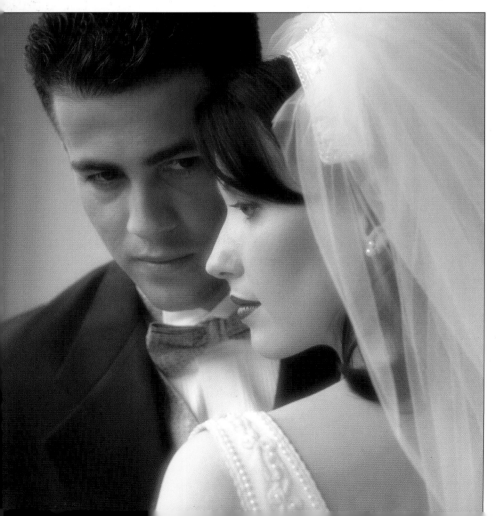

Portrait lighting imitates natural lighting, which is a basic one-light look. Here, the photographer harnessed the beauty of natural window light and a beautiful profile. The softness of the window light was enhanced by the use of a Black Net #2 diffusion filter over the camera lens. Photography by Rick Ferro.

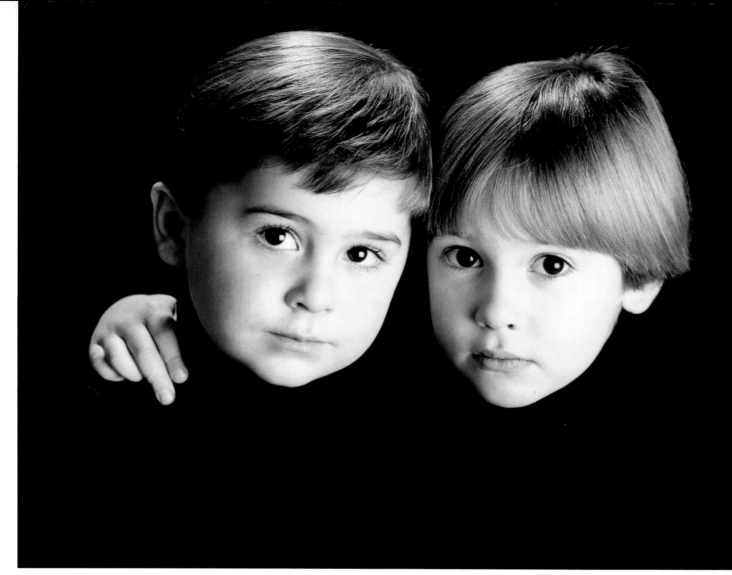

Broad and short lighting are seen in the same portrait. Notice how the faces are rendered. Broad lighting flattens out facial features, while short lighting produces a more dramatic lighting with greater roundness. Here, the main light was a double-scrimmed 35-inch softbox at an output of f/8. A snooted hair light was used at f/8 from directly behind the kids. For fill, a Halo Mono (a type of enclosed umbrella) was bounced off the rear wall at a setting of f/2.8. Exposure was at $^1/_{60}$ second at f/8. Kodak Plus-X Pan film was used at ISO 100. Photograph by Norman Phillips.

equipment, you can get lights even cheaper. The lights can be electronic flash units or they may be incandescent lights. The latter is preferred in learning situations, because what you see is exactly what you get. With strobes, a secondary modeling light is used within the lamp housing to closely approximate the effect of the flash.

Key and Fill Lights. The key and fill lights should be high-intensity bulbs seated in parabolic reflectors. Usually 250–500 Watts is sufficient for a small room. If using electronic flash, 200–400 Watts is a good power rating for portraiture. Reflectors should be silver-coated on the inside to reflect the maximum amount of light. If using diffusion, umbrellas or soft boxes, each light assembly should be supported on a sturdy stand to prevent it from tipping over.

The key light, if undiffused, should have barn doors affixed. These are black, metallic, adjustable flaps that can be opened or closed to control the width of the beam. Barn doors ensure that you light only the parts of the portrait you want lit. They also keep stray light off the camera lens, preventing lens flare.

The fill light should be equipped with a diffuser, which is nothing more than a piece of frosted plastic or acetate in a screen that mounts over the reflector. When using a diffuser over a light, make sure there is sufficient room between the diffuser and the reflector to allow heat to es-

cape. The fill light should also have barn doors attached. If using a diffused light source like an umbrella for the fill light, be sure that you are not "spilling" light into unwanted areas of the scene, such as the background.

Hair Light. The hair light, which is optional if you're on a budget, is a small light—usually a scaled-down reflector with barn doors for control. Normally, a reduced power setting is used, because the hair light is almost always undiffused. Barn doors are a necessity, as this light is placed behind the subject to illuminate the hair; without barn doors, the light may cause lens flare.

Background Light. The background light is also a lower-powered light. It is used to illuminate the background so that the subject and background will separate tonally. The background light is usually used on a small stand placed directly behind the subject, out of view of the camera lens. It can also be placed on a higher stand and directed onto the background from either side of the set.

Kicker Lights. Kickers are optional lights used in very much the same way as hair lights. These add highlights to the sides of the face or body, helping to increase the feeling of depth and richness in a portrait. Kickers produce highlights with brilliance, since the light from them just glances off the subject's skin or clothing. Because kickers are set behind the subject, barn doors or snoots (conical black reflectors used to shrink the beam of emitted light) should be used.

LIGHTING TYPES

There are two basic types of portrait lighting: broad lighting and short lighting.

Broad Lighting. Broad lighting means that the key light is illuminating the side of the face turned toward the camera. Broad lighting is used less frequently than short lighting because it tends to flatten out and de-emphasize facial contours. It can be used to widen a thin or long face.

Short Lighting. Short lighting means that the key light is illuminating the side of the face turned away from the camera. Short lighting emphasizes facial contours and can be used as a corrective lighting technique to nar-

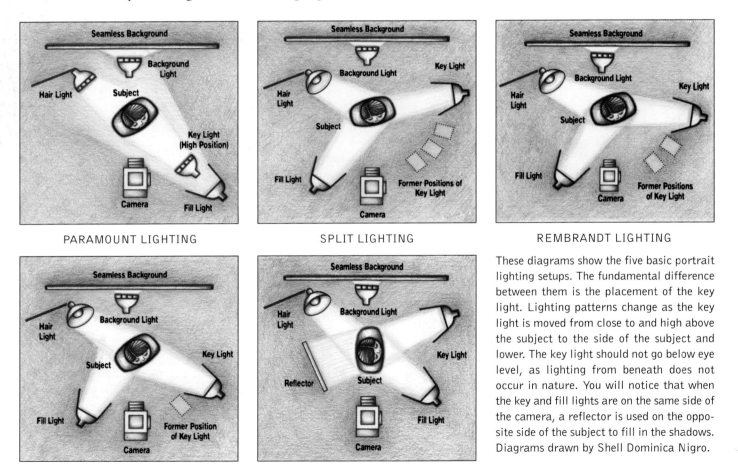

PARAMOUNT LIGHTING

SPLIT LIGHTING

REMBRANDT LIGHTING

LOOP LIGHTING

PROFILE OR RIM LIGHTING

These diagrams show the five basic portrait lighting setups. The fundamental difference between them is the placement of the key light. Lighting patterns change as the key light is moved from close to and high above the subject to the side of the subject and lower. The key light should not go below eye level, as lighting from beneath does not occur in nature. You will notice that when the key and fill lights are on the same side of the camera, a reflector is used on the opposite side of the subject to fill in the shadows. Diagrams drawn by Shell Dominica Nigro.

row a round or wide face. When used with a weak fill light, short lighting produces a dramatic lighting with bold highlights and deep shadows.

BASIC LIGHTING SETUPS

There are five basic portrait lighting setups. As you progress through them from Paramount to split lighting, each progressively makes the face slimmer. Each also progressively brings out more texture in the face because the light is more to one side.

Additionally, as you progress from Paramount to split lighting, you'll notice that the key light mimics the path of the setting sun—at first high, and then gradually lower in relation to the subject. It is important that the key light never dip below subject/head height. In traditional portraiture this does not occur, primarily because it does not occur in nature; light from the sun always comes from above.

Paramount Lighting. Paramount lighting, sometimes called butterfly lighting or glamour lighting, is a traditionally feminine lighting pattern that produces a symmetrical, butterfly-like shadow beneath the subject's nose. It tends to emphasize high cheekbones and good skin. It is generally not used on men because it tends to hollow out their cheeks and eye sockets.

The key light is placed high and directly in front of the subject's face, parallel to the vertical line of the subject's nose (see diagram on facing page). Since the light must be high and close to the subject to produce the wanted butterfly shadow, it should not be used on women with deep eye sockets, or no light will illuminate the eyes. The fill light is placed at the subject's head height, directly under the key light. Since both the key and fill lights are on the same side of the camera, a fill card must be used opposite these lights and in close to the subject to fill in the deep shadows on the neck and shaded cheek.

The hair light, which is always used opposite the key light, should light the hair only and not skim onto the face

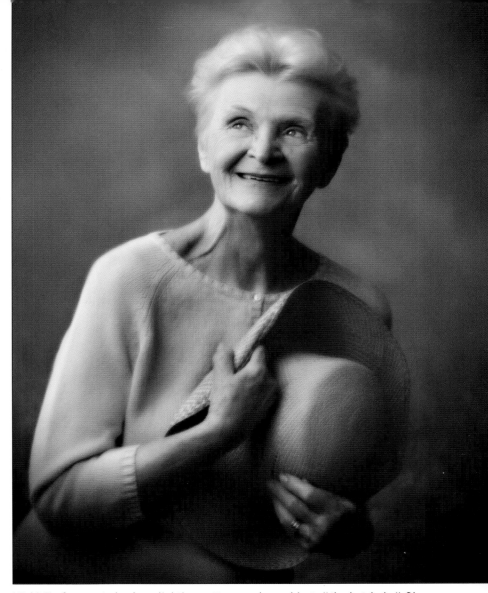

Vicki Taufer created a loop lighting pattern on her subject, "the hat lady." She opted for very minimal fill. The single main light, a large softbox, defines the lighting pattern but a second light source was also used: a reflector beneath the softbox that further softens the light and diffuses the shadow edge in the portrait. Both were used on camera left.

of the subject. The background light, used low and behind the subject, should form a semicircle of illumination on the seamless background (if using one) so that the tone of the background grows gradually darker the farther away from the subject you look.

Loop Lighting. Loop lighting is a minor variation of Paramount lighting. The key light is lowered and moved more to the side of the subject so that the shadow under the nose becomes a small loop on the shadow side of the face. This is one of the more commonly used lighting setups and is ideal for people with average, oval-shaped faces.

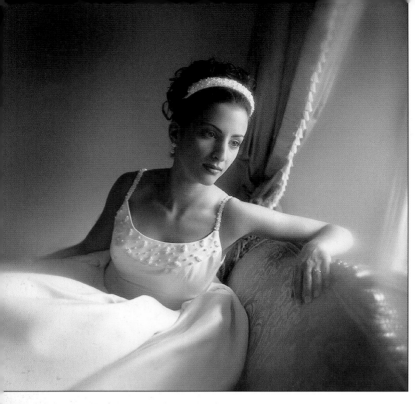

TOP—Classic Rembrandt lighting is characterized by the diamond-shaped highlight on the shadow side of the face. Basic window light and a single silver reflector were used to produce this classic image. This image was created using a Hasselblad camera with 80mm lens and a Lindahl drop-in vignette filter in a Lindahl lens shade. Photograph by Anthony Cava. BOTTOM—Good light can be found anywhere, but especially in an available-light studio. This was what was used by wedding specialist Jeffrey Woods, whose studio features a huge window that provides bright, soft light—and plenty of it. To create the beautiful Rembrandt lighting pattern seen here, he simply positioned his senior model in the light to create the dramatic shadow. Most of today's portrait photographers seem to favor a strong natural light.

In loop lighting, the fill light is positioned on the camera–subject axis. It is important that the fill light not cast a shadow of its own in order to maintain the one-light character of the portrait. The only place you can really observe if the fill light is doing its job is at the camera position. Look to see if the fill light is casting a shadow of its own by looking through the viewfinder.

The hair light and background light are used in the same way as they are in Paramount lighting.

Rembrandt Lighting. Rembrandt lighting (also called 45-degree lighting) is characterized by a small, triangular highlight on the shadowed cheek of the subject. The lighting takes its name from the famous Dutch painter who popularized this dramatic style of lighting. This type of lighting is often considered a masculine style and is commonly used with a weak fill light to accentuate the shadow-side highlight.

The key light is moved lower and farther to the side than in loop and Paramount lighting. In fact, the key light almost comes from the subject's side, depending on how far the head is turned away from the camera.

The fill light is used in the same manner as it is for loop lighting. The hair light, however, is often used a little closer to the subject for more brilliant highlights in the hair. The background light is in the standard position.

In Rembrandt lighting, kickers are often used to delineate the sides of the subject's face and to add brilliant highlights. Be careful when setting such lights not to allow them to shine directly into the camera lens; this will cause flare. The best way to check is to place your hand between the subject and the camera on the axis of the kicker. If your hand casts a shadow when it is placed in front of the lens, the kicker is shining directly into the lens and should be adjusted.

Split Lighting. Split lighting occurs when the key light illuminates only half the face. It is an ideal slimming light. It can be used to narrow a wide face or a wide nose. It can also be used with a weak fill to hide facial irregularities. Split lighting can be used with no fill light for a highly dramatic effect.

In split lighting, the key light is moved farther to the side of the subject and lower. In some cases, the key light is slightly behind the subject, depending on how far the subject is turned from the camera. The fill light, hair light, and background light are used normally.

Profile Lighting. Profile or rim lighting is used when the subject's head is turned 90 degrees from the camera

RIGHT—In this image, David Williams used soft side light to create a Rembrandt lighting pattern. The side lighting also reveals texture in the spackle on the door and the contractor's tools. Note, too, David's careful exposure; you can see detail in the shadows that reveal the unfinished room. The image was made with a FujiFilm FinePix S2 Pro camera and Sigma DG 24–70mm f/2.8 zoom lens. BELOW—Rita Loy created this award-winning bridal profile. The key light, softened through on-camera diffusion so that it glows, is perfectly positioned behind and above the bride in the classic position to produce a highlight on the shadow side of her cheek. There is good fill-in from a soft light at camera left, producing a 3:1 lighting ratio. The delicate hand posing against the dark mahogany of the love seat creates a pleasing contrast of opposites.

Here is another example of expertly handled rim lighting. In this instance, the key light was moved closer to parallel to the subject's face so that more of the frontal planes of her face were illuminated. No fill light was used, so the shadow areas seem to "fade to black." Photograph by Tony Corbell.

lens. It is a dramatic style of lighting used to accent elegant features. It is used less frequently now than in the past, but remains a stylish type of portrait lighting.

In rim lighting, the key light is placed behind the subject so that it illuminates the profile and leaves a highlight along the edge of the face. The key light will also highlight the hair and neck of the subject. Care should be taken so that the core of the light is centered on the face and not too much on the hair or neck.

The fill light is moved to the same side of the camera as the key light and a reflector is used to fill in the shadows (see rim lighting diagram, page 50). An optional hair light can be used on the opposite side of the key light for better tonal separation of the hair from the background. The background light is used normally.

THE FINER POINTS

In setting the lights for the basic portrait lighting patterns discussed here, it is important that you position the lights with sensitivity. If you merely aim the light directly at the subject, there is a good chance you will overlight the subject, producing pasty highlights with no delicate detail. You must adjust the lights carefully, and then observe the effects from the camera position.

Feathering. Instead of aiming the light so that the core of light strikes the subject, feather the light so that you employ the edge of the light to illuminate your subject. This is one way to add brilliance to your highlights, minute specular (pure white) highlights that further enhance the illusion of depth in a portrait. However, since you are using the edge of the light, you will sometimes

TOP—This image, by Joseph and Louise Simone, is entitled *Mona Lisa*. It features strong key lighting in a near-Rembrandt pattern with a very soft fill-in to lessen the drama of that lighting. The pose is extremely elegant and refined—the curve of the right hand points directly at the left hand, indicating to the viewer that the hands are significant keys to interpreting this young woman's character. The bold hair light enlivens her hair and the background, a hand-painted tapestry, is projected using the Scene Machine, a background projection system. The image was captured with a Contax 645 and a Kodak 645 digital back. BOTTOM—Chris Nelson made this striking close-up portrait with a softbox as a main light; a reflector was used on camera right and an umbrella was used above the camera, aimed straight in at the model, but feathered upward slightly to put more light on her red hair than her white sweater. The umbrella was set to output one stop less light than the main light. Crumpled gold Mylar was used as a background and a strip light, set at the same output as the softbox, was used as a hair light. The strip light was positioned above and behind the subject.

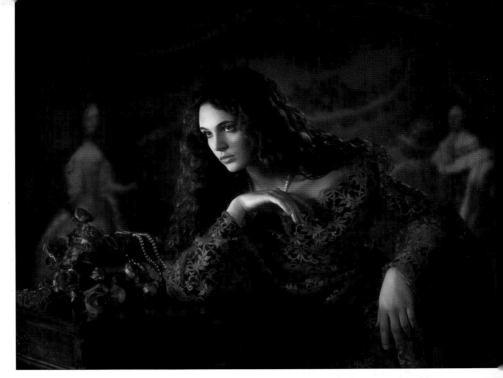

cause the level of light to drop off appreciably with no noticeable increase in highlight brilliance. In these cases, it is better to make a slight lateral adjustment of the light in one direction or another. Then check the result in the viewfinder.

Sometimes you will not be able to get the skin to "pop" regardless of how many slight adjustments you make to the key light. This usually means that your light is too close to the subject and you are overlighting your subject. Move the light back. A good working distance for your key light, depending on your room dimensions and the light intensity, is eight to twelve feet.

Fill Light Placement. The fill light can pose its own set of problems. If too close to the subject, the fill light often produces specular highlights on the shadow area of the face that make the skin appear oily. If this is the case, move the fill light back slightly, or move it laterally away from the camera a bit. You might also try feathering the light slightly. This method of limiting the fill light is preferable to closing down the barn doors of the light to lower its intensity.

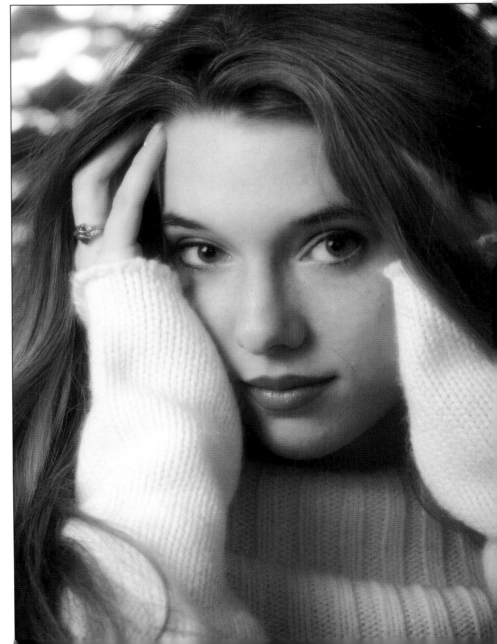

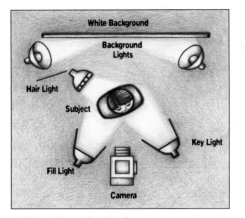

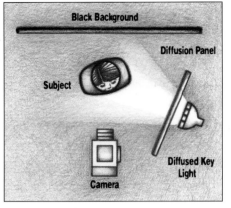

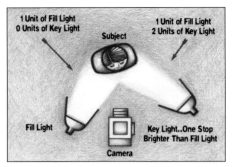

HIGH-KEY LIGHTING
In a high-key lighting setup, you must over-light the background if you want it pure white in the photo. Here, two floodlights were used to light the background so that it was one stop greater than the frontal subject lighting.

LOW-KEY LIGHTING
In low-key lighting, only one light is used from the side. To keep the shot dark throughout, no background or hair lights are used.

3:1 LIGHTING RATIO
The key and fill lights are the same approximate distance from the subject, but the key is one stop brighter. The fill casts one unit of light on the shadow side of the face and one unit on the highlight side. The key, twice as bright (one f-stop), casts two units of light on the highlight side of the face only. The key light casts no light on the shadow side. Therefore, the lighting ratio is 3:1.

Another problem that the fill light often creates is multiple catchlights. These are the small specular highlights that appear on the iris of the eye. When you use a fill light, you will get a set of catchlights from the fill as well as the primary set from the key light. The effect of two catchlights is to give the subject a directionless gaze. Therefore, this second set of catchlights is usually removed later in retouching.

LIGHTING RATIOS

The term "lighting ratio" is used to describe the difference in intensity between the shadow and highlight side of the face. This is useful in determining how much local contrast there will be in the portrait, as well as how much detail will be visible in the shadow areas. Light ratios are expressed numerically. For example, if an image has a 3:1 ratio, it means that the highlight side of the face has three units of light falling on it, while the shadow side has only one unit of light falling on it.

Calculating. When we talk about light ratios, each full stop is equal to two units of light, each half stop is equal to one unit of light, and each quarter stop is equivalent to a half unit of light. The fill light is always calculated as one unit of light, because it strikes both the highlight and shadow sides of the face. The light from the key light, which strikes only the highlight side of the face, is added to that number to calculate the final ratio.

For example, imagine you are creating a portrait in which the main light is one stop greater than the fill light. As always, the fill light constitutes one unit, because it illuminates both the shadow and highlight sides of the faces. The key light adds one stop (two units) to the highlight side of the face. Thus, the highlight side of the face receives three units of light (one from the fill light, plus two from the key), while the shadow side of the face received only one unit of light (from the fill light). Therefore, the light ratio in this portrait is 3:1.

Unique Personalities. A 2:1 ratio is the lowest lighting ratio you should employ. It shows only minimal roundness in the face and is most desirable for high-key portraits—those with low lighting ratios, light tones, and usually a light background. In a 2:1 lighting ratio, the key- and fill-light sources are the same intensity (one unit of light falls on the shadow and highlight sides of the face from the fill light, while one unit of light falls on the highlight side of the face from the key light—1+1=2:1). A 2:1 ratio will widen a narrow face and provide a flat rendering that lacks dimension, but which is ideal for a narrow face.

FACING PAGE—High key portraits don't have to be all whites. In this image by Fuzzy Duenkel, the ratio between the soft window-light key and the reflector fill is kept very close to a 2:1 ratio. In addition, the exposure was biased slightly toward overexposure to move the tonal scale toward the highlights. The darkest tone in the image is roughly an 18-percent gray. The photo was made with a Nikon D1X and Nikkor 80–200mm f/2.8 zoom lens.

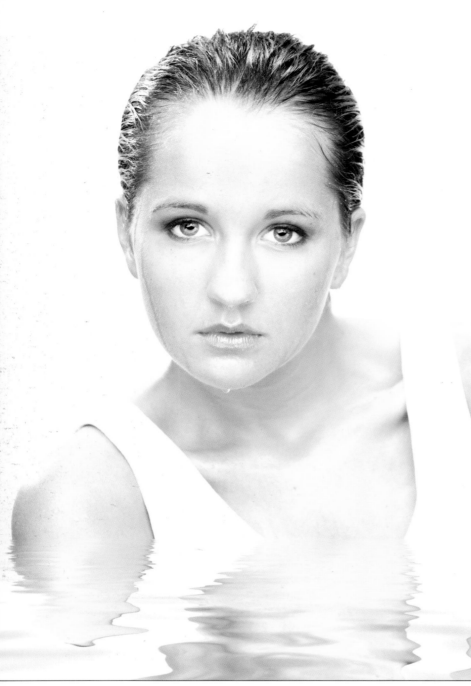

A 3:1 lighting ratio is produced when the key light is one stop greater in intensity than the fill light (one unit of light falls on both sides of the face from the fill light, and two units of light fall on the highlight side of the face from the key light—2+1=3:1). This ratio is the most preferred for color and black & white because it will yield an exposure with excellent shadow and highlight detail. It shows good roundness in the face and is ideal for rendering average-shaped faces.

A 4:1 ratio (the key light is 1½ stops greater in intensity than the fill light—2+1+1=4:1) is used when a slimming or dramatic effect is desired. In a 4:1 ratio, the shadow side of the face loses its slight glow and the accent of the portrait becomes the highlights. Ratios of 4:1 and higher are used in low-key portraits, which are characterized by a higher lighting ratio, dark tones, and usually a dark background.

A 5:1 ratio (the key light is 2 stops greater than the fill light—2+2+1=5:1) or higher is considered almost a high-contrast rendition. It is ideal for adding drama and is often used in character studies. Shadow detail is minimal at the higher ratios and as a result, they are not recommended unless your only concern is highlight detail.

SETTING THE LIGHTS

Most photographers have their own procedures for setting the portrait lights. You will

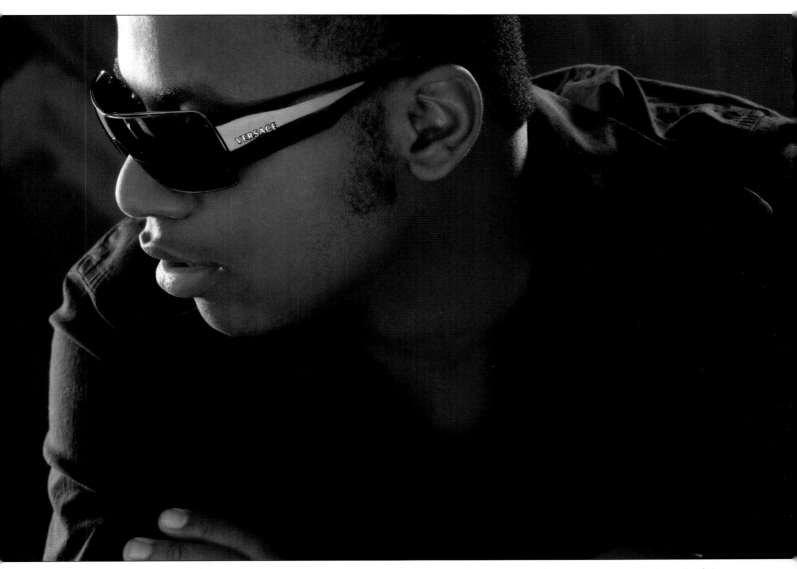

A low-key lighting ratio is dramatic. This rim-light profile by senior specialist Larry Peters has great drama because of the strength of the edge light and the pose itself. Note the ratio is not that steep, even though the highlight on the young man's forehead is rather strong.

develop your own system as you gain experience, but the following is one plan you can start with.

Generally, the first light you should set is the background light (if you're using one). Place the light behind the subject, illuminating the part of the background you want lit. Usually, the background light is brighter close to the subject, then fades gradually the farther out from the subject you look. This is accomplished by angling the light downward. If you have more space in front of than behind the subject in the composition, the light should be brighter behind the subject than in front, as seen from the camera. In other words, if the subject is slightly to the left of center in the frame, the background light should be brighter on the left side of the frame as well. This helps increase the sense of direction in the portrait. The background light is usually set up while all the other lights are turned off.

Next, the hair light (if using one) is set. This is also set up with your frontal lights extinguished so that you can look for stray light falling onto the face. If this happens, feather the light until it illuminates only the hair. When photographing men, sometimes the hair light can double as a kicker, illuminating both the hair and one side of the forehead or cheek at the same time.

Next, the fill light is set. Usually, it is used next to the camera (see the lighting diagrams on page 50). Adjust it for the amount of shadow detail you want to achieve. Examine the subject's face with only the fill light on and de-

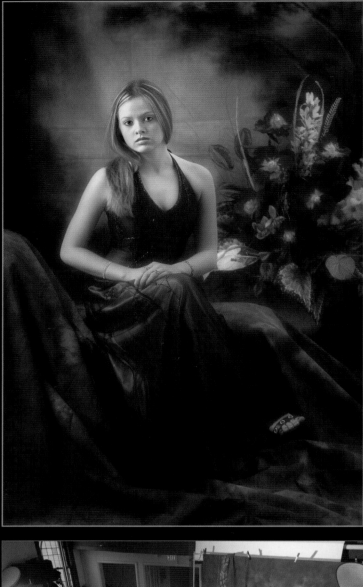

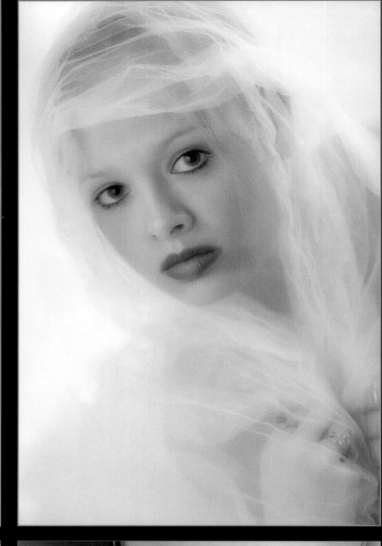

In this series of illustrations, Claude Jodoin shows how to create a low-key image with one light. The single Alien Bees strobe fires through two scrims to produce a soft, wraparound, split-light effect. A silver reflector kicks a little light back onto the model's hair for dimension. Some mild diffusion was added in Photoshop for a more romantic feeling. Even though the image is low key, the lighting ratio is no more than 2:1. The low-key feeling is achieved by biasing the exposure toward the shadows and by using dark tones throughout.

Claude again illustrates a one-light portrait using backlighting through a scrim and another scrim used as a frontal reflector. A low-powered Alien Bees strobe was aimed down on the model to produce an overhead backlight. The exposure was biased toward the highlights to create a high-key look. A custom white-balance reading was made first with an ExpoDisc. According to Claude, who shoots in JPEG Fine mode, he never has to color balance a file in Photoshop; he gets it right in the camera.

termine if the skin looks oily or flat. Sometimes you will have to use pancake makeup to dry up excessively moist skin if adjusting the fill light won't correct the problem. If the skin looks too matte and lifeless, increase the amount of fill.

Next, turn on the key light and adjust it for the lighting pattern you desire. Move it closer or farther from the subject to produce the ratio you want. Ratios are best metered by holding an incident light meter first in front of the shadow side of the face, and then in front of the highlight side, in each case pointing the meter directly at the light source. By determining how many stops of difference there are between your lights you will know the ratio.

METERING FOR EXPOSURE

If using an incident meter, hold the meter at the subject's nose and point it directly toward the lens. If any of the back lights (like hair lights or kickers) are shining on the meter's light-sensitive hemisphere, shield the meter from them, as they will adversely affect exposure. You are only interested in the intensity of the frontal lights when determining the correct exposure.

Another type of professional meter that yields precise results is the spot meter, which has a very narrow field of view—usually less than 5 degrees. Spot meters are reflected-light meters and for best results should be used with an 18-percent gray card, which will yield the proper exposure settings if held in precisely the same light

Claude Jodoin really likes this high-key shot (mainly because of the Puma socks). It was made using a single Alien Bees strobe on low power. As you can see from the standing pose, the strobe was fired through a scrim and a standing second scrim and white floor covering acted as fill. In this image you can really see how clean the whites are in Claude's brand of digital portraiture—a characteristic that he proudly attributes to an ExpoDisc and perfect exposures.

that will expose your subject. If you wish to check lighting ratios, hold the gray card facing the key-light source and take a reading on that axis. Do the same for the fill light, holding the card on axis and metering on that same axis. Make sure there is no glare on the card from any of the other lights when taking a reading.

FLAGS OR GOBOS

Sometimes, because of the nature of the lighting, it is difficult to keep unflattering light off of certain parts of the portrait. A good example of this is hands that receive too much light and therefore gain excessive dominance in the photograph. One solution is to use a device called a gobo, which is a light-blocking card, usually black, held on a boom-type light stand, sometimes known as a C stand. Gobos, or flags as they're sometimes called, can be positioned between the light and the subject to shade an area from direct light. When placed in the path of a diffused light source, the light will wrap around the flag, creating

Reflectors come in a variety of shapes and sizes. These are Lite Discs, which fold up to a quarter of their size for easy transport and storage. Reflectors come in transparent white, opaque white, silver, gold, and even black for subtractive lighting effects.

a very subtle light-blocking effect. The less diffused the light source, the more pronounced the effect of the gobo.

REFLECTORS

The opposite of a flag is a reflector panel, which may be white, metallic silver, or metallic gold. Reflectors may be flexible or rigid, but their sole purpose is to bounce light into shadow areas of the photograph. A reflector can often take the place of a fill light, especially when using a large, diffused key light. There is so much light scatter from the diffused light source that the reflector acts as a light collector, focusing light into needed areas.

THE NATURE OF FILL LIGHT

Every portrait image has a lighting ratio, even if no fill light or reflector is used. The fill comes from light reflected in the setting—either from a nearby wall, or ceiling bounce, or light extraneously reflected from multiple light sources. In each portrait the fill has a value and should be computed against the highlight side value in order to gauge the ratio before final exposures are made. The fill will determine the three-dimensionality of the rendering of the face(s) and effectively control the "personality" of the lighting.

6. LIGHTING VARIATIONS

*I*n chapter 5, we talked about how basic lights are used to produce the traditional portrait lighting patterns. The use of these lighting patterns, if practiced and refined, will help you produce elegant and professional-looking portraits.

You may find, however, that you prefer a more casual type of lighting that employs only one or two light sources. Your budget, too, may dictate a limited array of lighting equipment. In either case, you will find this chapter of interest.

The lighting techniques to be outlined here are very simple—most of them employ either available light, or at most two individual lights. These lighting techniques are simple and economical and you may find them particularly practical, as well.

WINDOW LIGHT

One of the most flattering types of lighting you can use in portraiture is window lighting. It is a soft light that minimizes facial imperfections, yet it is also directional with excellent modeling qualities. Window light is usually a fairly bright light source that will allow you to handhold the camera if a moderately fast ISO and wide lens aperture are used. Window light is infinitely variable, changing almost by the minute, allowing a great variety of moods in a single shooting session.

Window lighting has several large drawbacks as well. Since daylight falls off rapidly once it enters a window, and is much weaker several feet from the window than it is close to the window, great care must be taken when determining exposure. If the subject moves, even as little as six to eight inches, exposure will change. Another drawback is that you cannot move the light source, so you must

Window light is soft but directional. The farther your subject is from the window, the less intense the light gets and the more contrasty it gets. Here, the mother and child are close to the soft window light. After the shoot, diffusion was added in Photoshop to further lower the contrast and increase the softness of the image. Jennifer George used a Nikon F100, with a Nikkor 70–210mm lens, to create this image. The exposure, with reflector fill, was $1/30$ second at f/5.6 on Kodak TCN 400 film at ISO 400. The title of the photo is *Madonna and Child.*

David William has a south-facing doorway in his studio. This produces beautiful, soft light that requires little or no fill. He simply opens one or both French doors to let more or less light in. He usually uses a reflector close by to fill in shadows not affected by the diffused daylight. Here, the little ballerina is just plopped down on a dresser, which David often uses as a posing bench for his smaller subjects. David photographed by light flooding in through his open doors. No fill was needed. Williams often plays imaginative games with his child subjects to elicit priceless expressions.

move your subject in relation to the window. This can sometimes set up odd poses. When shooting in buildings not designed for photography, you will sometimes have to work with distracting backgrounds and at uncomfortably close shooting distances.

The best quality of window light is found in the soft light of mid-morning or mid-afternoon. Direct sunlight is difficult to work with because of its intensity and because it will often create shadows of the individual window panes on the subject. It is often said that north light is the best for window-lit portraits. This is not necessarily true. Good quality light can be had from a window facing any direction, provided the light is soft.

Subject Positioning. One of the most difficult aspects of shooting window light portraits is positioning your subject so that there is good facial modeling. If the subject is placed parallel to the window, you will get a form of split

lighting that can be harsh. It is best to position your subject away from the window slightly so that he or she can look back toward the window. Thus, the lighting will highlight more of the face.

You can also position yourself between the window and your subject for a flat type of lighting. Often, however, you'll find that your body will block some much-needed light, or that the subject must be quite far from the window to get the proper perspective and composition. Under these circumstances, the light level will often be too low to make a decent exposure, even with a high ISO.

Usually, it is best to position the subject three to five feet from the window. This not only gives good, soft lighting, but also gives you a little extra room to produce a flattering pose and pleasing composition.

Metering. The best way to meter for exposure is with a handheld incident meter. Hold it in front of the subject's

face in the same light, and take a reading, pointing the light-sensitive hemisphere directly at the camera lens.

If using a reflected meter, like the in-camera meter, move in close to the subject and take a reading off the subject's face. Most camera light meters take an averaged reading, so if you move in close on a person with an average skin tone, the meter will read the face, hair, and what little clothing and background it can see and give you a fairly good exposure reading. If the subject is particularly fair-skinned, however, remember to open up at least one f-stop from the indicated reading.

If using an average ISO setting (say, ISO 100), you should be able to make a handheld exposure at a reasonable shutter speed like $\frac{1}{30}$ second with the lens opened up to $f/2.8$. Of course, this depends on the time of day and intensity of the light, but in most cases a handheld exposure should be possible. Since you will be using the lens at or near its widest aperture, it is important to focus carefully. Focus on the subject's eyes in a full-face or seven-eighths pose. If the subject's head is turned farther from the camera, as in a three-quarter view, focus on the bridge of the nose. Depth of field is minimal at these apertures, so control the pose and focus carefully for maximum sharpness on the face.

White Balance. If shooting digitally, a custom white-balance reading should be taken,

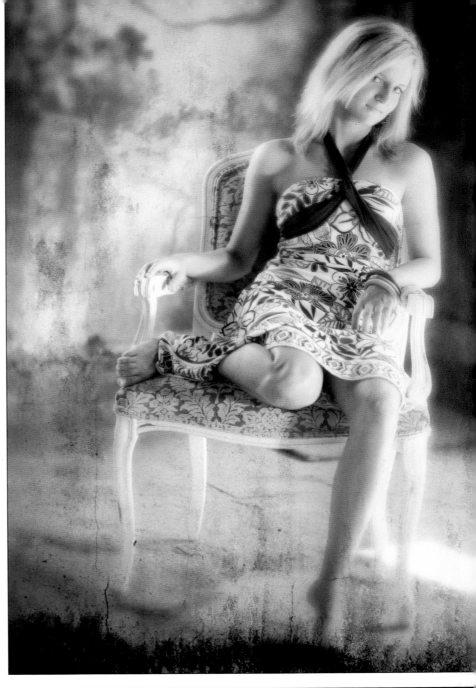

TOP—This window-light portrait by Jeff Woods incorporates the texture-laden walls of the abandoned building location as a transparent layer of the image. The window light is a large one, allowing both direct and diffused light to pass through it. Jeff positioned his subject just out of the direct light (note the highlight on the floor) and had her turn her head back toward the light. He used a reflector to camera left to help fill in the shadows from the window light. Note the unusual placement of a Victorian chair in a warehouse-type environment. BOTTOM—Suzette Nesire is a children's photographer who frequently works by existing light. Here, she employed a shaft of overhead light on her patio, outside her studio. You can see the shape of the light in the catchlights of the baby's eyes. The lighting is very soft but produces excellent specular highlights within the larger highlight areas.

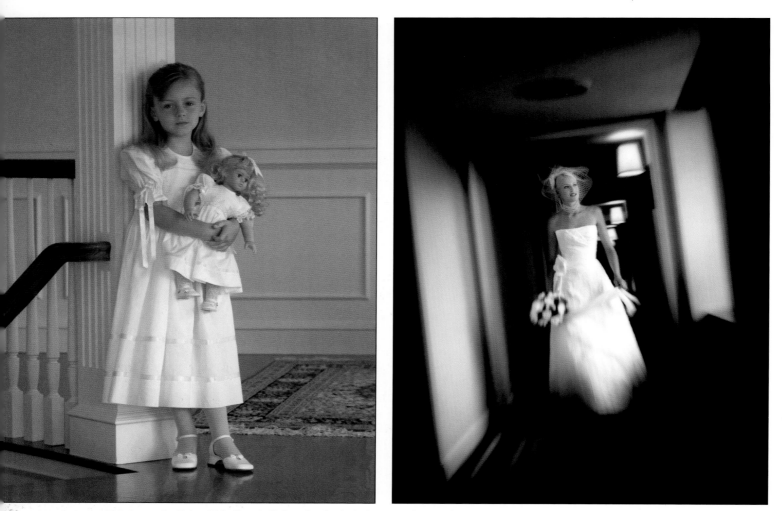

LEFT—This image by Brian Shindle was lit by a bank of windows roughly ten feet from the little girl. A single reflector was used on the shadow side of the girl for fill-in. The image was made digitally with a FujiFilm FinePix S2 Pro and 35–70mm f/2.8 Nikkor lens. The ISO was set to 400 and the exposure was $^1/_{90}$ second at f/4.8. Note the matching outfits of the doll and little girl—an effect suggested by the photographer. RIGHT—Sometimes, no fill is possible and the photographer must make the best of the lighting situation. Here, Marcus Bell had his bride stride toward him in a hallway lit by intermittent bay windows. The unlit areas were made black in printing to give the image some drama. He also tinted the image blue in Photoshop and tilted the frame to give it a very fashion-oriented edge. Although it looks like camera movement that is blurring the dress and bouquet, it is actually a little motion blur added in Photoshop.

since most window-light situations will be mixed light (daylight and room light). The ExpoDisc is ideal for this type of lighting situation. Although preset white-balance values supplied in the camera's firmware may be adequate, it is better to take a custom white-balance reading. If working in changing light, take another custom white-balance reading every twenty minutes or so to ensure that the changing light does not affect the color balance of your scene.

Fill-in Illumination. One of the biggest problems commonly encountered with window light is that there is not adequate fill light to illuminate the shadow side of the subject's face.

The easiest way to fill the shadows is with a large white or silver reflector placed next to the subject on the side opposite the window. The card has to be angled properly to direct the light back into the face. If you are shooting a three-quarter- or full-length portrait, a fill card may not be sufficient; you may need to provide another source of illumination to achieve a good fill-in balance. Sometimes, if you flick on a few room lights, you can raise the ambient light level. Other times, you may have to use auxiliary bounce flash.

If using the room lights for fill, be sure they do not overpower the window light. Otherwise, you will encounter a strange lighting pattern with an unnatural, dou-

ble key-light effect. When using daylight-balanced color film or a daylight white-balance setting, you will get a warm glow from the tungsten fill lights when using them for fill-in light. This is not objectionable as long as the light is diffused and not too intense. Measure the intensity of the fill light by taking a light reading from the shadow side of the face, and then another from the highlight side. There should be at least ½ to 1 full stop difference between the highlight and shadow sides of the face. (*Note:* It is also a good idea to have a room light in the background behind the subject. This opens up an otherwise dark background and provides better depth in the portrait. If possible, position the light out of view of the camera. Otherwise, it can be distracting.)

If none of the above methods of fill-in is available to you, use bounce flash. You can bounce the light from a portable electronic flash into an umbrella or off a white card, the ceiling, or a nearby wall—but be sure that it is ½ to 1 full stop less intense than the daylight. It is important when using flash for fill-in to either carry a flashmeter for determining the intensity of the flash, or use an automated TTL flash system, which can accurately incorporate the daylight, flash, and other light sources into a proper exposure.

Diffusing Window Light. If you find a nice location for a portrait but the light coming through the window is direct sunlight, you can diffuse the window light with an acetate diffusing flat. These flats are sold commercially in sizes up to eight feet long, but you can also make your own by attaching diffusion material (like frosted shower-curtain material) to a lightweight frame or fixing the material in place inside the window frame using gaffer's tape.

LEFT—Modern TTL-metered flash is the best way to set the ratio between existing light and bounce flash. Here, Dennis Orchard captured window light, incandescent room light, and bounce flash in a single exposure. The bounce flash was fired simply to open up the shadow side of the girl's face and it is quite minimal. RIGHT—Jennifer George created this wonderful portrait, called *Cousins,* using window light only. The subjects were positioned precisely so that the girl on the right would not block the light falling on the girl on the left. Jennifer used minimal fill to keep the lighting ratio strong and to add a bit of mystery to the background elements. She photographed the image with a FujiFilm FinePix S2 and wide-angle zoom at ISO 400. The handheld exposure was 1/45 second at f/3.5.

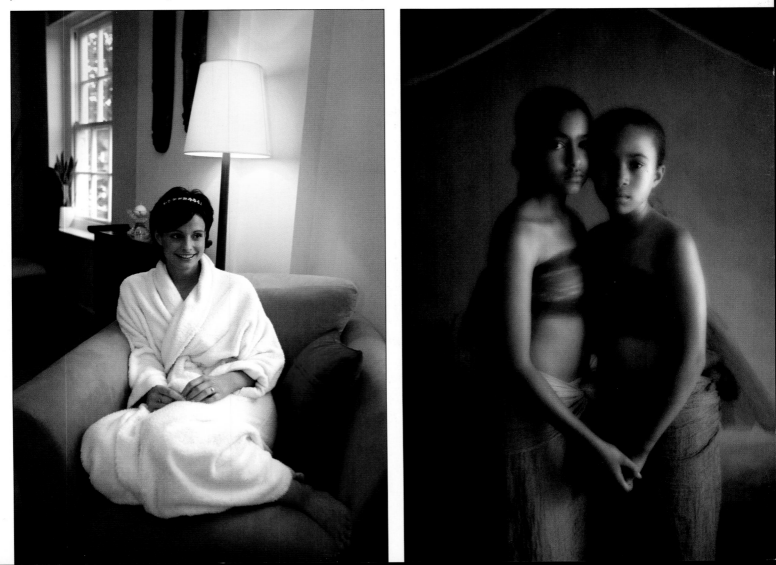

BOUNCE FLASH AND COLORED WALLS

You should never bounce flash off colored walls. The light reflected back onto your subject will be the same color as the walls. Even if you use a white card to bounce the flash into, you may get some tinted light in the shadow areas of the face. Although you may be able to correct some of the tint with white balance, you will still get a noticeable color shift.

Position the diffuser at a height that softens the light falling on your subject. Remember that the larger the diffuser you use, the softer the light will be on your portrait subject.

You can also use the scrim to diffuse direct sunlight coming through a window for a golden, elegant window light. Light diffused in this manner has the warm feeling of sunlight but without the harsh shadows. In fact, the light is so scattered that it is often difficult to see a defined lighting pattern. As a result, you will often find that you don't need a fill-in source at all. Even without fill, it is not unusual to have a low lighting ratio in the 2:1 to 3:1 range.

ONE-LIGHT PORTRAITS

If you want to improve your portrait lighting techniques drastically in a relatively short time, learn to use one light to do the job of many. One light can effectively model the features of a single subject, or even a group of up to three people, with relative ease. Whether you own strobe, portable or studio flash equipment, or tungsten or quartz lighting equipment, you will get your money's worth from it by learning to use one light well. You will also better understand lighting, and learn to "see" good lighting by mastering a single light.

Portable Flash. Portable flash is the most difficult of one-light applications. Portable flash units do not have modeling lights, so it is impossible to see the lighting effect before you take the picture. However, there are certain ways to use a portable flash in a predictable way to get excellent portrait lighting.

Bounce Flash. Bounce flash is an ideal type of portrait light. It is soft and directional. By bouncing the flash off a side wall or white card aimed at the subject, you can achieve an elegant type of wraparound lighting that illuminates the subject's face beautifully.

With the window light blocked by the opaque screens, the only way to bring light to the scene was via bounce flash, which Kersti Malvre used expertly.

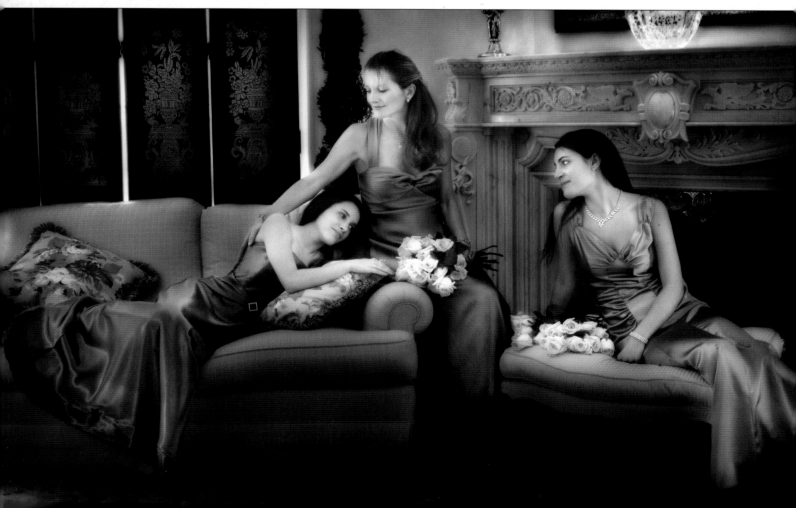

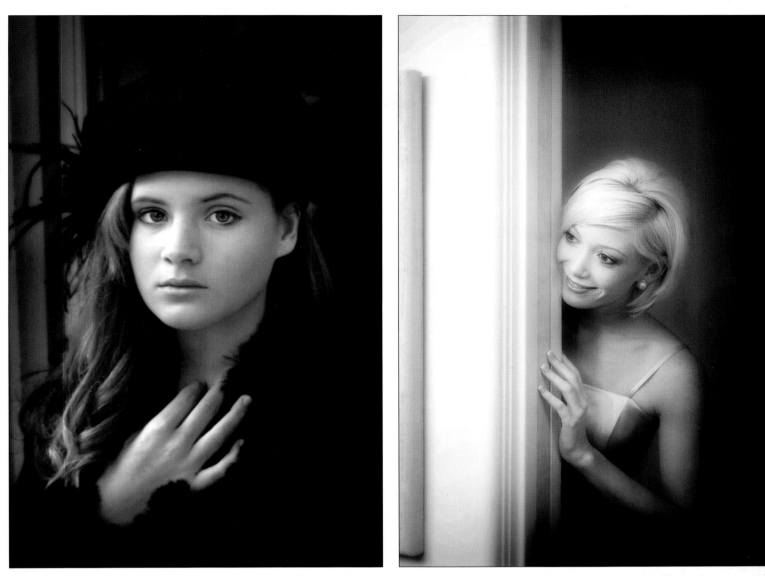

LEFT—Kersti Malvre photographed Dani very close to a window, which she later burned in to minimize its presence in the image. She used a small reflector on the shadow side of the face to kick a little light back into the shadow side of the face. The light was dim and overcast outside, making the volume of light very low—$\frac{1}{45}$ second at f/5.6 with the subject positioned right next to the window. RIGHT—Joe Photo created this lovely bounce-flash portrait using TTL balanced fill flash with his Nikon D1X. Joe often uses bounce flash in his weddings, but keeps it dialed down so that it helps augment the existing light rather than becoming the main light.

You must gauge angles when using bounce flash. Aim the flash unit at a point on the wall that will produce the widest beam of light reflecting back onto your subject. If the only available wall is very far from the subject, it might be better to bounce the light off a large white card onto the subject. This is an effect similar to umbrella lighting. The card should be between one and three feet away from the flash unit for best results. It can be held in place by an assistant or affixed to a light stand using gaffer's tape.

Bounce Flash Devices. There are a number of devices on the market that make using flash fill a little easier. One such device is the Lumiquest ProMax system, which allows 80 percent of the flash's illumination to bounce off the ceiling while 20 percent is redirected forward as fill light. This solves the overhead problem of bounce flash. The system also includes interchangeable white, gold, and silver inserts as well as a removable frosted diffusion screen.

This same company also offers the Pocket Bouncer, which enlarges and redirects light at a 90-degree angle from the flash to soften the quality of light and distribute it over a wider area.

While no exposure compensation is necessary with TTL flash exposure systems, operating distances are somewhat reduced. Light loss is approximately 1⅓ stops; with the ProMax system, however, using the gold or silver inserts will lower the light loss to approximately ⅔ stop.

Bounce Flash Exposure. The best way to determine exposure is to fire a bounce test and review it on the camera's LCD. If the scene requires more flash at the exposure settings you've established, add flash output in ⅓-stop increments or adjust exposure settings.

Some portable automatic flash units allow the flash head to swivel in any direction, while the flash sensor remains pointed at the subject. With these units, set the flash to an aperture recommended for bounce flash and consult the distance scale on the flash calculator dial to make sure that there will be enough light for a bounce-flash exposure.

Some flash units have a test button that allows you to fire the flash in the bounce mode. If a light comes on (it is usually green for "go"), then you have enough light for the exposure.

TTL Flash Exposure. TTL flash systems, particularly those made by Nikon and Canon, produce amazingly accurate exposures in bounce-flash mode. Further, the bounce-flash output can be set to correlate to the available light-meter reading in fractions of f-stops, meaning that you can set your flash to fire at ⅓ stop less intensity than the daylight reading, for perfect, unnoticeable fill flash. Conversely, you can set your bounce exposure to fire at one stop over your daylight reading to overpower problematic room light. The versatility of these systems is remarkable and both manufacturers' systems have been refined over many years, making them virtually foolproof and fully controllable.

On-Camera Flash. On-camera flash should be avoided altogether for making portraits, except as a fill-in source. The light from these units is too harsh and flat; it produces no roundness or contouring of the subject's face. However, when you diffuse on-camera flash, you get a softer frontal lighting similar to fashion lighting. While diffused flash is still a flat lighting and frontal in nature, the softness of it produces much better contouring than direct flash. There are various devices that can be used to diffuse on-camera flash. Most can even be used with your flash in auto or TTL mode, making exposure calculation effortless.

FASHION LIGHTING

If you study the photos in fashion and glamour magazines, you will notice that the lighting is almost always frontal in nature and very close to the lens/subject axis. (You can determine the position of the lights by looking at the catchlights in the model's eyes. If the catchlights are close to the pupil, then the light(s) are close to the lens—either slightly above the lens or just to the side of it.) Fashion photographers overcome the lack of roundness and modeling that this type of lighting gives by using makeup to contour the face. Cheekbones are shaded, as is either side of the nose, to give a better sense of roundness and dimension in the face.

All of the classic studio-portrait lighting patterns presented in chapter 5 can also be observed in nature. Sunlight is infinitely variable. You can observe this by studying an object over a period of time. In addition to the changing angle of the sun, the light reflected from nearby objects is always changing, making the light even more variable. The great diversity, then, of outdoor lighting makes for an ideal situation in which to learn about portrait lighting.

Unlike the studio, where you can set the lights to obtain any effect you want, in nature you must take what you find. By far the best place to make outdoor portraits is in the shade, away from direct sunlight. There are ways to utilize direct sun in portraits, as will be shown elsewhere, but first one needs to learn to see lighting in the shade.

SHADE

Shade is nothing more than diffused sunlight. Contrary to popular belief, shade is not directionless. It has a very definite direction.

The best shade for any photographic subject, but primarily for people, is found in or near a clearing in the woods. Where the trees provide an overhang above the subjects, the light is blocked. From the clearing, diffused light filters in from the sides, producing better modeling on the face than in open shade. (Open shade is overhead in nature and most unflattering. Like noontime sun, it leaves deep shadows in the eye sockets and under the nose and chin of the subjects. If you are forced to shoot in open shade, you must fill-in the daylight with a frontal flash or reflector.)

Robert and Suzanne Love primarily use natural light, so finding the right light and being able to see it is an absolute must for their kind of outdoor photography. Here, the family was placed in shade, but in order to raise the light level of the shade to match that of the background, a Lumedyne flash head in a 24-inch square softbox was placed behind the camera to create even lighting from side to side.

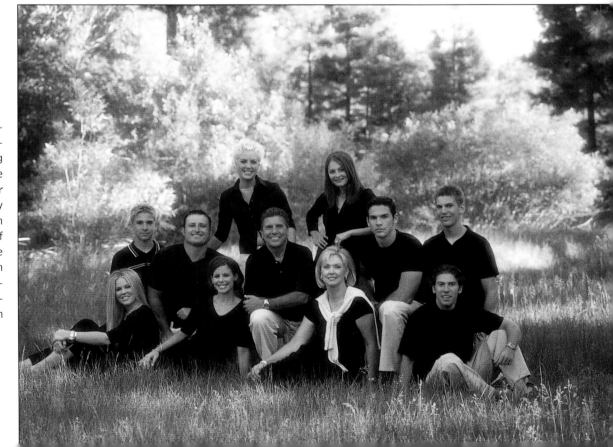

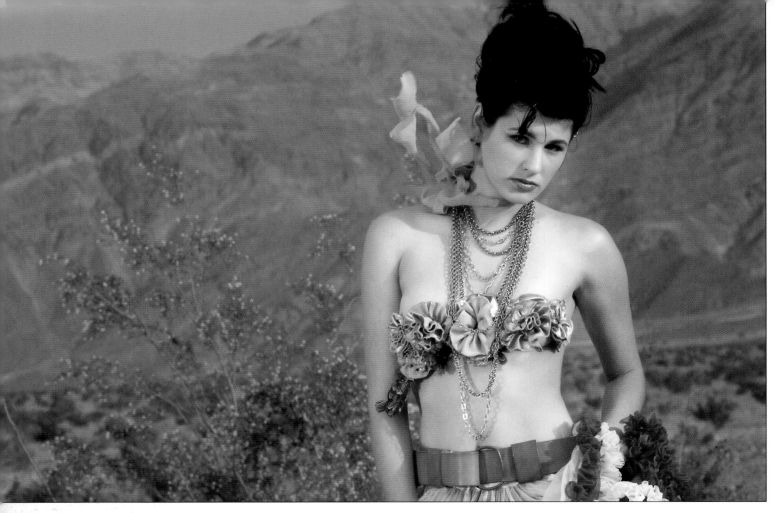

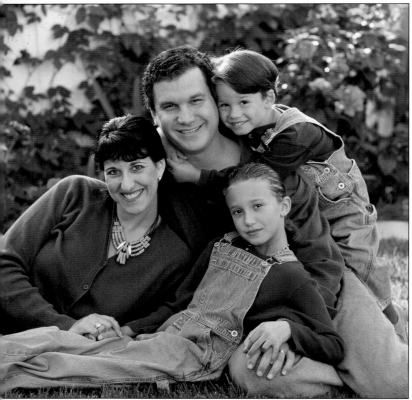

ABOVE—Cherie Steinberg Coté used backlight and a frontal reflector at camera left to produce an elegant fashion portrait. The reflector gives life to the shadows and complements the backlight. LEFT—This beautiful golden outdoor portrait was made with available light and a gold foil reflector aimed in close to the family's faces. The use of the reflector does two positive things. First, it evens out the uneven shade lighting. Second, it adds a warm tone to the shaded light, which is often green or blue because of light reflected from surrounding foliage or sky. Photograph by Heidi Mauracher.

Another popular misconception about shade is that it is always a soft light. Particularly on overcast days (and near midday), shade can be harsh, producing bright highlights and deep shadows. Move under an overhang, such as a tree with low-hanging branches or a covered porch, and you will immediately notice that the light is less harsh and that it also has good direction. The quality of light will also be less overhead in nature—coming from the side that is not obscured by the overhang.

FILL-IN LIGHT

You are at the mercy of nature when you are looking for a lighting location. Sometimes it is difficult to find the

good light, and this can make it necessary to use fill-in light—either by bouncing natural light into the scene or by using a supplementary artificial light source.

Reflected Fill Light. When working outdoors, it is a good idea to carry along a portable reflector. The size of this reflector should be fairly large; the larger it is, the more effective it will be. Portable light discs, reflectors made of fabric mounted on a flexible and collapsible circular frame, come in a variety of diameters and are a very effective means of fill-in illumination. They are available from a number of manufacturers and come in silver (for maximum fill output), white, gold foil (for a warming fill light), and black (for subtractive effects; more about this in a bit).

When the shadows produced by diffused light are harsh and deep, you will not get a flattering rendition of your subject. There will also be limited shadow detail. Using a reflector, you can fill in those shadows to produce a less severe lighting pattern. With a silver reflector used close to the subject, you can even overpower the overhead nature of the lighting, creating a more pleasing and flattering lighting direction.

Many times, nature provides its own fill-in light. Patches of sand, light-colored shrubbery, or a nearby building may supply all the fill-in you'll need. But be careful that fill light directed upward from the ground onto your subject does not overpower the key light. Lighting coming from under the eye–nose axis is generally unflattering and often called "ghoul light" for obvious reasons.

The fill-in reflector should be used close to the subject; just out of view of the camera lens. You may need to adjust it several times to fine-tune the effect and create the right

amount of fill-in. Always observe lighting effects from the camera position.

Flash Fill Light. Sometimes you will need more fill light than any portable reflector can provide. This is when electronic flash fill-in is called for. With flash, you can use either an on-camera unit, which fills in the lighting on the subject–lens axis, or an auxiliary electronic flash, complete with its own reflector and/or diffusion setup. Either way, you must be certain the flash doesn't overpower the ambient-light exposure or you will darken the background too much. Many on-camera TTL flash systems use a mode for TTL fill-in flash that will balance the flash output to the ambient-light exposure for balanced fill-flash. Many such systems are also controllable by virtue of flash-output compensation that allows you to dial in full- or fractional-

Chris Nelson's advice: "Guys dislike a posed look, so do something natural." Two lighting techniques are at work here. First, Chris moved his subject to an area that had overhead trees. The direct light was blocked from overhead, but diffused light filtered in from camera left. Second, he used a barebulb flash to provide adequate fill-in, even though it was set to output at a stop less than the existing light level.

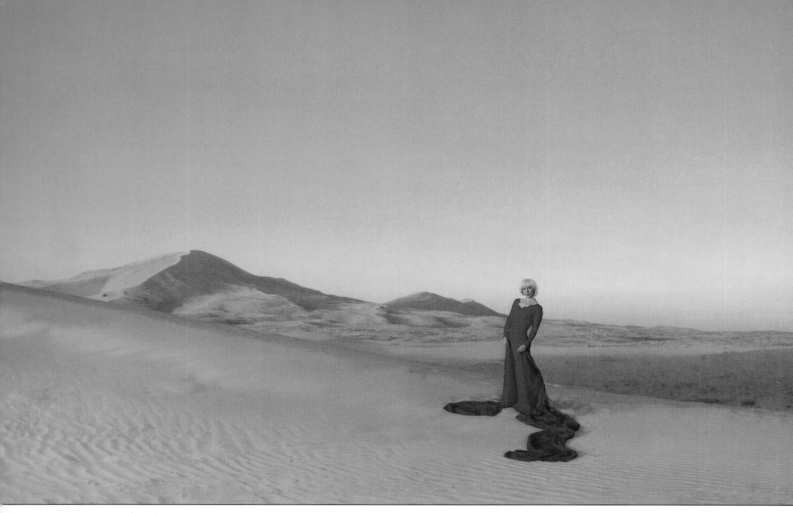

ABOVE—This is another great portrait made by available light only. Here, Heidi Mauracher used a low-angle, skimming light for a very flattering effect. The golden sand dunes provided a natural fill in. The rest is just great composition. Heidi created this image on a Hasselblad camera with a MegaVision digital back.
LEFT—Monte Zucker used a full 6x3-foot scrim, held above and behind his subjects, to repurpose the back-lighting. He also used a white frontal reflector to kick light back into the scene, filling the shadows.

stop output changes for the desired ratio of ambient-to-fill illumination.

SUBTRACTIVE LIGHTING

There are occasions when the light is so diffuse that it provides no modeling of the facial features. In other words, there is no dimension or direction to the light source. In these cases, you would use a black fill card or disc close to the subject. A black reflector literally reflects black onto the subject, effectively

subtracting light from one side of the face and creating a ratio between the highlight and shadow sides. This difference in illumination will show depth and roundness better than the flat overall light.

ELIMINATING OVERHEAD LIGHT

If you find a nice location for your portrait but the light is too overhead in nature (creating dark eye sockets and unpleasant shadows under the nose and chin), you can use a card directly over the subject's head to block the overhead illumination. The light that strikes the subject from either side will then become the dominant light source. There are two drawbacks to using an overhead card. First, you will need to have an assistant, or a C stand, to hold the card in place over the subject. Second, using the overhead card lowers the overall light level, meaning that you may have to shoot at a slower shutter speed or wider lens aperture than anticipated.

Here are two portraits with opposite problems. In the portrait of the banker and his vault, taken by Chris LaLonde, the vault door needed to be tack sharp. So Chris helped the situation by bringing him back as far as he could so that an intermediate f-stop like f/6.7 would do the job. He also lit the vault door with two Nikon SB-800 strobes, while lighting the banker with an umbrella from a close distannce (see diagram). In the portrait of the young girl in the abandoned building, Jeff Woods used a wide open aperture of f/2.8 combined with judicious placement of his subject in relation to the far wall to get just the right amount of softness from the background. The lighting is from a Wescott Spider Light, a continuous daylight-balanced light source, using both tungsten and/or fluorescent tubes. It is a 24x30-inch portable softbox that simply plugs into the wall. Jeff used a reflector off to the side as well as a handheld video light to illuminate the background.

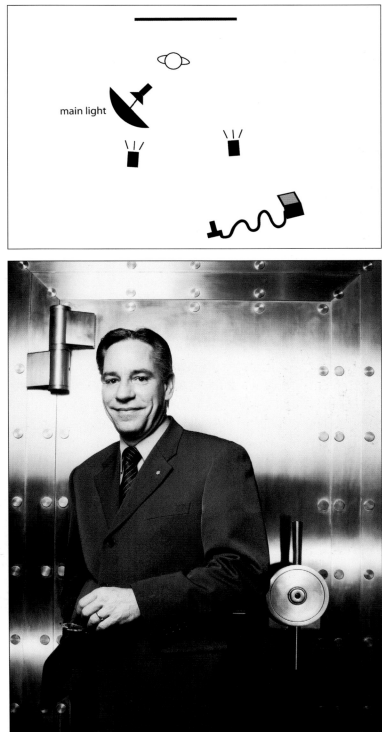

main light

Sometimes, great light from direct sunlight is literally right around the corner. Patti Andre does wonderful kids albums, and most of them are photographed on location in the middle of the day. Here, a patch of sunlit ground is creating beautiful diffused but directional light on this little girl. Patti had to position her subject near a fence that is blocking the direct sunlight.

SCRIMS

If you find an ideal location, but the light filtering through trees is a mixture of direct and diffused light (*i.e.*, spotty light), you can use a scrim held between the subject and the light source to provide directional diffused lighting.

Scrims, sometimes called diffusion flats, are available commercially from a number of manufacturers and come in sizes up to 6x8 feet. These devices are made of translucent material on a semi-rigid frame, so they need to be held by an assistant (or assistants) to be used effectively. Scrims are great when you want to photograph your subject in direct sunlight. Simply position the scrim between the light source and the subject to soften and change the available lighting. The closer the scrim is to the subject, the softer the light will be on the subject.

The scrim will lower the light on the subject, so meter the scene with it held in place. Since the light will be lower

on your subject than the background and the rest of the scene, the background may be somewhat overexposed—but this is not necessarily an unflattering effect. To avoid the background completely washing out, choose a dark- to mid-colored background so the effect will not be as noticeable. This type of diffusion works best with head-and-shoulders portraits, since the size of the diffuser can be much smaller and held much closer to the subject.

Another use for this type of scrim is in combination with a reflector. With backlit subjects, the scrim can be held above and behind the subjects and a simple reflector used as fill-in for dramatically soft outdoor lighting.

BACKGROUND CONTROL

The best type of background for a portrait made in the shade is one that is monochromatic. If the background is all the same color, the subject will stand out from it.

Problems arise when there are patches of sunlight in the background. These can be minimized by shooting at wide apertures, using the shallow depth of field to blur the background. You can also use some type of diffusion in Photoshop accomplish the same effect.

If your background is cluttered or has a bald sky, the best way to handle it is in Photoshop. Whether the image was recorded digitally, or on film and scanned later, you can use Photoshop to create transparent vignettes of any color to de-emphasize the background. You can also selectively diffuse the background without sacrificing the critical focus on the subject. Simply duplicate the background layer, which contains the original image, and apply the desired diffusion to the duplicate layer. Then, use the Eraser tool on the duplicate layer to allow the sharp details on the original underlying layer to show through only where you want them to. Alternately, you can adjust the opacity of the new layer.

DIRECT SUNLIGHT

While shade is the preferable outdoor light for making portraits, successful images can also be created in direct sunlight. The two main problems with direct sunlight are the harshness (contrast) of the light and the subject's expression as a result of this harshness. If the person is looking toward a bright area, he or she will naturally squint—a very unnatural expression at best.

Skimming the Light. To control the harshness of the light, position your subject so that the light skims the face rather than striking it head-on. This will bring out the roundness in the face, reducing the pasty, blocked-up skin tones often associated with portraits made in direct sun.

Cross Lighting. When the sun is low in the sky, you can achieve good cross lighting. This occurs when light is coming from the side of the subject, so almost half of the face is in shadow while the other half is highlighted. In the studio, this is known as split lighting. In this situation, it is an easy matter to position a fill card close to the subject to reduce the ratio between the highlight and shadow sides of the face. The additional benefit of working with

In backlit portraits, it is crucial to avoid underexposure. Here, the elegant pose is matched only by the elegant control of the backlighting, which produced open shadows and beautiful highlights along the contour of the subject's body. Notice, too, the elegant line of the subject's pose. Photograph by Tony Corbell.

LENS FLARE

Be wary of lens flare in backlit situations. Use a lens shade or angle the camera so it does not receive any direct rays of light on the lens. Lens flare degrades the image's sharpness and contrast. This may not always be obvious at the lens's maximum aperture, so stop down and preview the shot to double-check.

the sun at a low angle is that the subject will not squint, particularly if looking away from the sun. You must be careful to position the subject's head so that the lighting does not hollow out the eye socket on the highlight side of the face. Subtle repositioning will usually correct this.

Backlighting. Backlighting is another very good type of direct-sun lighting. The subject is backlit when the sun is behind the person, illuminating their hair and the line of their neck and shoulders.

With backlighting, it is essential to use good fill-in light. When using a reflector, place it as close as possible to the subject without being in view of the camera lens. The reflector is normally positioned between the subject and the camera (beneath the lens) and angled upward into the subject's face.

Don't trust your in-camera meter in backlit situations. It will read the bright background and highlights on the hair instead of the exposure on the face. If you expose for the background light intensity, you will silhouette the subject. If you have no other meter than the in-camera one, move in close and take a reading on the subject's face, being careful not to block the light from the reflector.

It is important to check the background while composing a portrait in direct sunlight. Since there is considerably more light than in a portrait made in the shade, the tendency is to use an average shutter speed like 1/250 second with a smaller-than-usual aperture like f/11. Smaller apertures will sharpen up the background and distract from your subject. Preview the depth of field to analyze the background. Use a faster shutter speed and wider lens aperture to minimize background effects.

It's always best, if using a DSLR, to fire a few test shots and evaluate the background and overall exposure at various settings. Use the magnifier and highlight clipping function, which most DSLRs employ in the LCD playback routines, to check for blown-out highlights and too-sharp backgrounds.

USING FLASH OUTDOORS

There are two ways to use electronic flash outdoors: you can use flash fill, which means the ambient light is your main light and the flash simply fills in the shadows; or you

can use flash key, in which the flash overpowers the ambient light to become the main light.

Flash Fill. Although most electronic flash systems use TTL circuitry to measure exposure and control flash output, you may be using a manual flash unit that is non-TTL. To create flash-fill, take a reading of the ambient light, then set the flash output at or below that reading. For instance, if the daylight reading is 1/125 second at f/11, setting the flash output to f/11 would provide adequate but not overpowering flash-fill. Setting the flash output to f/8 would make the flash-fill less noticeable. Of course, intermediate settings are possible for fine-tuning your results.

Many on-camera TTL flash systems include a mode for TTL fill-in flash that will balance the flash output to the ambient-light exposure. These systems are variable, allowing you to dial in full- or fractional-stop output adjustments for the desired ambient-to-fill ratio. They are marvelous systems and, more importantly, they are reliable and predictable. Most of these systems also allow you to remove the flash from the camera with a TTL remote cord.

If you are using a studio-type strobe, like a monolight or barebulb flash, for which the power output is rated in Watt-seconds, you must rely on a different means of varying flash output. With an incident flash meter, take a reading of the daylight exposure in "ambient" mode. Next, in "flash-only" mode, take a reading of just the flash, positioned where you'd like it for the exposure. The flash will either be on a light stand or held by an assistant. The flash output can be regulated by adjusting the flash unit's power settings, which are usually fractional—1/2, 1/4, 1/8, and so forth, or the flash unit's distance from the subject. If the meter reading for the daylight exposure is 1/125 second at f/8, set your flash output so that the flash exposure is f/5.6–8 to create good flash-fill illumination.

Flash Key. To use your flash as a key light that overrides the daylight, adjust the flash so that it produces an

Here is a situation where the subject was out in the middle of overhead shade with no blockers like shade trees or a building. The light was overhead and bordering on being partial sunlight, so it was harsh. The challenge was to wipe out the overhead hazy sunlight. Chris Nelson did this by firing a barebulb flash at the same output as the daylight, thus eliminating the overhead shadows and lighting pattern. The flash was close to the camera, just a little to the left.

TOP—In this charming backlit portrait by Patti Andre, the softness of the background is a function of slight overexposure and a wide taking aperture. BOTTOM—Would you believe this elegant lighting is all natural? It is—and that's how Fuzzy Duenkel likes to work. Soft backlight was enhanced by the use of a silvered reflector, making the light more directional and crisp. The reflector was close and beneath the subject's face to provide a beautiful lighting pattern. A wide aperture and the application of Gaussian blur in Photoshop created a mask of sharpness that accentuates this girl's features.

exposure greater than the ambient-light exposure. In the example used above, you would want a flash output setting of f/11 or f/16. This may entail bringing the flash in close to the subject. With automatic-flash, adjust the f-stop control so that the flash output will equal f/11 or f/16. It is unwise to override the ambient light exposure by more than two f-stops. This will cause a spotlight effect that darkens the background and makes the portrait appear as if it were shot at night. Modern TTL-flash metering, again, makes this type of calculation effortless.

When using the flash-key technique, it is best if the flash can be removed from the camera and positioned above and to one side of the subject. This will more closely imitate nature's light, which always comes from above and never head-on. Moving the flash to the side will improve the modeling of the light and show more roundness in the face. Sometimes a secondary reflector is called for.

ADDITIONAL TIPS FOR OUTDOOR LIGHTING

Create Separation. One thing you must beware of outdoors is subject separation from the background. A dark-haired subject against a dark background will not tonally separate, creating a tonal merger. You must find a way to reflect light onto the hair so that it remains distinct from the background. Sometimes a reflector placed in close to the subject's face will do the job.

Use Care in Subject Positioning. Natural-looking subject positioning is often a problem when working outdoors. If available, a fence makes a good support for the subject. If you have to pose the subject on the ground, be sure it is not wet or dirty. Bring along a small blanket that can be folded and hidden under the subject. It will ease the discomfort of a long shooting session and also keep the subject clean.

Employ a Tripod. If you are not using flash, you should use a tripod when shooting outdoor portraits. Shutter speeds will generally be on the slow side, especially

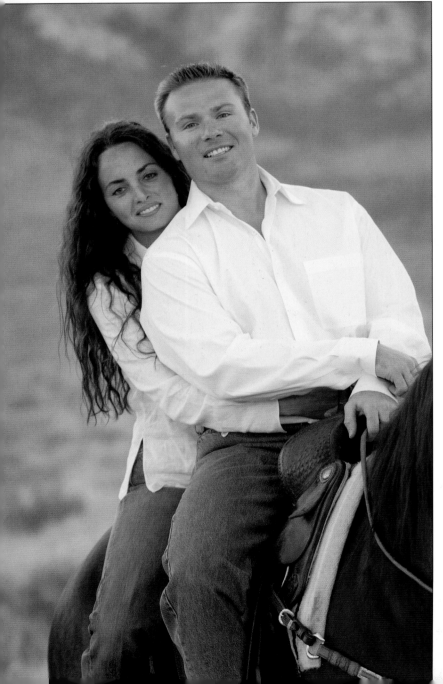

when you are shooting in shade, so eliminating camera movement is important. Using a tripod will also help you compose your portrait more carefully, giving you the freedom to walk around the scene and adjust things as well as to converse freely with your subject. Additionally, a tripod comes in handy for positioning a reflector; the large ones often come with loops that can be attached to the legs or knobs of the tripod when you are working without an assistant.

Watch the Color in the Shadows. Another problem you may encounter is excess cool coloration in portraits taken in shade. If your subject is standing in a grove of trees surrounded by green foliage, there is a good chance that green will be reflected into the subject's face. If the subject is exposed to clear, blue, open sky, there may be an excess of cyan in the skin tones.

Color cast is one of the things you should look for when making test shots of your subject—and you will have to *consciously* look for it, as your eyes will naturally accommodate most color shifts. Whereas one had to employ CC (color-correction) filters to fix the color shift when shooting film, with digital capture, the color bias can be corrected by shooting in RAW mode and adjusting the white balance in the RAW file processor. Additionally, unlike film, just the shadows can be color corrected digitally. In RAW processors, such as Adobe Camera Raw, you can change the tint of the shadows without correcting the tint of the highlights. So if you have tinted shadows and neutral highlights, just the shadow areas can be adjusted.

8. SPONTANEOUS PORTRAITS

Some of the finest portraits are those made without the subject being aware of the camera. This style of portraiture is based on the images made popular by contemporary wedding photojournalists. The objective is to let the scene tell the story, recording a delicate slice of life that captures the greater meaning of the events shown in the lives of those pictured.

The most important aspect of shooting spontaneous portraits is working unobserved, which can be next to impossible when the subject is seated in front of lights in one of the most artificial of settings—the portrait studio. However, while the studio portrait photographer cannot work unobserved like the wedding photojournalist, he or she can be observant and quick to react. Many fine portrait artists rely on their ability to observe and appraise the subject's features and personality while looking for those moments that reveal the essence of the person.

OBSERVING THE SUBJECT

Tim Kelly is one of America's finest portrait photographers. He suggests, "As you turn your attention to load film, you may glimpse your subject in a totally self-disclosing moment of self-revelation." This illusive expression became known around Kelly's studio as "the thirteenth frame"—the one that basi-

cally got away. He now pays special attention to the moments during and after film changes or breaks in the shooting. The image of the debutante relaxing (below) was one such "candid" moment. He advises, "Watch your subjects before you capture the image. Sometimes the things they do naturally become great artistic poses." Tim Kelly doesn't direct the subject into a pose. Rather, he suggests that you get the subject "into the zone" of the pose by coaching their position, but let them go from there. This allows him to capture a more natural feeling. Kelly does not warn his clients when he is ready to start a portrait session. "I don't believe in faking the spontaneity of the subject's expression," Kelly says.

Master photographer Tim Kelly has learned to pay attention during those lulls in the posing, such as when changing film backs. Here, in an image entitled *The Debutante*, Kelly captured the perfect blend of elegance and indifference as the girl relaxed during a break in the shooting.

ABOVE—Dennis Orchard is not above "restaging" a shot to get a good one. Here, this mom had just given her two boys a fierce hug and Orchard missed it. He grabbed a chair to get above the crowd, and said "How about another hug?" She complied, grabbed the boys and Orchard recreated the moment. LEFT—Marcus Bell captured not only the natural beauty of this bride, but her personality as well. In this high-key study of whites and off-whites, offset by her almost black eyes, the photographer has created a compelling portrait that forces you to analyze her eyes, which reveal a quiet confidence and intelligence. This image was made by available light only.

While the pure photojournalist does not intrude on the scene, it is sometimes necessary to inject a bit of "direction" into the scene. I am reminded of a story related by Dennis Orchard, a well-known British wedding photographer. He observed a mother embracing her two sons at a wedding and it was a priceless moment. By the time he got up on a chair the shot had disappeared. He called over to the mom and said, "How about another hug?" Since the emotion was still fresh, she complied and Orchard got an award-winning shot.

Wedding and portrait photographer Marcus Bell is never in a rush to take his portraits. He leaves nothing to

chance, but also lets his subjects define their own poses. He says, "I want to capture the individuality and personality of the person. The posing needs to be natural to the person you're photographing and to emulate the person's personality or features, rather than detracting from them. I use several techniques to ensure the posing relates to the subject, but to do this you first need to do your groundwork and include your subject in your preparations."

Bell uses a number of techniques to begin the interaction, like having a coffee or walking to the shooting location. This provides ample opportunity to get the relationship established. "Where possible," he says, "I want to minimize the direction that I'm giving them and to allow them to be themselves. Because of the relationship and trust that we have started, though, I can give them directions in a way that seems more like normal conversa-

tion than me telling them what to do. They also start feeling more involved in the whole process."

Marcus Bell uses the large LCD screen of his digital camera as a social and posing tool, showing his clients between shots what's going on and offering friendly ways to improve on the pose. He will often take an image of the scene and show them the shot even before he has included them in the scene. According to Marcus, "This builds rapport, trust, and unity as you have their cooperation and enthusiasm."

RIGHT—What stands out in this portrait is the joy exhibited by all three girls. Photographer Fernando Basurto brought this wonderful group expression out by gentle conversation and personality. BELOW—Fernando Basurto, an expert wedding photographer, prefers to set the scene, as a good film director would, and turn his "actors" loose with an idea of what he is trying to capture. Such is the case here, in an emotion-filled engagement portrait. Basurto had the couple close their eyes, letting their emotions move to the forefront for a memorable portrait.

Parker Pfister is a gifted wedding photographer. Here he uses diffused sunlight bounced up onto the bride's face from below—normally not an attractive lighting. He chose to photograph her beautiful eyes in a dreamy pose that reveals the beauty of her eye makeup and sensuous lips. The image was made with a Nikon D1X and 80–200mm zoom lens set at the 150mm setting.

Award-winning photographer Jerry Ghionis does not pose his clients, he "prompts" them. "I prompt them into situations that appear natural," he says. He first chooses the lighting, selects the background and foreground, and then directs his clients into a "rough" pose—a romantic hug, a casual walk, the bride adjusting her veil, and so forth. The spontaneous moments he gets are directed and seem to evolve during the shoot, depending on what suits the different personalities he is working with.

A technique Jerry relies on is the "wouldn't it be great" principle. For example, if he thinks to himself, "Wouldn't it be great if the bride cracked up laughing, with her eyes closed and the groom leaning toward her?" Then he will ask for the pose. Some would argue that the shot has been manufactured. Jerry, however, thinks it's no more manufactured than a scene in a movie. "Who cares how you got there—the end justifies the means. You first

have to previsualize the shot you want before you can direct it."

The net result of the techniques described by these photographers—Kelly, Orchard, Bell and Ghionis—is the release and capture of spontaneous expressions.

SHOOTING TECHNIQUES

In spontaneous portraiture, the aesthetic aspects of lighting, composition, and posing should not be discarded in favor of merely recording a special scene with enough exposure so the participants and situations are recognizable.

Composition. You are depending on the action to give you the impact of the photograph. Therefore, you should compose the scene loosely so that it may be cropped later for better composition. Leave plenty of space around the subject(s) and concentrate on the scene and the action itself.

Shutter Speed. At slow shutter speeds, steady camera handling is all-important. To help steady the camera, keep your elbows in close to your body when the camera is held up to your eye. Position the thumb of your right hand on the camera base-plate so that it acts as a counter-support for your index finger, which depresses the shutter button. Practice this method of shooting and it will extend your potential handheld-shooting range down to $\frac{1}{8}$ or $\frac{1}{15}$ second.

Squeeze the shutter button rather than pressing down firmly. Try to use just the tip of your finger to press down to avoid camera shake.

If you are not confident working at $\frac{1}{60}$- or $\frac{1}{30}$-second shutter speeds, brace yourself against a doorjamb or wall for better support. You can also position the camera on a chair or tabletop to steady it. Monopods are also great supports that allow you to be mobile but give you the needed camera support to work in low and ultra-low light.

Don't Skimp. Whether you are working digitally or with film, shoot plenty of images. These moments are fleeting, you'll probably shoot quite a few not-so-great images for every really good one you get.

Master Your Camera Controls. The best journalistic photographers have their camera-handling technique down cold. Focusing, composition, and exposure should all be second nature. The better your skill level at quick and efficient camera handling, the better your portraits will be.

TOP—This image was made by photojournalist Scott Eklund, a staffer of the *Seattle Post-Intelligencer*. Eklund makes his living by his reflexes and when he encounters a scene such as this, he waits for the moment to define itself. With beautiful daylight filtering in, Scott focused on the groom and waited until a smile enveloped all three men. RIGHT—Here is a typical Jerry Ghionis portrait. It was inspired by a little direction and the actions of his subject, who completely buys into the process.

9. CORRECTIVE TECHNIQUES

The art of good portraiture is found in the photographer's ability to idealize a subject. This demands that the photographer know practical methods of correcting the subject's physical flaws and irregularities.

It's important to understand that people don't see themselves the way they actually appear. Subconsciously, they shorten their noses, imagine they have more hair than they really do, and in short, pretend they are better looking than they really are. A good portrait photographer knows this and acts on it the instant a subject arrives for a session. As a matter of procedure, the photographer analyzes the face and body and makes mental notes as to how best to light, pose, and compose the subject to produce a flattering likeness.

This chapter deals with practical ways to idealize the subject. Within reason, a list of the possible physical shortcomings of people has been given, along with a practical method to cure that particular ill. To the serious portrait photographer, this type of corrective photography is as important as lighting, posing, and composition basics.

FACIAL ANALYSIS

The expert portrait photographer should be able to analyze a subject's face with a brief examination, much like a doctor examines a patient for symptoms. Under flat lighting, examine the subject from straight on and gradually move to the right to examine one side of the face from an angle, and then repeat on the left side. You can do this while conversing with the person in an initial consultation and they will feel less self-conscious. Examine the face on both sides from full face to profile. In your analysis, you are looking for:

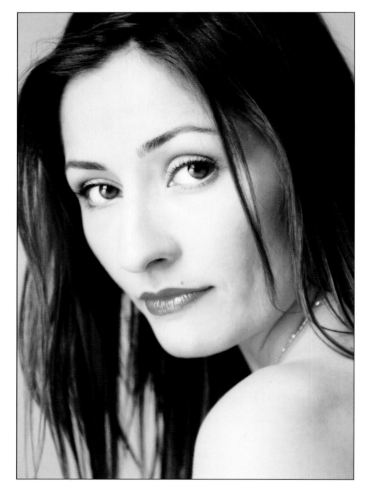

Expert portrait photographers go through a facial analysis of everyone they meet. They tell themselves how high the camera should be, what kind of lighting (short/broad, diffused/specular, etc.), facial angle, and pose. In this interesting portrait by Anthony Cava, the pose and angle of her face are perfect. The photographer has optimized his subject beautifully. The treatment, a kind of cross-processed digital effect, leaves the lips red and everything else in the yellow spectrum. The image was made with a Nikon D1X and short Nikkor zoom at the 70mm setting. The exposure was $^1/_{640}$ second at f/2.8.

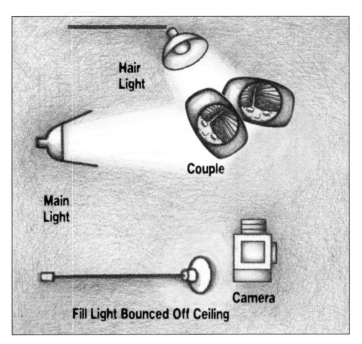

Hair Light

Couple

Main Light

Camera

Fill Light Bounced Off Ceiling

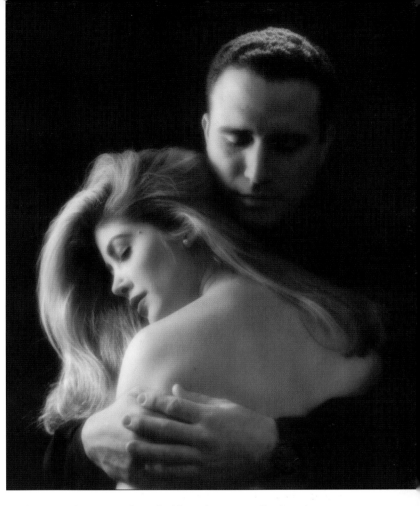

Soft focus is not only a "disguising" corrective technique, but provides a romantic mood. Robert Lino created this image using a Mamiya RB67 with Mamiya-Sekor SF (soft focus) 150mm lens. It was shot on Kodak VPS 160 film and exposed for $1/125$ second at f/11. The main light was a Speedotron Force 10 with a Beauty Light parabolic reflector. For fill, a Norman 808 was used. It was set at full power and bounced off the ceiling. The hair light was a Norman 808 at half power.

1. The most flattering angle from which to photograph the person. It will usually be at the seven-eighths or three-quarters facial view, as opposed to head-on or in profile.

2. A difference in eye size. Most people's eyes are not exactly the same size, but can be made to look the same by positioning the smaller eye closest to the lens so that perspective takes over and the larger eye looks normal because it is farther from the lens.

3. Changes in the face's shape and character as you move around and to the side of your subject. Watch the cheekbones become more or less prominent from different angles. High and/or pronounced cheekbones are a flattering feature in males or females. A square jaw line may be softened when viewed from one angle; a round face may appear more oval-shaped and flattering from a different angle; a slim face may seem wider and healthier when viewed from head on, and so forth.

4. The person's best expression. Through conversation, determine which expression best modifies the best angle—a smile, a half-smile, no smile, head up, head down, etc.

SOFT FOCUS AND DIFFUSION

Skin problems are the most frequent physical problem the portrait photographer encounters. Young subjects have generally poor skin—blemishes or pockmarks. Older subjects have wrinkles, age lines, and age spots. In subjects of all ages, the effects of aging, diet, and illness are mirrored in the face.

Soft focus or diffusion on the camera lens minimizes facial defects and can instantly take years off an elderly subject. Softer images are often more flattering than portraits in which every facial detail is visible. Soft-focus images have also come to connote a romantic mood.

There are four ways to diffuse an image for soft-focus effects. First, you can use a soft-focus lens, which is a lens designed to produce a sharp image point surrounded by an out-of-focus halo. These lenses produce this effect because they are uncorrected in some degree for spherical aberration. Soft-focus lenses do not produce an out-of-

SOFT FOCUS AND APERTURE

With both spherical-aberration soft-focus lenses and diffusion filters, the soft-focus effect is diminished by stopping down the lens. Therefore, the lens is used wide open, close to or at its maximum aperture for the softest image. Another type of soft-focus lens, which is not too popular today (and is more prevalent in the larger formats), uses controlled chromatic aberration, and is unaffected by stopping the lens down.

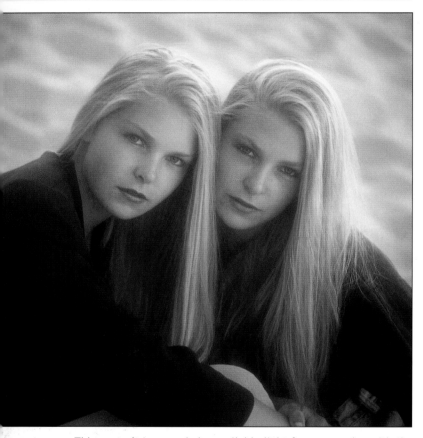

This portrait was made by available light from open sky, with the sun setting behind the girls. A gold reflector was placed in front of their faces to warm the fill light. Slight on-camera diffusion was used in combination with slight overexposure. This image was shot on a Bronica SQ-Ai camera with 150mm lens. The film used was Kodak Portra 400 VC. Photograph by Robert and Suzanne Love.

focus image; rather, they give a sharp image with an out-of-focus halation around it.

The second means of diffusing an image is with a soft-focus or diffusion filter. These blend the highlights of the image into the shadow areas by diffusing the light rays as they pass through the filter. Soft-focus or diffusion filters come in degrees of softness and are often sold in sets with varying degrees of diffusion.

The third method of image diffusion is to diffuse the negative (if shooting film) during the printing process. This has the opposite effect of on-camera diffusion, blending the shadows into the highlights. Unfortunately, this sometimes produces muddy prints with lifeless highlights, depending on the technique, time of diffusion, and material used.

Perhaps the best way to minimize facial flaws is in Photoshop using selective diffusion. This technique will be outlined in chapter 10. Selective diffusion allows you to keep crucial areas of the face sharp—the eyes, lips, nose, and eyebrows—while diffusing the problem areas of the face. The viewer is fooled by seeing important parts of the face in focus, making the technique foolproof.

Regardless of how you diffuse the image, you will want to be judicious about the amount of softness you give your subject. Men do not want to be photographed too softly, as it may appear effeminate to them. Women with lovely skin will not want to be photographed too softly either, as their good skin is a personal asset they want to show off. In these cases, you may want to use a more moderate amount of softness just to blend the skin a little. You can also select a smaller aperture, like f/5.6 or f/8. This will still give some softness—but considerably less than if the lens were used wide open.

CAMERA HEIGHT AND PERSPECTIVE

When photographing people with average features, there are a few general rules that govern camera height in relation to the subject. These rules will produce normal perspective with average people.

For average people being photographed in a head-and-shoulders view, the rule of thumb is that camera height should be the same height as the tip of the subject's nose. For three-quarter-length portraits, the camera should be at a height midway between the subject's waist and neck. In full-length portraits, the camera should be the same height as the subject's waist.

In each case, the camera is at a height that divides the subject in two equal halves in the viewfinder. This is so that the features above and below the lens/subject axis are the same distance from the lens, and thus recede equally for "normal" perspective. When the camera is raised or lowered, the perspective changes. By controlling perspective, you can alter the physical traits of your subject.

By raising the camera height in a three-quarter- or full-length portrait, you can enlarge the head-and-shoulder region of the subject, but slim the hips and legs. Conversely, if you lower the camera, you reduce the size of the head, and enlarge the size of the legs and thighs. Tilting the camera down when raising the camera, and up when lowering the camera increases these effects. The closer the camera is to the subject, the more pronounced the changes are. If you find that after you make an adjustment of camera height for a desired effect there is no change, move the camera in closer to the subject and observe the effect again.

When you raise or lower the camera in a head-and-shoulders portrait, the effects are even more dramatic. This is a prime means of correcting facial irregularities. Raising the camera height lengthens the nose, slims the chin and jaw lines, and broadens the forehead. Lowering camera height shortens the nose, de-emphasizes the forehead, and widens the jaw while accentuating the chin.

CORRECTING SPECIFIC PROBLEMS

This section deals with methods to correct specific physical traits you will encounter with everyday people. Be tactful about making any corrective suggestions.

Overweight Subjects. Have an overweight subject dress in dark clothing, which will make him or her appear ten to fifteen pounds slimmer. Use a pose that has the subject turned at a 45-degree angle to the camera. Never photograph a larger person head-on—unless you are trying to accentuate their size.

Use a low-key lighting pattern and use short lighting so that most of the subject is in shadow. The higher lighting ratio that produces low-key lighting will make your subject appear slimmer. Use a dark-colored background

This is an amazing portrait of a family with their newborn taken by Joseph and Louise Simone. A hair light, set to f/16, lit the baby, as well as the hair of the mother, the father, and the daughter next to mom. An umbrella fill at the camera position output soft fill light at f/8. The main light, a parabolic reflector with diffusion and barn doors, was positioned to the left of the family and set to output at f/16. The image was made with a Hasselblad and 120mm lens at an exposure of $^1/_{100}$ second at f/16.

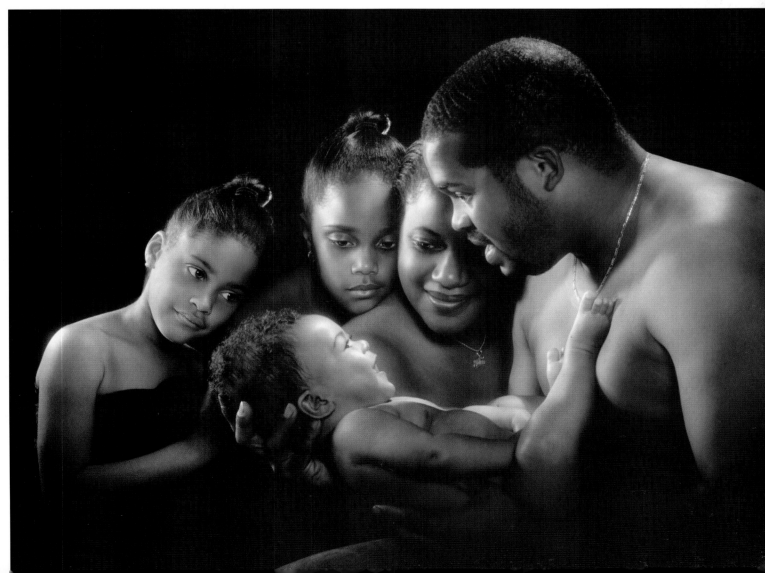

and if possible, merging the tone of the background with the subject's clothes. To do this, minimize or eliminate the background light and any kickers you might otherwise use to highlight the shadow-side edge of the subject.

Standing poses are more flattering. Seated, excess weight accumulates around the waistline. A dark vignette at the bottom of the portrait is another trick to minimize the appearance of extra weight.

If the overweight person has excess skin under their chin, keep the light off the neck, or use a gobo, a light-blocking card placed between light and subject, to keep light off this area.

Thin or Underweight Subjects. A thin person is much easier to photograph than an overweight person. Have the person wear light-colored clothing and use a high-key lighting ratio and light-colored background. When posing a thin person, have him or her face the camera more to provide more width. A seven-eighths angle is ideal for people on the thin side.

If the person is extremely thin, do not allow him or her to wear sleeveless shirts or blouses. For a man, a light-colored sports coat will help fill him out; for a woman, fluffy dresses or blouses will disguise thin arms.

For a thin face, use broad lighting and a lighting ratio in the 2:1 or 3:1 range. Since the side of the face turned

toward the camera is highlighted, it will appear wider than if short lighting is used. The general rule is, the broader the person's face, the more of it should be kept in shadow; the more narrow the face, the more of it should be highlighted—the basic differences between broad and short lighting.

Elderly Subjects. The older the subject, the more wrinkles he or she will have. It is best to use some type of diffusion, but do not soften the image to the point that none of the wrinkles are visible. Men, especially, should not be overly softened as their wrinkles are often considered "character lines."

Use a frontal type of lighting so that there are no deep shadows in the wrinkles and deep furrows of the face. Use a softer, diffused type of lighting, such as umbrella light. Soft lighting will de-emphasize wrinkles.

A smaller image size is also called for in photographing elderly people. Even when making a head-and-shoulders portrait, the image size should be about 10–15 percent smaller, so that the signs of age are not as noticeable.

Eyeglasses. The best way to photograph eyeglasses is to use blanks (frames without lenses), obtained from the sitter's optometrist. If the portrait is scheduled far enough in advance, arrangements can usually be made with the optometrist for a set of loaner frames. If blanks are not available, have the person slide his glasses down on his or her nose slightly. This changes the angle of incidence and helps to eliminate unwanted reflections.

When photographing a subject wearing eyeglasses, the key light should be diffused so that the frames do not cast a shadow that darkens the eyes. Place the key light even with or just higher than the subject's head height, then move it out to the side so that its reflection is not visible in the eyeglasses as seen

Sometimes great portraiture is not about minimizing flaws, but maximizing great features. Here, Tim Kelly eliminated just about everything about this girl except her nearly perfectly shaped face. He used black everywhere to defocus attention, photographing her in a black sweater in a black chair. Tim had her lean forward in the chair, so you can't even relate to the type of pose in use. These are all intentional techniques to focus your attention on her face.

Slender subjects can be photographed head-on with no angle to the shoulder axis. A very broad, highlight area and the pose enhance this girl's natural beauty. Photograph by Tony Corbell.

from the camera. This produces a split or 45-degree lighting pattern. The fill light should also be adjusted laterally away from the camera until its reflection disappears. If you cannot eliminate the fill light's reflection, try bouncing the fill light off the ceiling or the back wall of the studio.

When your subject is wearing thick glasses, it is not unusual for the eyes to be darker than the rest of the face. This is because the thickness of the glass reduces the intensity of light being transmitted to the eyes. If this happens, there is nothing you can do about it during the shooting session, but the area can be dodged digitally or during printing to restore the same print density as in the rest of the face.

If your subject wears "photo-gray" or any other type of self-adjusting, light-sensitive lenses, have him keep his glasses in his pocket until you are ready to shoot. This will keep the lenses from getting dark prematurely from the shooting lights. Of course, once the light strikes them they will darken, so you might want to encourage your subject to remove his or her glasses for the portrait.

One Eye Smaller than the Other. Most people have one eye smaller than the other. This should be one of the first things you observe about your subject. If you want both eyes to look the same size in the portrait, pose the subject in a seven-eighths to three-quarters view, and seat the person so that the smaller eye is closest to the camera. Because objects farther from the camera look smaller, and nearer objects look larger, both eyes should appear to be about the same size.

Baldness. If your subject is bald, lower the camera height so less of the top of his head is visible. Use a gobo between the main light and the subject to shield the bald part of his head from light. Another trick is to feather the main light so that the light falls off rapidly on the top and

back of his head. The darker in tone the bald area is, the less noticeable it will be. Do not use a hair light, and employ only minimal background light. If possible, try to blend the tone of the background with the top of your subject's head.

Double Chins. To reduce the view of the area beneath the chin, raise the camera height so that area is less prominent. Tilt the chin upward and raise the main light so that much of the area under the chin is in shadow.

Wide Faces. To slim a wide face, pose the person in a three-quarters view, and use short lighting so that most of the face is in shadow. The wider the face, the higher the lighting ratio should be. If the face is extremely wide, even a 5:1 ratio would be suitable.

Thin Faces. To widen a thin face, the solution is to highlight as much of the face as possible. This means using broad lighting, where the side of the face most visible to the camera is highlighted. You should use a frontal pose, such as a seven-eighths view, and keep the lighting ratio on the low side—in the 2:1 to 3:1 range. Kickers and hair lights will add depth and dimension to the portrait, and

further widen a thin face. A smiling pose will also widen the cheek and mouth area.

Broad Foreheads. To diminish a wide or high forehead, lower the camera height and tilt the person's chin upward slightly. Remember, the closer the camera is to the subject, the more noticeable these corrective measures will be. If you find that by lowering the camera and raising the chin, the forehead is only marginally smaller, move the camera in closer and observe the effect again—but watch out for other distortions.

Deep-Set Eyes and Protruding Eyes. To correct deep-set eyes, keep the main light low to fill the eye sockets with light. Keep the lighting ratio low so there is as much fill light as possible to lighten the eyes. Raising the chin will also help diminish the look of deep-set eyes. To correct protruding eyes, raise the main light and have the person look down so that more of the eyelid is showing.

Large Ears. To scale down large ears, the best thing to do is to hide the far ear by placing the person in a three-quarters view, making sure that the far ear is out of view or in shadow (either by using a gobo to block the light from the ear or by feathering the main light). If the subject's ears are very large, examine the person in a profile pose. A profile pose will totally eliminate the problem.

Very Dark Skin Tones. Unusually dark skin tones must be compensated for in exposure if you are to obtain a full tonal range in the portrait. For the darkest skin tones, open up a full f-stop over the indicated incident meter reading. For moderately dark subjects, like deeply suntanned people, open up one-half stop over the indicated exposure.

Uneven Mouths. If your subject has an uneven mouth (one side higher than the other, for example) or a crooked smile, turn his or her head so that the higher side of the mouth is closest to the camera, or tilt the subject's head so that the line of the mouth is more or less even.

Long Noses and Pug Noses. To reduce the appearance of a long nose, lower the camera and tilt the chin upward slightly. Lower the key light so that, if you have to shoot from much below nose height, there are no deep shadows under the nose. You should use a frontal pose, either a full-face or seven-eighths view, to disguise the length of your subject's nose.

For a pug nose or short nose, raise the camera height to give a longer line to the nose. Have the subject look downward slightly and try to place a specular highlight along the ridge of the nose. The highlight tends to lengthen a short nose.

Long Necks and Short Necks. While a long neck can be considered sophisticated, it can also appear unnatural—especially in a head-and-shoulders portrait. By raising the camera height, lowering the chin, keeping the neck partially in shadow, and pulling up the shirt or coat-collar, you will shorten an overly long neck. If you see the subject's neck as graceful and elegant, back up and make a three-quarter- or full-length portrait and emphasize the graceful line of the neck in the composition.

For short or stubby necks, place light from the key light on the neck. This is accomplished by lowering the key light, or feathering it downward. Increase the fill light

This wonderful portrait by Giorgio Karayiannis says more in what it omits than what is visible. Giorgio used a very strong lighting ratio to omit large portions of the image—a technique that is often used to minimize the visible areas of a large person. The light, a square softbox, was moved back from the subject to increase its specularity. With no fill-in, much of the portrait is black. The deep blacks and dark areas lend mystery to the portrait.

LEFT—Baldness, or a pronounced receding hairline, can sometimes be handled by judicious cropping—as in the case of this portrait by David Williams. Notice how the hand is brought into the composition as a major element and how its strong posing helps to add character and flavor to the portrait. RIGHT—This is the type of portrait one might not attempt with a teenage subject a few years ago because the retouching might have been extensive. Now with the many retouching techniques available in Photoshop, it is easy to smooth the entire complexion in a matter of minutes. Photo by Brian King.

on the neck so there is more light on the shadow side of the neck. Lowering the camera height and suggesting a V-neck collar will also lengthen the appearance of a short neck.

Wide Mouths and Narrow Mouths. To reduce an overly wide mouth, photograph the person in three-quarters view and with no smile. For a narrow or small mouth, photograph the person in a more frontal pose and have him or her smile broadly.

Long Chins and Stubby Chins. Choose a higher camera angle and turn the face to the side to correct a long chin. For a stubby chin, use a lower camera angle and photograph the person in a frontal pose.

Oily Skin. Excessively oily skin looks shiny in a portrait. If you combine oily skin with sharp, undiffused lighting, the effect will be unappealing. Always keep a powder puff and a tin of face powder on hand to pat down oily

areas. The areas to watch are the frontal planes of the face—the center of the forehead and chin, and the cheekbones. The appearance of oily skin can also be minimized by using a diffused main light, such as umbrella or softbox lighting.

Dry Skin. Excessively dry skin looks dull and lifeless in a portrait. To give dry skin dimension, use a sharp, undiffused main light. If the skin still looks dull and without texture, have the person use a little hand lotion or body oil on their face to create small specular highlights in the skin. Don't overdo it with the lotion or oil, or you will have the reverse problem—oily skin.

Skin Defects. Facial imperfections like scars and discoloration are best disguised by placing them in shadow, using a short lighting setup and a strong lighting ratio. Many of these issues can now also be addressed using digital retouching. Always get clearance from the subject be-

Sometimes the needs of a portrait client override everything else. Here, this senior wanted his two prize possessions in the photo, so photographer Chris Nelson accommodated him. Because Chris's objectives were to feature the car and the guitar (as well as the subject), lighting and posing requirements changed considerably. Flash-fill helped fill in the overhead light of photographing in open shade.

fore removing such features; they may have acclimated to them and not want them removed.

BE DISCRIMINATING

Here's a problem you may not have thought of: what if the person is proud of the trait you consider a difficulty? Or what should you do when you encounter more than one problem?

The first question is best settled in a brief conversation with your subject. You can comment on his or her features by saying something like, "You have large eyes, and the line of your nose is quite elegant." If the person is at all self-conscious about either one of these traits, he or she will usually say something like, "Oh, my nose is too long, I wish I could change it." Then you will know that the person is unhappy with his nose, but happy with his eyes, and you'll know how to proceed.

The second question is a little more difficult. It takes experience before you can discern which of the problems is the more serious one, and most in need of correction. Generally, by handholding the camera and moving into the corrective positions (*i.e.*, a higher or lower camera angle) you can see how the physical characteristics are altered. By experimenting with various lighting, poses, and camera angles, you should be able to come up with the best posing strategy. Another good trick is to show them a few frames on the camera's LCD. If they are at all self-conscious, they will comment on their looks.

More than good lighting, posing, and composition techniques, the successful portrait photographer knows how to deal with the irregularities of the human face. All of the great portrait photographers know that their success lies in being able to make ordinary people look absolutely extraordinary.

10. PHOTOSHOP RETOUCHING TECHNIQUES

*I*n the first edition of this book there was no section on Photoshop retouching techniques. Although that edition was published only a few years ago, most photographers still employed traditional retouching methods at that time—or more often, they employed full-time retouchers. Today, everything has changed; even those photographers who still shoot with film usually have the image digitized for output. As a result, conventional retouching techniques have given way to digital methods.

Adobe Photoshop has permanently changed the style and scope of portrait images. The photographer, in the comfort of his or her home or studio, can now routinely accomplish special effects that could only be achieved by an expert darkroom technician in years past. Conventional retouching is just the tip of the iceberg where Photoshop is concerned. Retouching a digital image in Photoshop is much less difficult than conventional retouching and the image is "worked" as a positive, unlike traditional negative retouching. Creative effects include blurring the background, selective diffusion in key areas of the face, transparent vignettes, swapping heads in group photos—the list is endless. Literally, if it can be imagined, it can be performed in Photoshop.

RETOUCHING THEN
Traditional retouching involved the use of a large- or medium-format negative and a skilled retoucher, who would apply leads and/or retouching dyes to the negative. The idea behind this traditional retouching was to blend the uneven densities of the negative for a smoother, more polished look. By building up the tone in the slightly less dense areas, the skin became cleaner and more uniform; in short, it came closer to the ideal.

Before retouching could begin the negative was often "doped," meaning that retouching medium was applied to give the negative "tooth" (a surface receptive to accepting leads and dyes). Then, the retoucher worked on a retouching stand with a brightly backlit panel. The negative was mounted above the light and a powerful magnifying glass on a gooseneck stand was used to enlarge the area of the negative for the retoucher. With leads of various hardnesses that were sharpened to perfection, the retoucher would begin blending areas of the negative, using the leads to build up density. Starting out with the retouching pencils, using the emulsion side of the negative, the retoucher would usually start with the harder lead for average retouching. The softer leads were then used for deeper shadow areas. The lead needed to be constantly resharpened to maintain an extremely sharp point.

Adobe Photoshop has permanently changed the style and scope of portrait images.

Using these techniques, lines were softened, blemishes removed, smile lines and deep furrows minimized, catchlights repaired, age spots removed, and all the myriad of items covered by the retoucher were handled in turn. It was a painstaking and time-consuming skill that one had to spend years training to do well. One of the constant problems for a retoucher was when a negative refused to accept any more lead. It would then have to be flipped and more lead (or dye) applied to the other side of the negative. And to make matters worse, the techniques involved for lead retouching are somewhat different than

those for dyes, which involve using an almost dry brush to apply very thin applications in very small areas.

Other tools used by the conventional retoucher were the abrading tool (a needle used to remove pinholes and other completely opaque spots on the negative), the etching knife (used to "shave" density in microscopic dimensions from the negative—to repair blown-out highlights, for example) and the spotting brushes and dyes (which were used to retouch the print from over-retouching or dust spots produced in enlargement).

RETOUCHING NOW

The fact that most photographers moved away from the large-format negative toward the medium- and small-format negative, and now to digital, has all but put an end to conventional retouching. Retouching is now done to the digital file and the image is conveniently "worked as a positive," so that what you see on the monitor is what you get. Retouching a scanned or native digital image in Adobe Photoshop is much easier and less time consuming.

Retouching a digital image in Photoshop allows you to view any portion of the image at up to a 1600-percent enlargement on screen, making it possible to rework virtually any detail in the image. A wide variety of brushes and pencils and erasers can be selected, and the opacity and transparency of each tool is easily adjusted in minute increments. Photoshop allows you to select an area you want to retouch, confining your changes

TOP—Here's what Brian King, a senior specialist, says about retouching. "Basically, I take the images a bit further than my lab by adding additional work under the eyes and smoothing out facial areas with larger pores using the blur tool. My favorite treatment so far is to clean up the whites of the eyes with either a brush tool or the dodge tool and then deepen the existing eye color. I have been having fun playing with the saturation levels and also the Gaussian blur filter to create a more defined selective focus." BOTTOM—In this David Williams portrait of mother and child, you can barely see the effects of his selective-focus technique—which is as it should be. He has idealized the complexions of both subjects, leaving only the eyes, teeth, lips, eyebrows, and part of the hair sharp. The technique takes years off middle-aged skin and makes children look almost angelic.

to only the selected area (thereby eliminating misplaced brush strokes, etc.).

There are also some amazing specialized tools for retouching, such as the healing brush. With this tool, you can conceal a problem area by covering it with "cloned" material from an adjacent area of the image—and Photoshop automatically takes care of blending the lighting angles and textures for you. Take, for instance, the lines under a person's eyes. With the healing brush, you can sample the smooth area directly under the facial lines and then, with a click of the mouse, apply the smooth area to the creased area, thus gradually wiping out the facial irregularities. Blemishes are so simply removed it's almost laughable—especially when compared to the work that one went into that operation in the conventional retoucher's studio.

Not only can facial irregularities be eliminated digitally, but drastic retouching tasks, like swapping the head from one image and placing it in another, are now a routine matter—just select, copy, and paste. There is almost no end to the complex effects that can be produced digitally.

The following is a collection of Photoshop techniques that you will find useful for various retouching tasks.

WORKING WITH LAYERS

Layers allow you to work on one element of an image without disturbing the others. Think of them as sheets of acetate stacked one on top of the other. Where there is no image data on a layer, you can see through to the layer below.

Layers are one of the most flexible tools in Photoshop—however, they can also cause some management problems. Getting into the habit of naming each one will help you to organize and work with multiple layers. To do this, just double-click on the layer name in the layers palette.

Linking Layers. If you have a number of layers that you want to move around the image, you can link them together. Linked layers can be moved or affected all at once. To link layers, activate the layers you want to link, then click on the chain-link symbol at the bottom of the layers palette. Clicking the chain-link symbol again will unlink the layers.

Layer Sets. You can also create layer sets, folders that contain layers. To do this, click on the folder icon at the

The layers palette with callouts, explaining the different icons and features found in Photoshop CS2.

bottom of the layers palette to add an empty folder. Then, drag layers into it. Alternately, you can link a series of layers together, then go to the layers palette and choose "new set from linked" from the flyout menu at the top-right of the palette.

Background Copy Layer. Many different creative effects involve using Photoshop's layers. When you open an image and go to the layers palette, you will see your background layer with a padlock icon next to it, meaning that this is your original image. Make a copy of the background layer by clicking and dragging the background layer onto the new-layer icon. Working on a duplicate of your original makes it easy to compare the "before" and "after" versions of your image as you work. Additionally, if you need to revert to the original image, you can simply delete all the layers except your original background layer.

Deborah Ferro created this beautiful portrait of a teenage girl and helped minimize retouching by basically blowing out the highlights in Photoshop's levels control. She finished off the portrait with dry brush strokes and a custom border treatment resembling a Polaroid Type 57 negative/print film.

Once you've created your duplicate background layer, you should immediately save the image in the PSD (Photoshop Document) or TIFF file format, which will allow you to preserve the layers, including the original background layer and background copy layer. Other file formats will require you to flatten the layers, which merges all the layers into one and obliterates your working layers.

RETOUCHING

Soft Focus. Once you've made a copy of the background layer, the eraser tool allows you to selectively permit the underlying background layer to show through—good for creating selective effects.

For example, working on the background copy layer, you can apply the Gaussian blur filter (Filter> Blur>Gaussian Blur). This will blur the entire image. To restore the original sharpness to selected areas, you can then use the eraser tool to "erase" the blurred background copy layer and allow the sharp background layer to show through.

You can set the eraser opacity and flow to 100 percent to reveal the hidden original background layer completely, or you can set the opacity to around 50 or 25 percent and bring back the sharpness gradually.

As you work, you'll probably want to enlarge the image to ensure that you erase accurately. You can also switch between brushes, depending on the area you need to erase. Your selection of a soft- or hard-edged brush, and its size, will change the sharpness of the perimeter edge of the erased area. A good middle ground is a small- to medium-sized, soft-edged brush.

This technique is ideal for retouching the entire face, then restoring sharpness to select areas—the eyes and eyebrows, the nose, the lips and teeth, and so forth. It also works well with special effects filters, like Nik Software's Monday Morning Sepia—a moody, soft focus, warm tone filter. Simply perform the effect on the background copy, then bring back any of the original detail you want by allowing the original background layer to show through.

CLAUDE JODOIN'S FACIAL RETOUCHING

Blemishes. Enlarge the face to 100 percent and select the Patch tool. Then, surround the blemish and drag your cursor to an adjacent area of skin. This will replace the blemish while maintaining the same general color and texture of the skin.

Smoothing. Duplicate the background layer and add four pixels of Gaussian blur. Using the eraser tool (or, if you prefer, a layer mask) selectively reveal the sharp, retouched layer underneath.

Eyes. Create a curves adjustment layer and lighten the overall image by about 20 percent. Create a layer mask and fill it with black, then set the foreground color to white and select the brush tool. Paint on the mask to gradually lighten the whites of the eyes but do not make them completely white. The presence of blood vessels in the eyes is very realistic and should not be eliminated entirely. You can adapt this same technique to darken the iris and pupils, adding contrast to the eyes. You can also use the dodge tool to lighten the interior of the iris, avoiding the edge. This increases the edge contrast for a more dynamic look. Burn in the pupil to make it more stark.

Soft Focus Effect. Flatten the image and duplicate the background layer. Then, go to Gaussian blur and increase the radius to about 25 pixels, so that the entire image is blurred. Set layer opacity to 50 percent and you'll have a true soft-focus lens effect—a soft image atop a sharp image. Use a layer mask to restore sharpness in critical areas like the eyes, lips, eyebrows, and hairline. Then, select a brush that is the size of the subject's face. Set the brush opacity to about 5 percent and touch once or twice to bring out just a little more overall detail.

Vignetting. Make a new layer and fill it with black. Adjust its opacity to about 30 percent so that the image looks dimmed. Add a mask to the layer. Then select the gradient tool and set it to produce a white-to-black radial gradient. Click once near the eyes, then again out near the edge of the image. The result will be a full vignette with the face lighter than the edges.

These tips are courtesy of Claude Jodoin's *Click to Print Workflow* series of CDs, which are available from www.claudejodoin.com/. Each of the techniques described was used on the images below.

Bride retouched by Claude using the techniques described above. Photographs by Claude Jodoin.

This before and after example includes all of the techniques described on the previous page. The original digital image was so sharp that it needed softening so that the face would not be so incredibly detailed. Even people with exceptional eyesight do not experience others' features in this way. Photographs by Claude Jodoin.

Selective Focus. This is like the effect described above. To begin, duplicate the background layer as described above. Blur the background copy layer using the Gaussian blur filter (Filter>Blur>Gaussian Blur) at a pixel radius of 10 or less. From there, you can employ one of two different methods.

Method one entails using the eraser tool with a soft-edged, medium-sized brush at an opacity of 100 percent to reveal the hidden original background layer.

Method two involves using the lasso tool to make selections. Holding down the Shift key allows you to make multiple selections. Select the areas around the eyes and eyebrows, the hairline, the tip of the nose, the lips and teeth, the front edge of the ears, any jewelry that shows and other surface details that should be sharp. Next, you'll need to feather the selection, blurring its edges so that the two layers will blend seamlessly. To do this, go to Select>Feather and set the feather radius at up to 25 pixels. Next, hide the selections (Command + H) so that the dotted selection indicator (*i.e.,* "the marching ants") disap-

pears. Then, simply hit Delete and the original background layer will show through. If you missed something, hit deselect (Command + D) and select the new area (or areas). Once these are feathered, hit Delete.

Removing Blemishes. To remove small blemishes, dust spots, marks, or wrinkles, select the healing brush (the clone tool in Photoshop 6 or lower). When this tool is selected, an options bar will appear at the top of the screen. Select the normal mode and choose the "sampled as the source" setting. Next, select a soft-edged brush that is slightly larger than the area you are going to repair. Press Opt/Alt and click on a nearby area with the same tone and texture as the area you wish to fix. Then, click on the blemish and the sample will replace it. If it doesn't work, undo the operation (Command + Z), sample another area and try again. The healing brush differs from the clone tool (also called the rubber stamp tool in older versions of Photoshop) in that the healing brush automatically blends the sampled tonality with the area surrounding the blemish or mark.

Shininess and Wrinkles. To reduce the appearance of wrinkles and shiny areas, select the clone tool and set its opacity to 25 percent. The mode should be set to normal and the brush should, again, be soft-edged. Sample an unblemished area by hitting Opt/Alt and clicking once on the area you want to sample. As you use the tool, keep an eye on the crosshairs symbol that appears to show you the sampled area you are about to apply with your next click of the tool. If this area begins to move into a zone that is not the right color or texture, hit Opt/Alt and resample the desired area.

The clone tool is a very forgiving tool that can be applied numerous times in succession to restore a relatively large area. As you work, you will find that the more you apply the cloned area, the lighter the wrinkle becomes or the darker the shiny area becomes. Be sure to zoom out and check to make sure you haven't overdone it. This is one reason why it is always safer to work on a copy of the background layer instead of the background layer itself.

When reducing shine, don't remove the highlight entirely, just subdue it. The same goes for most wrinkles. For a natural look, they should be significantly subdued, but not completely eliminated.

Teeth and Eyes. By quickly cleaning up eyes and teeth, you can put real snap back into the image. To do this, use the dodge tool at an exposure of 25 percent. Since the whites of the eyes and teeth are only in the highlight range, set the range to highlights in the options bar.

For the eyes, use a small soft-edged brush and just work the whites of the eyes—but be careful not to overdo it. For teeth, select a brush that is the size of the largest teeth and make one pass. Voilà! That should do it.

For really yellow teeth, first make a selection using the lasso tool. It doesn't have to be extremely precise. Next, go to Image>Adjustments>Selective Color. Select "neutrals" and reduce the yellow. Make sure that the method setting at the bottom of the dialog box is set to absolute, which gives a more definitive result in smaller increments.

Jerry D, who specializes in digital makeovers, says his clients sometimes don't love themselves in their pictures. One bride said to him, "I love the photo . . . but can't you make me look thinner?" He said he could and proceeded to "remove her arm" in Photoshop and paste it back onto her "liquified" body, made thinner with the liquify filter. You cannot tell where the retouching was done and the bride was ecstatic over Jerry's magic.

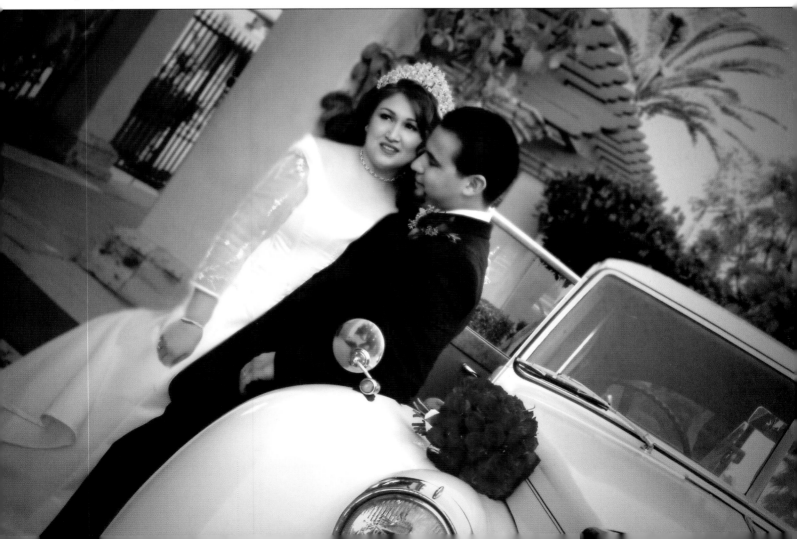

COLOR SAMPLING

One of Charles Maring's tricks of the trade is color sampling, which he uses when creating album pages in Photoshop. This is done using Photoshop's eyedropper tool. When you click on an area, the eyedropper reveals the component colors in either CMYK or RGB in the color palette. He then uses those color readings for graphic elements on the page he designs with those photographs, producing an integrated, color-coordinated design on the album page. If using a page-layout program like QuarkX-press or InDesign, those colors can be used to match the Photoshop colors precisely.

Remove yellow in small increments (one or two points at a time) and gauge the preview. You will instantly see the teeth whiten. Surrounding areas of pink lips and skin tone will be unaffected because they are a different color.

Glare on Glasses. Glare on glasses is a problem that's easily remedied. Enlarge the eyeglasses, one lens at a time. With the clone tool, select a small, soft brush and set its opacity to about 50 percent. The reduced opacity will keep the glass looking like glass. Sample an adjacent area (Option/Alt + click) and start to cover over the highlight. Deborah Ferro, a Photoshop expert, recommends using irregularly shaped brushes of different sizes to cover tricky highlights.

Contouring with the Liquify Filter. Photoshop has a fascinating suite of tools under the filters menu. The liquify function is a very useful one, as it allows you to bend and twist features either subtly or dramatically. When you activate the liquify function (Filter>Liquify), a full-screen dialog box will appear with your image in the center. To the left of the image are a set of tools that let you warp, pucker, or bloat an area simply by clicking and dragging. There is even a tool that freezes an area, protecting it from the action of the tool. When you want to unprotect the area, simply use the thaw tool. To the right of the image, you'll find settings for the brush size and pressure.

Using this tool, it is a simple matter to give your subject a tummy tuck, or take off fifteen pounds with a few well placed clicks on the hips and/or waistline. It is outrageous how simple this tool is to use, and the effects are seamless if done subtly. (If you notice you have overdone it, however, there is even a reconstruct tool that undoes the effect gradually—like watching a movie in reverse.)

Be careful not to eliminate elements of his or her appearance that the subject actually likes—these "flaws" are, after all, part of what makes every person unique. When this happens, you have gone too far. It is always better to approach this type of reconstructive retouching with a little feedback from your subject and a lot of subtlety.

ACTIONS

Actions are a series of commands that you record as you perform them and then play back to apply the exact same sequence of functions to another image or set of images—with a click of your mouse. In addition to streamlining your workflow, this will help to ensure consistent results.

To create a new action, select "new action" from the pull-down menu at the top right of the actions palette. You will be asked to name it, and then to start recording. Once recording, everything you do to the image will be recorded as part of the action (there are a few exceptions, such as individual brush strokes, that cannot be recorded). When done, simply stop recording by hitting the stop button (the black square) at the bottom of the actions palette. Then, whenever you want to perform that action, go to the actions palette, select the desired action and hit the play button at the bottom of the palette (the black triangle). The action will then run automatically on the open image.

Photoshop also comes with a variety of preloaded actions. You can use these actions as is or customize them to meet your needs. You can also purchase actions from reliable sources on the internet to utilize the experience of some of the best in the business. For example, Fred Miranda (www.fredmiranda.com) offers a wide variety of excellent actions for sale at a reasonable price.

11. FINE PRINTS

With traditional printmaking, it took years for one to perfect the craft. Now, because Photoshop is so easy to use, it is all too easy to neglect the discipline required to produce prints that reflect the traditional qualities of fine craftsmanship. Hopefully, this chapter will give some insight into the means and methods of making fine prints digitally.

WHAT IS A FINE PRINT?

In professional print competitions, judges have been asking this question for decades. Generally speaking, a fine print has a good range of tones from pure black to paperbase white with a good range of detailed midtones. This is true regardless of the media and whether the image is black & white or color. The highlights should be detailed, the blacks should be rich, and the image should contain a healthy contrast range. Additionally, the subject should dominate, either by virtue of tone, size, shape, or position in the frame.

GOOD COLOR MANAGEMENT

In the digital darkroom, accuracy and predictability come from managing color as the image moves from one device to the next—from the digital camera, to the monitor, to the printer, for example. A color management system is, therefore, designed to perform two important functions:

The hallmark of a fine print is image detail in all the significant areas of the image. It usually holds true that if the photographer is a lighting expert, that quality will carry through to the final print. Here, Tim Kelly has produced a remarkable image with detail only where Kelly wanted it (primarily in the highlights and not in the shadows). There are many degrees of subtle highlights and midtones, giving the portrait a depth and complexity.

It is recommended that you set your computer desktop to a neutral gray for the purpose of viewing and optimizing images. Because you will most likely make adjustments to color and luminosity, it is important to provide a completely neutral, colorless backdrop to avoid distractions. To optimize your working area the room lighting should also be adjusted to avoid any harsh direct lighting on the face of the monitor. This will allow more accurate adjustments to your images and will reduce eyestrain. Attempt to keep ambient light in the room as low as possible.

it interprets the RGB or CMYK color values embedded in an image file, and it maintains the appearance of those colors from one device to another—from input, to display, to output.

These systems rely on color profiles, a set of objective data that details how a particular device captures or displays color. Using these data sets as a translation device, the computer can provide better color continuity as images are moved from device to device.

Camera Profiles. Camera profiles are probably the least critical type of profiles, given the wide variety of lighting conditions under which most photographers work. This is especially true if you shoot in the RAW mode. In this case, color can be adjusted when processing the images files. Custom camera profiles are, however, beneficial if your camera consistently delivers off-color images, captures skin tones inaccurately, or fails to provide the color accuracy you need (critical in the fashion industry). They can also prove beneficial in a studio setting where a specific set of strobes produces consistently off-color results. That specific profile would not be useful for any other situation than *that* studio and *those* lights, but it could be more convenient than other means of color correction.

One of the most inexpensive and effective camera profiling systems is the ColorEyes profiling setup. It is simple enough, albeit time-consuming. Basically, you photograph a Macbeth ColorChecker (a highly accurate and standardized color chart) and create a profile using ColorEyes software. The software looks at each patch and measures the color the camera saw. Next, the software calculates the

Photographer Fuzzy Duenkel expertly controlled every area of this image in Photoshop. There are four areas of sharpness: the eyes, lips, nose and the lavender flowers. The rest of the image is softened in varying degrees, depending on the intent and tone. It is a masterful execution of a great image.

The subject's face is the focal point of this portrait. All the other details have been printed down, darker than the face or they have been accounted for in the lighting of the image. Note the color of the white piano keys which would have ordinarily been very bright. The detail in the tapestry and dark wood of the piano are preserved but subdued per the intent of the photographer. Photograph by Robert Lino

difference between what the camera saw and what the reference file says the color is supposed to be. Then, the software builds the profile, which is actually a set of corrections to make the camera "see" more accurately.

Monitor Profiles. If you set up three identical monitors and had them display the exact same image, they would each display the image in a slightly different way. Every monitor is different. This is where profiles come into play. Profiling, which uses a calibration device and accompanying software, characterizes the monitor's output so that it displays a neutral (or at least a predictable) range of colors.

A monitor profile is like a color-correction filter. Going back to the example of the three monitors above, one monitor might be slightly green, one magenta, one slightly darker than the other two. Once calibrated and profiled, the resulting profile, stored in your computer, will send a correction to the computer's video card—correcting the excess green, magenta, and brightness, respectively, so that all three monitors represent the same image identically.

Monitor profiling devices range widely in price, beginning in the $250–$500 range and reaching several thousand dollars at their most expensive. However, this is an investment you cannot avoid if you are going to get predictable results from your digital systems.

Printer Profiles. A custom profile for each printer and paper combination you use gives the best color match between what you see on your calibrated monitor and the printed image. Printer profiles are built by printing a set of known color patches. A spectrophotometer then reads the color patches so the software can interpret the difference between the original file and the printed patches. This information is applied when printing to ensure that colors are properly rendered.

To simplify their in-house printing process, many photographers rely on one printer and one paper. Epson includes profiles for many of its own brand of papers in the software with their printers. The Epson 2200, for example, offers six profiles for six premium Epson papers, plus a plain-paper setting for black-only 360dpi printing. When loaded, the profiles appear in your print window and control how your printer interacts with the paper.

You can, of course, add other profiles for other brands. Custom profiles, such as the highly regarded Atkinson profiles, can be downloaded from the Epson web site (www.epson.com) as well as other sites. Here's how it works: go to the web site, then download and print out a color chart. Mail it back to the company and they will send you, via e-mail, a profile or set of profiles.

Another great source of custom profiles for a wide variety of papers and printers is Dry Creek Photo (www.drycreekphoto.com/custom/customprofiles.htm). This company offers a profile-update package so that each time you change your printer's ink or ribbons (as in dye-sublimation printing) you can update the profile. Profiles are available for inkjet printers; dye-sublimation printers; small event printers, like those from Sony; Kodak 8500- and 8600-series printers; Fuji Pictography printers; RA-4

printers, such as LightJet, Durst Lambda/Epsilon, Fuji Frontier, Noritsu QSS, Gretag Sienna, Kodak LED, Agfa D-Lab, etc.; color laserjet printers; and thermal printers.

Most of the expensive commercial printers that photo labs use include rigorous self-calibration routines, which means that a single profile will last until major maintenance is done or until the machine settings are changed.

Output profiles define not only your printed output but also your ability to "soft proof" an image intended for a specific printer. A soft proof allows you to preview, on your calibrated monitor, how an image file will appear when printed to a specific, profiled output device. By referring to an output profile in an application like Photoshop, you can view out-of-gamut colors on your display prior to printing. Needless to say, accurate output profiles can save time, materials, and aggravation.

ARCHIVAL PERMANENCE

When using inkjet media, different inks offer drastic differences in archival permanence. This is measured in terms of the print's lightfastness, or resistance to fading. The Epson Ultrachrome pigment inks, on Epson's Radiant White paper, have a rated permanence of ninety years, much higher than their line of dye-based inks, which have a lightfastness rating of between five and ten years, depending on paper used and storage conditions. As good as Epson's Ultachrome pigment inks are, they do not provide the longevity and archival permanence of Epson's Archival line of pigment inks (which specify a light-fastness rating of up to *two-hundred* years). With

COLOR DIFFERENCES

Why, even in a color-managed system, does the print output often look different than the screen image? The answer lies not so much in the color-management as in the differences between media. Because monitors and printers have a different color gamuts (the fixed range of color values they can produce), the physical properties of these two different devices make it impossible to show exactly the same colors on your screen and on paper. However, effective color management allows you to align the output from all of your devices to simulate how the color values of your image will be reproduced in a print.

image permanence rivaling conventional photographic materials, there is no reason that digitally-printed portraits shouldn't last many generations.

ENLARGING IMAGES

Stair Interpolation. The best way to increase the size of images is to up-sample the image in small increments, otherwise known as stair interpolation. This method of upsizing is preferable to increasing image size in one large step, say from 100 percent directly to 400 percent. The concept of stair interpolation is simple: rather than making one big jump, you make a series of small changes, eventually increasing the image to the size you need.

This can be done manually by enlarging the image in small increments (say, half-inch increases for each step), alternating between the Bicubic, Bicubic Sharper, and Bicubic Smoother modes. If this seems too tedious, there are a number of completely automated plug-ins on the market, such as Fred Miranda's SI Pro and Resize Pro. With these, you just enter the desired final dimensions and hit OK. With either method, some additional sharpening may need to be applied to make the image look its best.

Alien Skin's Blow Up. Blow Up is a Photoshop-compatible plug-in that offers very high quality image enlargement. Blow Up is great for resizing images for large-format printing, offering excellent tools for sharpening and even adding film grain to compensate for the overly smooth look sometimes caused by extreme enlargement.

PRINT FINISHING

Dodging and Burning-In. When I was first starting out, I worked for a master photographer/printer, John Di-Joseph, who said, "There is no such thing as a straight print." Even though, as part of the job, we would have to make from twenty-five to five-hundred prints of the same negative at one time, and each print required some burning and dodging. Today, little has changed—even with digital capture, there is no such thing as a straight print. Every image can be improved by the local manipulation of tonal density.

To lighten an area of a digital image, select the dodge tool and a soft-edged brush that suits the size of the area to be worked. Then, in the options bar at the top of the screen, select the range of tones that you want to lighten

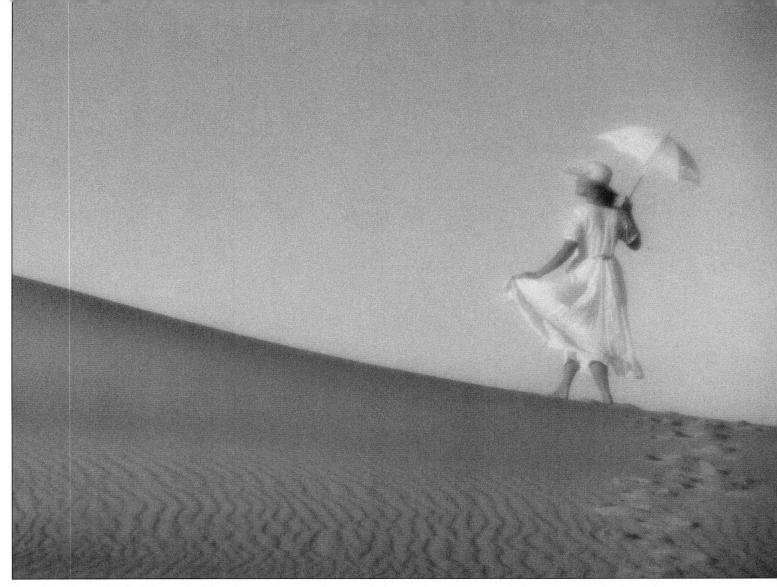

A combination of ultrafast film and a high degree of image enlargement along with a slight amount of negative diffusion in printing give a very romantic special effect. This image was created using a Canon EOS A2 camera with a Tamron 28–200mm AF lens at the 200mm setting. It was shot on Kodak 1600 Ektapress. Photograph by Robert and Suzanne Love.

(highlights, midtones, or shadows) and set the percentage of exposure. It's best to select a low percentage—8 percent is a good place to start. This way, you can work on a small area and build-up the effect with repeated applications. By repeatedly clicking and dragging the brush over the area to be dodged, you can gradually lighten it in such a way that the manipulation is completely unnoticeable. The burn tool features the same controls. The same technique can also be used, except that the exposure should be reduced to about 5 percent for a very subtle effect.

If the area you want to edit is adjacent to areas of opposite tone, it may be impossible to not spill the burn or dodge effect into them. In these cases, you should use the lasso or marquee tool, whichever is most appropriate, to select the area to be burned or dodged. This will ensure that the adjacent areas remain unaffected.

Contrast Control. Many times, a digital image is created lacking contrast in order to preserve the highlight and shadow detail in the original image. With too little contrast, however, the image will be unsuitable for printing. Overall contrast can be adjusted using the highlight and shadow sliders in the levels (Image>Adjustments>Levels). In the levels dialog box, by adjusting the shadow slider (the black triangle) to the right, you punch up the blacks. By adjusting the highlight slider (the white triangle) to the left, you clean up the whites.

The trick is to preserve shadow and highlight detail throughout. To review this, look at the luminosity chan-

USING KODAK COLOR PRINT VIEWING CARDS

If you've spotted a problem in your image but aren't quite sure of the color shift, there is a useful product available from Kodak for making color prints from negatives or slides. It is called the Kodak Color Print Viewing Filter Kit, and is comprised of six cards—cyan, magenta, yellow, red, green, and blue viewing cards. With a medium-gray neutral background on you monitor desktop, inspect the image on the monitor using the card that is the complementary color of the indicated color shift. For example, if the shift looks blue, use the yellow card to view the image. If the color shift is green, choose the magenta card, and so on. With one eye closed, flick the appropriate card quickly in and out of your field of view, examining the midtones as you do so. Avoid looking at the image highlights, as you will learn nothing from this. If the yellow card neutralizes the color shift in the midtones and shadows, then you are on the right track. There are three densities on each card, so try each one before ruling out a specific color correction. Once you've identified the problem, use the appropriate selection and sliders in the selective-color dialog box (or, if you prefer, the curves command) to neutralize the color shift.

nel of the image histogram (Window>Histogram). Move your cursor over the black point and white point while keeping an eye on the "level" field in the window below. Basically, a detailed white (for all printers) is around 235 (in RGB mode). A detailed black is around 15–35 (in RGB mode), depending on the printer and paper used.

Color Correction. For professionals, the curves are considered Photoshop's most precise tool for color-correcting an image. Using the curves is, however, a complicated and subjective process that takes some time to learn.

Selective Color. For less advanced Photoshop users, or when only small and isolated changes are needed, the selective color command (Image>Adjustments>Selective Color) can be extremely useful. This tool does not require you to know in advance which channel (R, G, or B) is the one affecting the color shift. It only requires you to select which color needs adjustment.

In the selective color dialog box, you'll see slider controls for cyan, magenta, yellow, and black. At the bottom of the box, make sure that the method is set to absolute,

which gives a more definitive result in smaller increments. At the top of the box, choose the color you want to change by selecting it from the pull-down menu. You can choose to alter the reds, yellows, greens, cyans, blues, magentas, whites, neutrals, or blacks. Once you've selected the color to change, simply adjust the sliders to modify the selected color in whatever way you like.

The changes you make to the sliders in the dialog box will affect only that color. Note, however, that the changed values will affect every area of that color. Therefore, if you select "blue" to change the color of the sky, it will also change the blue in the subject's eyes and her blue sweater.

When using the selective color command, most skin tones fall into the range that is considered neutral, so you can color correct the skin tones without affecting the white dress or the brightly colored bridesmaid's gowns, for instance. Skin tones are comprised of varying amounts of magenta and yellow, so these are the sliders that normally need to be adjusted. In outdoor images, however, you will sometimes also pick up excess cyan in the skin tones; this can be eliminated using the cyan slider. For teeth that are yellowed, select "yellows" and remove the color to brighten the teeth.

Wedding dresses will often reflect a nearby color, particularly if the fabric has a satiny sheen. Outdoors, the dress might go green or blue if shade or grass is reflected into it. In this example, you would select "whites" from the color menu. Then, if the dress is too blue, you'd remove a little cyan and judge the preview. If the dress has gone green, add a little magenta and perhaps remove a slight amount of yellow.

In selective color, the black slider adds overall density to the image and is much like the levels control in Photoshop. Be sure to adjust only the blacks using the black slider, otherwise it will have the effect of fogging the image. When converting images from RGB to CMYK, the black slider is very useful for adding the punch that is missing after the conversion.

For a quick adjustment, you can also create a duplicate background layer, then open the selective color tool. Correct the neutrals by adding or subtracting color, then adjust the opacity of the new layer over the background layer. You will often get more subtlety than if you tried to correct the entire image.

Targeting White and Gray Points. For a quick way to neutralize the color in an image, go to Image>Adjustments>Levels, select the white-point eyedropper, and click on a point in the scene that should be pure white. This should bring any color shifts back in line. You can also use the same techniques with the gray-point eyedropper; just click on an area of the photo that should be neutral gray. When an image doesn't have a well defined gray or white point, however, you cannot use this quickie method.

Toning. With your image in RGB color mode, create a copy of the background layer. Working on that layer, go to Image>Adjustments>Desaturate to create a monotone image. Use the levels or curves to adjust the contrast at this point, if so desired. Then, go to selective color (Image>Adjustments>Selective Color) and choose "neutrals" from the color menu. Then adjust the magenta and yellow sliders to create a sepia look. Using more magenta than yellow will give you a truer sepia tone. More yellow than magenta will give a brown or selenium image tone. The entire range of warm toners is available using these two controls. If you want to create a cool-toned image, you can simply add cyan or reduce yellow (or both). Again, a full range of cool tones is available in almost infinite variety.

LEFT—This is an image originally made on color negative film, yet the tonalities and delicate highlight detail make it look as if it were conceived and shot on black & white. Darkened corners and edges, and slightly burned in areas of the dress, highlight the debutante and her face and hands. Photograph by Robert Lino. RIGHT—Robert Williams created this beautiful and authentic athlete's portrait, entitled Hoop Dreams. The image is fairly straightforward: it was captured on film with a Hasselblad and 180mm lens, then tinted in printing. With Photoshop, such effects are simple to create, yet still extremely effective visually.

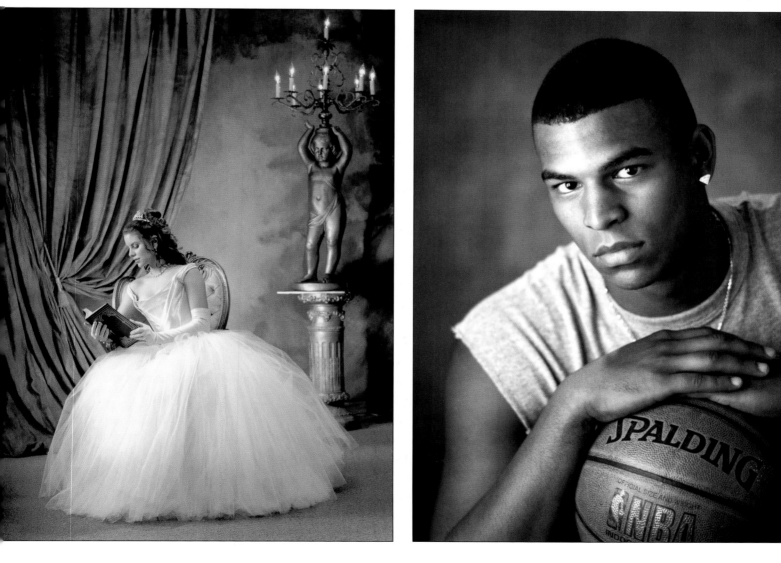

THE "FUZZYFILTER"

Fuzzy and Shirley Duenkel operate Duenkel Portrait Art, a successful studio in West Bend, WI. They began their business in the 1980s with weddings, and have evolved into a low-volume studio creating custom portraits, almost exclusively on-location and almost exclusively for seniors.

Fuzzy studies the work of commercial photographers and cinematographers, gaining inspiration from TV and magazine ads. He says, "With large budgets, art directors, and the constant push to create a look that sells, it's only logical that commercial shooters have usually been more on the cutting edge of creativity than portrait photographers. Therefore, it's wise to keep a close eye on what's new in fashion magazines and other media—especially when a significant part of your business is high school senior portraits."

One photographic technique Fuzzy has adopted is the use of high contrast but relatively moderate color saturation. To create this, he has developed a simple technique he calls the "FuzzyFilter." Fuzzy suggests making this an action for ease of use.

Here's the technique: Duplicate the background layer and desaturate the top layer completely. In curves, click on the center, and pull the line about one fourth of the way to the left. Click on the curve about one eighth of the way down the curve. Pull it down until just before the curve flattens against the bottom. Click on the curve near the top, and pull it down until the curve isn't flattened against the top. At this point, the top layer will be a very light, high-contrast, black & white image. Reduce the opacity of the top layer to about 45 percent. If you like, you can then click on the history brush and stroke color back into the cheeks, lips, and eyes at about 10 percent opacity. Finally, flatten the image and save it with a new name.

Original image was taken in the morning during fading fog. The sun was peeking over the horizon, providing enough of a directional main-light source. The surrounding fog added fill lighting.

Here's the same image after the "FuzzyFilter" was applied.

Handcoloring Effects. A popular effect is to add select areas of color to a monochrome image. This technique is done by duplicating the background layer of a color image, then desaturating it (Image>Adjustments>Desaturate). Working on the duplicate layer, adjust the brightness and contrast to your liking, then select the eraser tool. Choose a medium-sized soft brush and set the opacity of the eraser as you like (a high setting will reveal a lot of color; a low one will yield more subdued ones). Then, erase the areas you want to be in color, allowing the underlying color layer to show through the desaturated layer.

Vignettes. Vignettes can help focus the viewer's attention on the subject's face. Many photographers vignette every image in printing, darkening each corner to draw emphasis to the center of interest in the image. Even in high-key portraits, vignetting is a good way to add drama and heightened interest in the main subject.

This particular Photoshop vignetting technique comes from digital artist Deborah Lynn Ferro. To begin, duplicate the background layer. In the layers palette, create a new layer set to the normal mode. Then, select a color for the vignette by clicking on the foreground color in the main toolbar to bring up the color picker. You can choose any color or sample a color from within the photograph to guarantee a good color match (this is done using the eyedropper tool; click once and the sampled color becomes the foreground color).

Next, use the elliptical marquee tool or the lasso tool to select an area around the subject(s). Inverse the selection (Select>Inverse) and feather it (Select>Feather)—the larger the number, the softer the edge of your vignette will be. Try feathering to a radius of 75 to 100 pixels to keep the edge of the vignette really soft. Working on the new layer, fill the feathered selection (Edit>Fill) with the foreground color using a low percentage (like 10 percent). Be sure to select the "preserve transparency" option at the bottom of the fill dialog box.

SHARPENING

As most Photoshop experts will tell you, sharpening is the final step in working an image. One of the most common

problems encountered in this process is over-sharpening, which can compress detail out of an area (or the entire image) and create distracting halos.

The most flexible of Photoshop's sharpening tools is the unsharp mask filter, which gives you three controls.

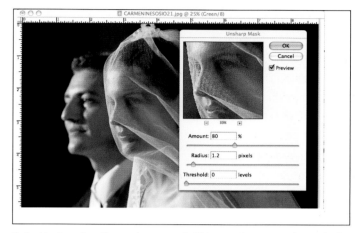

Selectively using the unsharp mask filter on the green channel of a Mauricio Donelli image.

Bob Coates' portraits display an almost extreme level of sharpness, even in the softer image of Heather (right). This level of sharpness not only imparts information but character in the portrait, especially in the portrait of Randy (left) with his weathered skin and rough hands.

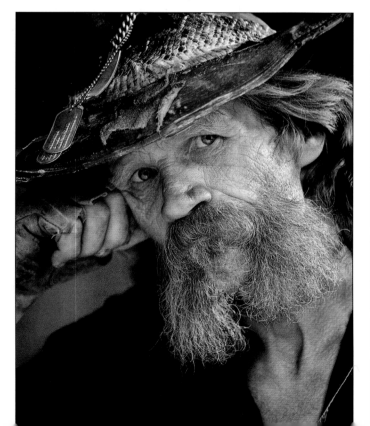

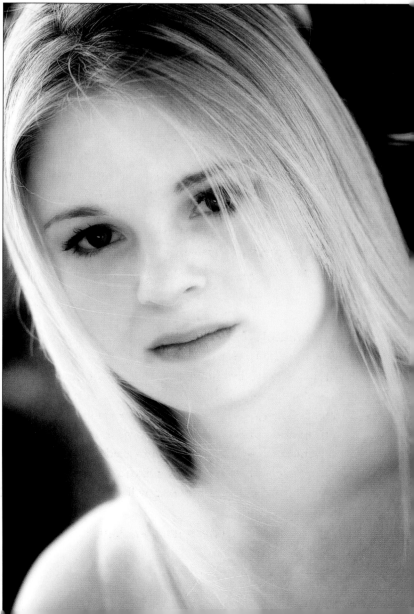

The amount setting tells Photoshop how much to increase the contrast of pixels. The radius setting controls the number of pixels surrounding the edge pixels that are affected by the sharpening (a lower value sharpens only the edge pixels; a higher value sharpens a wider band of pixels). The threshold setting determines how different the sharpened pixels must be from the surrounding area before they are considered edge pixels and sharpened by the filter. The default threshold value (0) sharpens all pixels in the image.

Often, you can achieve the best results by sharpening only one channel (R, G, or B) rather than the composite image (R, G, and B). Test the theory yourself. Open an image and go to File>Save As to create a duplicate file. With both files open, sharpen all three layers of one image in unsharp mask using these settings: Amount: 80 percent, Radius: 1.2 pixels, Threshold: 0 levels. On the second image, go to the channels palette and look at each channel individually. Sharpen the channel with the most midtones (usually the green channel, but not always) at the same settings. Turn the other two channels back on. Enlarge a key area, like the face, of both images at exactly the same magnification—say 200 percent.

At this level of sharpening, you will probably see artifacts in the image in which all three layers were sharpened simultaneously. In the image where only the green channel was sharpened, however, you will see a much finer rendition of the image.

BOB COATES' UNSHARP MASKING METHOD

Bob Coates, WPPI member and fellow Amherst Media author, has a very cool system of unsharp masking that he gave me to sharpen an ad he did for WPPI. It goes something like this. In Photoshop, go to Filter>Sharpen>Unsharp Mask. Set the Amount to 500, the Radius to 1.2 pixels, and the Threshold to 6 levels. At this point, the image will look absolutely horrible. Click OK, then go to Edit>Fade Unsharp Mask. Change the mode to luminosity and set the opacity at 20 to 30 percent, depending on your preference. The results are staggeringly good. By using the luminosity blending mode, you are essentially only sharpening the black & white image, which serves as a background of sharpness for the color components of the image.

CONCLUSION

Portraiture continues to change, and it will be fascinating to see what trends develop next. Certainly, digital will continue to replace film capture, and the digital effects inherent in digital imaging will become a bigger part of portraiture.

It also seems certain that traditional posing and lighting rules will also continue to be relaxed. There will always be a need for photographers to have a firm foundation in basic posing and compositional techniques; these will forever be a part of how the human form is rendered. What remains unclear, however, is how important the "spontaneous portrait" will become in the world of commercial portrait photography. If I took an educated guess, I would imagine that this area will grow as other photographic disciplines impact professional portraiture.

On that note, editorial photography will likely continue to have a profound impact on portraiture, especially as the discipline embraces a more fine-art approach, incorporating personal or thematic elements in the composition to raise the level of interpretation. The stylized images that appear in upscale magazines will certainly change the way we view ourselves, which is a fundamental aspect of contemporary portraiture.

The best thing about change is that it reflects a revitalization of the art form. Where there is change, there is no stagnation. And this is a very good thing for all of those who make or aspire to make their living by capturing the essence of people in professional portraits.

—*Bill Hurter*

THE PHOTOGRAPHERS

To illustrate this book, I have called upon some of the finest and most decorated portrait and wedding photographers in the country. A few, like Monte Zucker, are living legends among modern-day photographers; other are newcomers to the limelight. In all cases, though, their photography is exemplary. Many of the photographers included in this book have been honored by the country's top professional organizations, the Professional Photographers of America (PPA) and Wedding and Portrait Photographers International (WPPI). I want to thank all of the photographers for their participation in this book. Without them, it would not have been possible. I would also like to thank my illustrator and wife, Shell, who provided the drawings throughout and helped me organize and fine-tune many facets of this book.

Patti Andre. Patti Andre holds a Bachelor of Fine Arts Degree from Art Center College of Design in Pasadena, CA. Her work has appeared in many magazines and her clients include Scripps Hospital, Masar/Johnston, Ketchum Advertising, United Way, USC, and more. Her studio is called As Eye See It.

Fernando Basurto. Wedding photojournalist Fernando Basurto does business in the historical uptown Whittier area of Southern California. Fernando is a member of WPPI, has judged their print competitions, and holds the APM and AOPA degrees. Visit him at www.elegantphotographer.com.

Becker. Chris Becker, who goes by only his last name, is a gregarious and likeable wedding photojournalist who operates a hugely successful studio located in Mission Viejo, CA. He has been a featured speaker at WPPI and has also competed and done well in international print competition.

David Bentley. David Bentley owns and operates Bentley Studio, Ltd. in Frontenac, MO. With a background in engineering, he calls upon a systematic as well as creative approach to his assignments. Thirty years of experience and numerous awards speak to the success of this system.

Marcus Bell. Marcus Bell is one of Australia's most revered photographers. His work has been published in numerous magazines, including *Black White, Capture,* and *Portfolio Bride.* He is the author of *Master's Guide to Wedding Photography* (Amherst Media, 2006).

Don Blair. For about fifty years, the name Don Blair was synonymous with fine portraiture, craftsmanship, and extraordinary contributions to the industry. He was an acclaimed teacher, and also the author of *Seeing Light: The Art of Portrait Photography* (Amherst Media, 2004).

Stacy Dail Bratton. Stacy Bratton is an accomplished children's and family photographer, and a graduate of Art Center College of Design in Pasadena, CA. She is the author of *Baby Life* (Taylor Trade Publishing, 2004), a book featuring seventy-five of her black & white children's photographs.

Anthony Cava B.A., MPA, APPO. Anthony Cava owns and operates Photolux Studio with his brother, Frank. At 31 years of age, he became the youngest Master of Photographic Arts (MPA) in Canada. He also won the Grand Award at WPPI with the first print he ever entered in competition.

Bob Coates. Bob Coates Photography is based in Sedona, AZ. Bob's images have been published in numerous

national magazines, and he is the author of *Photographer's Guide to Wedding Album Design and Sales* and *Professional Strategies and Techniques for Digital Photographers*, both from Amherst Media.

Tony Corbell. Tony is the former Director of Photographic Education for Hasselblad USA, before which he served as a faculty member at the Brooks Institute of Photography. He is the author of *Basic Studio Lighting: The Photographer's Complete Guide to Professional Techniques* (Amphoto, 2001).

Jerry D. Jerry D owns and operates Enchanted Memories, a portrait and wedding studio in Upland, CA. Jerry has had several careers—from licensed cosmetologist to black-belt martial-arts instructor. Jerry has been highly decorated by WPPI and achieved many awards since joining the organization.

Terry Deglau. Terry Deglau is the former manager of trade relations at Eastman Kodak Company and currently operates his own business in Pittsburgh, PA. He is a Rochester Institute of Technology graduate with a degree in photographic science, and has lectured extensively throughout the world.

Mauricio Donelli. Mauricio Donelli's photographs have been published in *Vogue, Town & Country* and many national and international magazines. Based in Miami, FL, he has photographed weddings in Milan, Paris, Cuba, Venezuela and many other locales.

Bruce Dorn. As a member of the Director's Guild of America, Bruce's previous career involved casting, coaching, filming, and glamorizing "real people" for commercial clients including McDonalds, Budweiser, and Coca-Cola. As the owner of iDC Photography, he offers this award-winning expertise to his wedding clients.

Fuzzy Duenkel, M.Photog., Cr., CPP. Fuzzy Duenkel, of West Bend, WI, is a highly decorated photographer who has had prints selected for the National Traveling Loan Collection, Disney's Epcot Center, Photokina, and the International Photography Hall of Fame and Museum.

Scott Eklund. Scott Eklund makes his living as a photojournalist for the *Seattle Post-Intelligencer*, but recently got interested in photographing weddings. He has since won numerous awards for his wedding photography, which relies on a photojournalist's sense of timing and storytelling.

Deborah Lynn Ferro. Deborah has a background in watercolor painting, which she now applies digitally to create her acclaimed fine-art portraits. With her husband, Rick Ferro, she is the coauthor of *Wedding Photography with Adobe Photoshop* (Amherst Media, 2003).

Rick Ferro. Rick is an award-winning photographer who served as senior wedding photographer at Walt Disney World. He is the author of *Wedding Photography: Creative Techniques for Lighting and Posing* and coauthor of *Wedding Photography with Adobe Photoshop*, both from Amherst Media.

Jennifer George. Jennifer George was named the California Photographer of the Year and won the People's Choice Award in 2001 at the Professional Photographers of California convention. You can view more of her images at www.jwalkerphotography.com.

Jerry Ghionis. Jerry Ghionis of XSiGHT Photography and Video is one of Australia's top photographers. In 1999, he was honored with the AIPP award for best new talent in Victoria. In 2002, he won the AIPP's Victorian Wedding Album of the Year.

Claude Jodoin. Claude Jodoin is an award-winning photographer from Detroit, MI, who has been involved in digital imaging since 1986. He is an event specialist who shoots numerous weddings and portrait sessions throughout the year. E-mail him at claudej1@aol.com.

Giorgio Karayiannis. Giorgio Karayiannis is one of those rare photographers who specializes in editorial, fashion, advertising, commercial, and portrait photography—and is successful at each. He has been a technical photographic adviser for the Ilford Imaging Group International.

Tim Kelly. Tim Kelly, of Lake Mary, FL, holds the Master of Photography and Photographic Craftsman degrees, and is a long-time member of Kodak's Pro Team. In 2001, he was awarded a fellowship in the American Society of Photographers and named to the prestigious Cameracraftsmen of America.

Brian King. Brian King, of Hillard, OH, attended the Ohio Institute of Photography and has earned Certified Professional Photographer and Master of Photography degrees from PPA. He is a member of PPO-PPA Senior Photographers International and The American Society of Photographers.

Christian LaLonde. Christian operates a commercial division within Photolux, the studio owned by Frank and Anthony Cava, where he concentrates on corporate, architectural, food, product, and editorial jobs. In 2002 and 2003, he was named Canadian Commercial Photographer of the Year.

Robert Lino, M. Photo., Cr., PPA Cert., APM, AOPM, AEPA, FDPE, FSA. Robert Lino of Miami, FL, specializes in fine portraiture and social events. He is a highly decorated photographer in national print competitions and is a regular on the seminar circuit.

Robert Love, APM, AOPA, AEPA, M.Photog, Cr. CPP and **Suzanne Love, Cr. Photog.** Robert Love is a member of Cameracraftsmen of America, one of forty active members in the world. He and his wife, Suzanne Love, create all of their images on location.

Rita Loy. With her husband Doug, Rita Loy is the co-owner of Designing Portrait Images Spartanburg, SC. Rita is a recipient of Kodak's Gallery Award of Photographic Excellence and the Fuji Masterpiece Award. She is also a member of Kodak's prestigious Pro Team.

Kersti Malvre. Award-winning artist Kersti Malvre of Los Altos, CA, photographs babies, children, family groups, and lately, pets. Kersti's delicate, yet rich, use of color and attention to detail give her work a timeless, classical, and enduring quality.

Heidi Mauracher, M. Photog., Cr. CPP, FBIPP, AOPA, AEPA. The late Heidi Mauracher was acclaimed as both a photographer and a teacher. Her unique images have been featured in a variety of magazines and books, and earned many awards in international competition. She left us in March, 2003.

Chris Nelson. Before opening his studio in 1991, Chris Nelson worked as a press photographer and reporter for the *Milwaukee Sentinel*. Today, he concentrates on lifestyle portraits with a photojournalistic edge.

Suzette Nesire. Suzette Nesire is a highly regarded children's portrait photographer whose portraits provide an intimate look into a child's world. Her website offers some profound but simple knowledge about children and photographing them. Visit www.suzette.com.au.

Ferdinand Neubauer, PPA Certified, M.Photog. Cr., APM. Ferdinand Neubauer is the author of *The Art of Wedding Photography* and *Adventures in Infrared* (both self published). His work has appeared in numerous pub-

lications and he has been a speaker at many photographic conventions and events.

Dennis Orchard. Dennis Orchard is an award-winning photographer from Great Britain. He has been a speaker and an award winner at WPPI conventions and print competitions. He is a member of the British Guild of portrait and wedding photographers.

Larry Peters. Larry Peters operates three studios in Ohio and is one of the most successful and award-winning senior-portrait photographers in the nation. His web site (www.petersphotography.com) is loaded with good information about photographing seniors.

Parker Pfister. Parker Pfister of Hillsboro, OH, is the consummate wedding photographer and is quickly developing a national celebrity for this work (although he also has a beautiful portfolio of fine-art nature images). To learn more, visit www.pfisterphoto-art.com

Norman Phillips, AOPA. Norman Phillips is a frequent contributor to photographic publications, a print judge, and a guest speaker at seminars and workshops nationwide. He is the author of *Professional Posing Techniques for Wedding and Portrait Photographers* (Amherst Media, 2006).

Joe Photo. Joe Photo's images have been featured in magazines like *Grace Ormonde's Wedding Style* and *Elegant Bride*. His weddings have also been seen on NBC's *Life Moments* and the Lifetime channel's *Weddings of a Lifetime* and *My Best Friend's Wedding*.

Tim Schooler. Tim Schooler Photography is an award-winning studio specializing in high school senior photography with a cutting edge. Tim's work has been published internationally in magazines and books. His studio is located in Lafayette, LA. Visit his website at www.timschooler.com.

Brian and Judith Shindle. Brian and Judith Shindle own Creative Moments in Westerville, OH. This studio is home to three enterprises under one umbrella: a working studio, an art gallery, and a full-blown event-planning business. Brian's work has received numerous awards in international competition.

Joseph and Louise Simone. Joseph and Louise Simone have been a team since 1975, the year they established their Montreal studio. In addition to creating countless award-winning portraits, the Simones have lectured across Europe and the United States.

Kenneth Sklute. Kenneth purchased his first studio in 1984 and soon after received his masters degree from PPA. In 1996, he moved to Arizona, where he enjoys a thriving business. He has earned numerous honors, including several Fuji Masterpiece Awards and Kodak Gallery Awards.

Cherie Steinberg Coté. Cherie began her career as a photojournalist at the *Toronto Sun*, where she was the paper's first female freelance photographer. Cherie currently lives in Los Angeles and has recently been published in the *L.A. Times, Los Angeles Magazine,* and *Towne & Country.*

Vicki and Jed Taufer. Vicki Taufer and Jed Taufer are the owners of V Gallery in Morton, IL. Vicki has received national recognition for her portraits and is an award-winner in WPPI print competitions. Jed is the head of the imaging department at V Gallery. Visit their impressive website at www.vgallery.net.

David Anthony Williams, M.Photog. FRPS. In 1992, David achieved the rare distinction of Associateship and Fellowship of the Royal Photographic Society of Great Britain (FRPS) on the same day. He has also been awarded the Accolade of Outstanding Photographic Achievement by WPPI.

Robert Williams. Robert Williams operates a studio in northeast Ohio that photographs children, families, and seniors, as well a producing work for corporate clients like General Tire, Xerox, and Holiday Inn. For further information, visit www.robertwilliamsstudio.com.

Jeffrey and Julia Woods. Jeffrey and Julia Woods are award-winning wedding and portrait photographers who work as a team. Among their many honors are two Fuji Masterpiece awards and a Kodak Gallery Award. To see more of their images, visit www.jwweddinglife.com.

Yervant Zanazanian, M. Photog. AIPP, F.AIPP. As a boy, Yervant worked after school for his father, photographer to the Emperor Hailé Silassé of Ethiopia. Today, he owns a prestigious photography studio in Australia and has won awards too numerous to mention.

Monte Zucker. When it comes to perfection in posing and lighting, timeless imagery, and contemporary yet classic photographs, Monte Zucker is world famous. He's been bestowed every major honor the photographic profession can offer, including WPPI's Lifetime Achievement Award. Sadly, Monte Zucker passed away during production of this book after a short illness.

GLOSSARY

Abrading tool. A needle-tipped retoucher's tool used to remove pinholes and spots on negatives and prints.

Action. In Adobe Photoshop, a series of commands that you play back on a single file or a batch of files.

Barn doors. Black, metal folding doors that attach to a light's reflector. Used to control the width of the beam of light.

Bit. Stands for binary digit. Smallest unit of information handled by a computer. One bit is expressed as a 1 or a 0 in a binary numeral. A single bit conveys little information a human would consider meaningful. However, a group of eight bits makes up a byte, representing more substantive information.

Bit-depth. Number of bits per pixel allocated for storing color information in an image file.

Bounce flash. Reflecting the light of a studio or portable flash off a surface such as a ceiling or wall to produce indirect, shadowless lighting.

Broad lighting. A lighting setup in which the key light illuminates the side of the subject's face turned toward the camera.

Burning-in. A darkroom technique in which specific areas of the print surface are given additional exposure in order to darken them. Simulated in Photoshop with the burn tool.

Butterfly lighting. A lighting setup in which the key light is placed high and directly in line with the subject's nose. This lighting produces a butterfly-like shadow under the nose. Also called Paramount lighting.

Byte. A unit of data, typically consisting of eight bits. Computer memory and storage are referenced in bytes (*i.e.* in kilobytes [1000 bytes], megabytes [1 million bytes], or gigabytes [1 trillion bytes]).

Calibration. The process of altering the behavior of a device so that it will function within a known range of performance or output.

Catchlight. The specular highlights that appear in the iris or pupil of the subject's eyes. These are reflections from the portrait lights.

Channel. Used in digital imaging, the channels are a grayscale representation of the amount of each primary color in each area of an image (plus one composite channel showing the complete color image). The color mode of the image determines the number of color channels created. For example, an RGB image has three channels (one each for red, green, and blue) plus a composite RGB channel. Additional channels can also be created in an image file to preserve masks or selections.

Color Management. System of software-based checks and balances that ensures consistent color through capture, display, editing, and output device profiles.

Color Space. The range of colors that a given output device (such as a monitor or printer) is able to produce.

Color temperature. The degrees Kelvin of a light source or film sensitivity. Color films are balanced for 5500°K (daylight), 3200°K (tungsten), or 3400°K (photoflood).

Cross-lighting. Lighting that comes from the side of the subject, skimming across the facial surfaces to reveal the texture in the skin. Also called side-lighting.

Depth of field. The distance that is sharp beyond and in front of the focus point at a given f-stop.

Depth of focus. The amount of sharpness that extends in front of and behind the focus point. Some lenses' depth of focus extends 50 percent in front of and 50 percent behind the focus point. Other lenses vary.

Diffusion flat. A portable, translucent diffuser that can be positioned in a window frame or near the subject to diffuse the light striking the subject.

Dodging. Darkroom technique in which specific areas of the print are given less exposure by blocking the light to those areas of the print, making them lighter. Simulated in Photoshop by the dodge tool.

Dope. Retouching medium that is often applied to negatives to give them a suitable retouching surface.

Dragging the shutter. Using a shutter speed slower than the X-sync speed in order to capture the ambient light in a scene.

E.I. (Exposure Index). The term refers to a film speed other than the rated ISO of the film.

Embedding. The process of including a color profile as part of the data within an image file.

Etching. A subtractive retouching technique used to selectively reduce density in an area of the negative.

Feathering. Misdirecting the light deliberately so that the edge of the beam of light illuminates the subject.

Fill card. A white or silver foil–covered card used to reflect light back into the shadow areas of the subject.

Fill light. A secondary light source used to illuminate the shadows created by the key light.

Flash fill. Using electronic flash to fill in the shadows created by the main light source.

Flashing. A darkroom technique used in printing to darken an area of the print by exposing it to raw light. The same technique can be achieved in Photoshop using a transparent vignette.

Flash key. Using flash as the main-light source and the ambient light as the fill-light source.

Flashmeter. A handheld incident light meter that measures both the ambient light of a scene and, when connected to an electronic flash, will read flash only or a combination of flash and ambient light.

Focusing an umbrella. Adjusting the distance between the light source and inside surface of an umbrella to optimize light output.

Foreshortening. A distortion of normal perspective caused by close proximity of the camera/lens to the subject. This exaggerates subject features—noses appear elongated, chins jut out, and the backs of heads may appear smaller than normal.

45-degree lighting. A portrait lighting pattern that is characterized by a triangular highlight on the shadow side of the face. Also known as Rembrandt lighting.

Full-length portrait. An image that depicts the the model from head to toe, whether the subject is standing, seated, or reclining.

Furrows. The vertical grooves in the face adjacent to the mouth. Furrows are made deeper when the subject smiles. Often called laugh lines.

Gaussian blur. Photoshop filter that diffuses a digital image.

Gobo. A light-blocking card that is supported on a stand or boom and positioned between the light source and subject to selectively block light from portions of the scene.

Golden mean. A rule of composition that is applied by drawing a diagonal line from one corner of the frame to the other, then drawing a line from either remaining corner of the frame so that the diagonal is intersected perpendicularly.

Grayscale. A color model consisting of up to 254 shades of gray plus absolute black and absolute white. Every pixel of a grayscale image displays as a brightness value ranging from 0 (black) to 255 (white). Grayscale values can also be measured as percentages of black ink coverage (0 percent is equal to white, 100 percent is equal to black).

Head-and-shoulder axis. Imaginary lines running horizontally through the shoulders (shoulder axis) and vertically down the ridge of the nose (head axis).

High-key lighting. A type of lighting characterized by a low lighting ratio and a predominance of light tones.

Highlight brilliance. The specularity of highlights on the skin.

Histogram. A graphic representation that indicates, for a given image, the number of pixels that exist for each brightness level. This extends from "absolute" black (on the left) to "absolute" white (on the right).

Hot spot. A highlight area that is overexposed and without detail.

ICC Profile. Device-specific information that describes how the device behaves in terms of color density and color gamut. These profiles enable the color management system to act as a translator between two or more different devices.

Incident light meter. A handheld light meter that measures the amount of light falling on its light-sensitive dome.

JPEG (Joint Photographic Experts Group). An image file format that employs lossy compression algorithms to reduce the file storage size.

Key light. In portraiture, the light used to establish the lighting pattern and define the facial features of the subject.

Kicker. A light coming from behind the subject that highlights the hair or contour of the body.

Lead-in line. In compositions, a pleasing line in the scene that leads the viewer's eye toward the main subject.

Lens circle. The area of focused light rays falling on the film plane or digital imaging chip.

Levels. A tool in Photoshop that allows you to correct the tonal range and color balance of an image.

Lighting ratio. The difference in intensity between the highlight and shadows side of the face.

Loop lighting. A portrait lighting pattern characterized by a loop-like shadow on the shadow side of the subject's face. This differs from Paramount or butterfly lighting because the main light is slightly lower and farther to the side of the subject.

Low-key lighting. A type of lighting characterized by a high lighting ratio and strong scene contrast as well as a predominance of dark tones.

Main light. Synonymous with key light.

Mask. In Photoshop, an adjustment tool that allows you to isolate areas of an image as you apply color changes, filters, or other effects to the overall image.

Modeling light. A secondary light mounted in the center of a studio flash head that gives a close approximation of the lighting that the flash tube will produce. Usually, modeling lights employ high intensity, low heat-output quartz bulbs.

Optimum lens aperture. The aperture on a lens that produces the sharpest image. It is usually two stops stopped down from wide open.

Over-lighting. A condition that occurs when the main light is either too close to the subject or too intense. This makes it impossible to record detail in highlighted areas.

Parabolic reflector. An oval-shaped dish that houses a light and directs its beam outward in an even and controlled manner.

Paramount lighting. One of the basic portrait lighting patterns, Paramount lighting is characterized by a key light placed high and directly in line with the subject's nose. This lighting produces a butterfly-like shadow under the nose. Also called butterfly lighting.

Perspective. The appearance of objects in a scene as determined by their relative distance and position.

Pixel (picture element). The smallest element used to form a digital image.

Point light source. A small light source, like the sun, which produces sharp-edged shadows without diffusion.

Print driver. Software that interprets data from a device, usually a computer, into instructions that a specific printer uses to create a graphical representation of that data on paper or other media.

Profiling. The method by which the color reproduction characteristics of a device are measured and recorded in a standardized fashion. Profiles are used to ensure color consistency in throughout the digital workflow.

PSD (Photoshop document). The default file format in Photoshop. This saves all image layers created within the file.

Push-processing. Extended development of film, sometimes in a special developer, that increases the effective speed of the film.

RAW file. A file format that records the picture data from a digital sensor without applying any in-camera corrections. These files must first be processed by compatible software. RAW processing includes the option to adjust exposure, white balance, and color of the image, all the while leaving the original RAW picture data unchanged.

Reflected light meter. A meter that measures the amount of light reflected from a surface or scene. All in-camera meters are of the reflected type.

Reflector. (1) Same as fill card. (2) A housing on a light that reflects the light outward in a controlled beam.

Rembrandt lighting. Same as 45-degree lighting.

RGB. A color mode common in digital imaging in which all of the colors in an image are made up of varying shades of red (R), green (G), and blue (B) used in combination with each other.

Rim lighting. Portrait lighting pattern where the key light is placed behind the subject and illuminates the edge of the subject. This is most often used with profile poses.

Rule of thirds. A guideline for composition that divides the image area into thirds, horizontally and vertically. The intersection of any two lines in this resulting grid is considered a dynamic point where the subject can be placed for the most visual impact.

Scrim. A panel used to diffuse sunlight. Scrims can be mounted in panels and set in windows, used on stands, or they can be suspended in front of a light source to diffuse the light.

Seven-eighths view. Facial pose that shows approximately seven-eighths of the face. Almost a full-face view as seen from the camera.

Sharpening. In Photoshop, filters that increase apparent sharpness of an image by increasing the contrast of adjacent pixels within it.

Short lighting. One of two basic types of portrait lighting. In short lighting, the key light illuminates the side of the face turned away from the camera.

Slave. A remote triggering device used to fire auxiliary flash units. These may be optical or radio-controlled.

Softbox. Same as a box light. It can contain one or more light heads and employ either a single or double-diffused scrim.

Soft-focus lens. A special lens that uses spherical or chromatic aberration in its design to diffuse the image points.

Specular highlights. Very small, bright, paper-base white highlights.

Split lighting. A type of portrait lighting that splits the face into two distinct areas: a shadow side and a highlight side. The key light is placed far to the side of the subject and slightly higher than the subject's head height.

Straight flash. The light of an on-camera flash unit that is used without diffusion.

Subtractive fill-in. Lighting technique that uses a black card to subtract light out of a subject area in order to create a better defined lighting ratio. Also refers to the placement of a black card over the subject in outdoor portraiture to make the light more frontal and less overhead.

Three-quarter-length pose. Pose that includes all but the lower portion of the subject's anatomy. This can be from above the knees and up, or below the knees and up.

Three-quarter view. A facial pose that allows the camera to see three-quarters of the facial area. The subject's face is usually turned 45-degrees away from the lens so that the far ear disappears from the camera view.

TIFF. A file format commonly used for digital images. TIFF files employ lossless compression, meaning that no matter how many times they are opened and closed, the data remains the same (unlike JPEG files, which are designated as lossy files, meaning that data is lost each time the files are resaved).

Tooth. Refers to a negative that has a built-in retouching surface that will accept retouching leads.

TTL-balanced fill flash. A flash exposure system that reads the flash exposure through the camera lens and adjusts the flash output relative to the ambient light for a balanced flash–ambient exposure.

Umbrella lighting. A type of soft lighting that uses one or more photographic umbrellas to diffuse the light source(s).

Unsharp mask. A sharpening tool in Adobe Photoshop that is usually the last step in preparing an image for printing.

Vignette. A semicircular, soft-edged border around the main subject. Vignettes can be either light or dark in tone and can be included at the time of shooting, or added later in printing or in Photoshop.

Watt-seconds. Numerical system used to rate the power output of electronic flash units. This is primarily used to rate studio strobe systems.

Wraparound lighting. A soft type of light that wraps around subjects to produce a low lighting ratio and open, well-illuminated highlight areas.

INDEX

A

Actions, 102
Adobe Camera RAW, 28–30
Adobe DNG format, 27
Adobe Lightroom, 30
Adobe Photoshop, 95–112
Aperture, 15–17, 88
 optimal, 15–17
 soft focus, impact on, 88

B

Background, lighting, 23, 50, 59,
 76–77
Backing up, 31–32
Backlighting, 77–78
Baldness, 91
Broad lighting, 50
Burning, 106–7

C

Camera, 10–11, 88–89
 digital 35mm, 10–11
 height, 88–89
 large format, 10
Candid images, *see* Spontaneous
 portraits, 80–85
Casual style, 7–10, 80–85
Color balance, 10, 27–30
Color correction, 108–9
 selective color, 108
 white and gray points, 109
Color management, 103–6
 camera profiles, 104–5

(Color management, cont'd)
 monitor profiles, 105
 printer profiles, 105–6
Color space, 30–31
Composition, 42–47
 direction, 44–45
 focus, role in composition, 47
 forms, 45
 golden mean, 43–44
 lines, 46–47
 rule of thirds, 42–43
 subject tone, 45–46
Contrast, 20, 107–8
Copyright notices, 25
Corrective techniques, 86–94
 baldness, 91
 broad foreheads, 92
 camera height, 88–89
 double chin, 91
 elderly subjects, 90
 eyeglasses, 90–91
 eyes, deep set, 92
 eyes, protruding, 92
 eyes, uneven sizes, 91
 facial analysis, 86–87
 necks, 92
 noses, 92
 overweight subjects, 89–90
 skin, 93–94
 soft focus, 87–88
 underweight subjects, 91
 wide faces, 91–92
Cross lighting, 77

D

Depth of field, 15
Diffusion, 87–88, 98
Digital capture, 19–21, 24–32
 black & white mode, 20
 contrast, 20
 exposure, 21, 24–25
 file formats, 20, 25–30
 ISO setting, 19–20
 metadata, 25
 noise, 19, 21
 sharpness, 21
 white balance, 20–21
DNG format, 27
Dodging, 106–7

E

Elderly subjects, 90
Exposure, 21, 24–25, 61–65
Eyeglasses, 90–91
Eyes, 91–92, 101–3
 deep set, 92
 protruding, 92
 retouching, 101–3
 uneven sizes, 91

F

Fashion lighting, 70
Feathering the light, 54–55
File formats, 20, 25–30
 DNG, 27
 JPEG, 25–26
 RAW, 26–30

Film, 18–19
 black & white, 18–19
 families, 18
Flags, 62
Flash, 68–70, 73–74, 78–79
 bounce, 68–70
 fill, outdoors, 73–74, 78
 key, outdoors, 78–79
 on-camera, 70
 portable, 68–70
 TTL, 70, 73–74
Focusing, 14–15, 47

G
Gobos, 62
Golden mean, 43–44

H
Handcoloring techniques, 110
Histogram, 11

I
ISO setting, 19–20, 24–25

J
JPEG format, 25–26

K
Key light, 49–50, 61
Kicker light, 50
Kodak print viewing filters, 108

L
Lenses, 11–17
 aperture, optimal, 15–17
 depth of field, 15
 digital conversion, 13
 focal length, 11–13
 focusing, 14–15
 image stabilization, 11
Lens flare, 77
Lighting equipment, 22–23, 62,
 68–70, 76
 continuous *vs.* strobe, 22–23
 flags, 62

(Lighting equipment, cont'd)
 flash, on-camera, 68–70
 gobos, 62
 reflectors, 62
 scrims, 76
 softboxes, 23
 umbrellas, 23
Lighting ratios, 56–58
 calculating, 56
 personalities, 56–58
Lighting techniques, 21–25, 48–80
 background, 23, 50, 59, 76–77
 backlighting, 77–78
 broad lighting, 50
 corrective, *see* Corrective
 techniques
 cross lighting, 77
 fashion lighting, 70
 feathering, 54–55
 fill light, 49–50, 55–56, 59–61,
 62
 hair light, 50, 59
 key light, 49–50, 61
 kicker light, 50
 loop lighting, 51–52
 metering, 21–22, 24–25, 61–62
 one-light portraits, 68–70
 outdoor lighting, 71–80
 Paramount lighting, 51
 placing the lights, 58–61
 profile lighting, 53–54
 ratios, *see* Lighting ratios
 Rembrandt lighting, 52
 short lighting, 50–51
 split lighting, 53
 subtractive, 74–75
 window light, *see* Window light
Loop lighting, 51–52

M
Memory cards, reformatting, 32
Metadata, 25
Metering, 21–22, 24–25, 61–62,
 64–65
 calculating E.I., 24–25

(Metering, cont'd)
 gray card, 62
 incident flashmeters, 22, 61
 incident-light meters, 22
 reflected-light meters, 21–22
 spotmeters, 61–62
 window light, 64–65
Mouth, 36–37, 93
 gap between lips, 36–37
 laugh lines, 37
 moistening lips, 36
 narrow, 93
 natural smiles, 36
 tension, avoiding, 36
 wide, 93

N
Necks, 92
Noise, 19, 21
Noses, 92

O
One-light portraits, 68–70
 bounce flash, 68–70
 on-camera flash, 70
 portable flash, 68–70
 TTL, 70
Outdoor lighting, 71–80
 background control, 76–77
 backlighting, 77–78
 cross lighting, 77
 direct sunlight, 77–78
 fill-in light, 72–74
 flash, 78–79
 overhead, 75
 scrims, 76
 separation, creating, 79
 shade, 71–72
 shadows, color in, 80
 subject positioning, 79
 subtractive techniques, 74–75
 tripod, 79–80
Overweight subjects, 89–91

P
Paramount lighting, 51
Perspective, 88–89
Posing, 33–41
 arms, 37
 chin height, 27
 comfort, 34
 corrective, *see* Corrective
 techniques
 eyes, 36
 feet, 40–41
 full-length portraits, 40
 hands, 38, 41
 head positions, 34–35
 head tilt, 35–36
 legs, 40–41
 mouth, 36–37
 shoulders, 34
 three-quarter-length portraits, 40
Print finishing, 32, 103–11
 archival permanence, 106
 burning, 106–7
 color correction, *see* Color
 correction
 color management, 103–6
 contrast control, 107–8
 dodging, 106–7
 enlarging images, 106
 handcoloring techniques, 110
 sharpening, 111–12
 toning techniques, 109
 vignettes, 110–11
Profile lighting, 53–54

R
RAW format, 26–30
 Adobe Camera RAW, 28–30
 Adobe Lightroom, 30
 RAW converters, 26–30
Reflectors, 62
Rembrandt lighting, 52
Retouching techniques, 95–102
 actions, 102
 blemishes, 100
 contouring, 102
 eyeglasses, 103
 eyes, 101–2
 layers, working with, 97–98
 shininess, 101
 soft focus, 98
 teeth, 101–2
 traditional techniques, 95–96
 wrinkles, 101
Rule of thirds, 42–43

S
Sharpening, 21, 111–12
Short lighting, 50–51
Shutter speed, 17–18, 85
Skin, 93–94, 100–102
 dry, 93
 imperfections, 93–94
 oily, 93
 retouching, 100–102
Softboxes, 23
Soft focus, 87–88, 98
Split lighting, 53

Spontaneous portraits, 80–85
 camera controls, 85
 composition, 84
 observing the subject, 80–84
 shutter speed, 85

T
Teeth, 101–2
Telephoto lens, *see* Lens, focal
 length
Toning techniques, 109
Tripod, 79–80

U
Umbrellas, 23
Underweight subjects, 91

V
Vignettes, 110–11

W
White balance, 20–21
Wide-angle lens, *see* Lens, focal
 length
Window light, 63–68
 diffusing, 67–68
 fill-in light, 66–67
 metering, 64–65
 subject positioning, 64
 white balance, 65–66

Z
Zoom lens, *see* Lenses, focal
 length

PROFESSIONAL PORTRAIT LIGHTING
TECHNIQUES AND IMAGES FROM MASTER PHOTOGRAPHERS

Michelle Perkins

Get a behind-the-scenes look at the lighting techniques employed by the world's top portrait photographers. $34.95 list, 8.5x11, 128p, 200 color photos, index, order no. 2000.

MASTER POSING GUIDE
FOR CHILDREN'S PORTRAIT PHOTOGRAPHY

Norman Phillips

Create perfect portraits of infants, tots, kids, and teens. Includes techniques for standing, sitting, and floor poses for boys and girls, individuals, and groups. $34.95 list, 8.5x11, 128p, 305 color images, order no. 1826.

LEGAL HANDBOOK FOR PHOTOGRAPHERS, 2nd Ed.

Bert P. Krages, Esq.

Learn what you can and cannot photograph, how to handle conflicts should they arise, how to protect your rights to your images in the digital age, and more. $34.95 list, 8.5x11, 128p, 80 b&w photos, index, order no. 1829.

MASTER GUIDE
FOR PROFESSIONAL PHOTOGRAPHERS

Patrick Rice

Turn your hobby into a thriving profession. This book covers equipment essentials, capture strategies, lighting, posing, digital effects, and more, providing a solid footing for a successful career. $34.95 list, 8.5x11, 128p, 200 color images, order no. 1830.

PROFESSIONAL FILTER TECHNIQUES
FOR DIGITAL PHOTOGRAPHERS

Stan Sholik

Select the best filter options for your photographic style and discover how their use will affect your images. $34.95 list, 8.5x11, 128p, 150 color images, index, order no. 1831.

MASTER'S GUIDE TO WEDDING PHOTOGRAPHY
CAPTURING UNFORGETTABLE MOMENTS AND LASTING IMPRESSIONS

Marcus Bell

Learn to capture the unique energy and mood of each wedding and build a lifelong client relationship. $34.95 list, 8.5x11, 128p, 200 color photos, index, order no. 1832.

MASTER LIGHTING GUIDE
FOR COMMERCIAL PHOTOGRAPHERS

Robert Morrissey

Use the tools and techniques pros rely on to land corporate clients. Includes diagrams, images, and techniques for a failsafe approach for shots that sell. $34.95 list, 8.5x11, 128p, 110 color photos, 125 diagrams, index, order no. 1833.

DIGITAL CAPTURE AND WORKFLOW
FOR PROFESSIONAL PHOTOGRAPHERS

Tom Lee

Cut your image-processing time by fine-tuning your workflow. Includes tips for working with Photoshop and Adobe Bridge, plus framing, matting, and more. $34.95 list, 8.5x11, 128p, 150 color images, index, order no. 1835.

THE PHOTOGRAPHER'S GUIDE TO COLOR MANAGEMENT
PROFESSIONAL TECHNIQUES FOR CONSISTENT RESULTS

Phil Nelson

Learn how to keep color consistent from device to device, ensuring greater efficiency and more accurate results. $34.95 list, 8.5x11, 128p, 175 color photos, index, order no. 1838.

SOFTBOX LIGHTING TECHNIQUES
FOR PROFESSIONAL PHOTOGRAPHERS

Stephen A. Dantzig

Learn to use one of photography's most popular lighting devices to produce soft and flawless effects for portraits, product shots, and more. $34.95 list, 8.5x11, 128p, 260 color images, index, order no. 1839.

CHILDREN'S PORTRAIT PHOTOGRAPHY HANDBOOK

Bill Hurter

Packed with inside tips from industry leaders, this book shows you the ins and outs of working with some of photography's most challenging subjects. $34.95 list, 8.5x11, 128p, 175 color images, index, order no. 1840.

JEFF SMITH'S LIGHTING FOR OUTDOOR AND LOCATION PORTRAIT PHOTOGRAPHY

Learn how to use light throughout the day—indoors and out—and make location portraits a highly profitable venture for your studio. $34.95 list, 8.5x11, 128p, 170 color images, index, order no. 1841.

PROFESSIONAL CHILDREN'S PORTRAIT PHOTOGRAPHY

Lou Jacobs Jr.

Fifteen top photographers reveal their most successful techniques—from working with uncooperative kids, to lighting, to marketing your studio. $34.95 list, 8.5x11, 128p, 200 color photos, index, order no. 2001.

CHILDREN'S PORTRAIT PHOTOGRAPHY
A PHOTOJOURNALISTIC APPROACH

Kevin Newsome

Learn how to capture spirited images that reflect your young subject's unique personality and developmental stage. $34.95 list, 8.5x11, 128p, 150 color images, index, order no. 1843.

PROFESSIONAL PORTRAIT POSING
TECHNIQUES AND IMAGES FROM MASTER PHOTOGRAPHERS

Michelle Perkins

Learn how master photographers pose subjects to create unforgettable images. $34.95 list, 8.5x11, 128p, 175 color images, index, order no. 2002.

STUDIO PORTRAIT PHOTOGRAPHY OF CHILDREN AND BABIES, 3rd Ed.

Marilyn Sholin

Work with the youngest portrait clients to create cherished images. Includes techniques for working with kids at every developmental stage, from infant to preschooler. $34.95 list, 8.5x11, 128p, 140 color photos, order no. 1845.

MONTE ZUCKER'S
PORTRAIT PHOTOGRAPHY HANDBOOK

Acclaimed portrait photographer Monte Zucker takes you behind the scenes and shows you how to create a "Monte Portrait." Covers techniques for both studio and location shoots. $34.95 list, 8.5x11, 128p, 200 color photos, index, order no. 1846.

DIGITAL PHOTOGRAPHY FOR CHILDREN'S AND FAMILY PORTRAITURE, 2nd Ed.

Kathleen Hawkins

Learn how staying on top of advances in digital photography can boost your sales and improve your artistry and workflow. $34.95 list, 8.5x11, 128p, 195 color images, index, order no. 1847.

LIGHTING AND POSING TECHNIQUES FOR PHOTOGRAPHING WOMEN

Norman Phillips

Make every female client look her very best. This book features tips from top pros and diagrams that will facilitate learning. $34.95 list, 8.5x11, 128p, 200 color images, index, order no. 1848.

JEFF SMITH'S POSING TECHNIQUES FOR LOCATION PORTRAIT PHOTOGRAPHY

Use architectural and natural elements to support the pose, maximize the flow of the session, and create refined, artful poses for individual subjects and groups—indoors or out. $34.95 list, 8.5x11, 128p, 150 color photos, index, order no. 1851.

POSING TECHNIQUES FOR PHOTOGRAPHING MODEL PORTFOLIOS

Billy Pegram

Learn to evaluate your model and create flattering poses for fashion photos, catalog and editorial images, and more. $34.95 list, 8.5x11, 128p, 200 color images, index, order no. 1848.

THE BEST OF PORTRAIT PHOTOGRAPHY
2nd Ed.

Bill Hurter

View outstanding images from top pros and learn how they create their masterful classic and contemporary portraits. $34.95 list, 8.5x11, 128p, 180 color photos, index, order no. 1854.

THE ART OF PREGNANCY PHOTOGRAPHY

Jennifer George

Learn the essential posing, lighting, composition, business, and marketing skills you need to create stunning pregnancy portraits your clientele can't do without! $34.95 list, 8.5x11, 128p, 150 color photos, index, order no. 1855.

BIG BUCKS SELLING YOUR PHOTOGRAPHY, 4th Ed.

Cliff Hollenbeck

Build a new business or revitalize an existing one with the comprehensive tips in this popular book. Includes twenty forms you can use for invoicing clients, collections, follow-ups, and more. $34.95 list, 8.5x11, 144p, resources, business forms, order no. 1856.

ILLUSTRATED DICTIONARY OF PHOTOGRAPHY

Barbara A. Lynch-Johnt & Michelle Perkins

Gain insight into camera and lighting equipment, accessories, technological advances, film and historic processes, famous photographers, artistic movements, and more with the concise descriptions in this illustrated book. $34.95 list, 8.5x11, 144p, 150 color images, order no. 1857.

PROFESSIONAL PORTRAIT PHOTOGRAPHY
TECHNIQUES AND IMAGES FROM MASTER PHOTOGRAPHERS

Lou Jacobs Jr.

Veteran author and photographer Lou Jacobs Jr. interviews ten top portrait pros, sharing their secrets for success. $34.95 list, 8.5x11, 128p, 150 color photos, index, order no. 2003.

THE SANDY PUC' GUIDE TO
CHILDREN'S PORTRAIT PHOTOGRAPHY

Learn how Puc' handles every client interaction and session for priceless portraits, the ultimate client experience, and maximum profits. $34.95 list, 8.5x11, 128p, 180 color images, index, order no. 1859.

MINIMALIST LIGHTING
PROFESSIONAL TECHNIQUES FOR LOCATION PHOTOGRAPHY

Kirk Tuck

Use small, computerized, battery-operated flash units and lightweight accessories to get the top-quality results you want on location! $34.95 list, 8.5x11, 128p, 175 color images and diagrams, index, order no. 1860.

FILM & DIGITAL TECHNIQUES FOR
ZONE SYSTEM PHOTOGRAPHY

Dr. Glenn Rand

Learn how to use this systematic approach for achieving perfect exposure, developing or digitally processing your work, and printing your images to ensure the dynamic photographs that suit your creative vision. $34.95 list, 8.5x11, 128p, 125 b&w/color images, index, order no. 1861.

THE KATHLEEN HAWKINS GUIDE TO
SALES AND MARKETING FOR PROFESSIONAL PHOTOGRAPHERS

Learn how to create a brand identity that lures clients into your studio, then wow them with outstanding customer service and powerful images that will ensure big sales and repeat clients. $34.95 list, 8.5x11, 128p, 175 color images, index, order no. 1862.

LIGHTING TECHNIQUES
FOR MIDDLE KEY PORTRAIT PHOTOGRAPHY

Norman Phillips

In middle key images, the average brightness of a scene is roughly equivalent to middle gray. Phillips shows you how to orchestrate every aspect of a middle key shoot for a cohesive, uncluttered, flattering result. $34.95 list, 8.5x11, 128p, 175 color images/diagrams, index, order no. 1863.

PHOTOGRAPHER'S GUIDE TO
WEDDING ALBUM DESIGN AND SALES, 2nd Ed.

Bob Coates

Learn how industry leaders design, assemble, and market their outstanding albums with the insights and advice provided in this popular book. $34.95 list, 8.5x11, 128p, 175 full-color images, index, order no. 1865.

LIGHTING FOR PHOTOGRAPHY TECHNIQUES FOR
STUDIO AND LOCATION SHOOTS

Dr. Glenn Rand

Gain the technical knowledge of natural and artificial light you need to take control of every scene you encounter and produce incredible photographs. $34.95 list, 8.5x11, 128p, 150 color images/diagrams, index, order no. 1866.